5/01

☙ THE WOMEN ❧ IMPRESSIONISTS

A Sourcebook

Russell T. Clement, Annick Houzé,
and Christiane Erbolato-Ramsey

Art Reference Collection, Number 24

GREENWOOD PRESS
Westport, Connecticut • London

Library of Congress Cataloging-in-Publication Data

Clement, Russell T.
 The women impressionists : a sourcebook / Russell T. Clement, Annick Houzé, and
 Christiane Erbolato-Ramsey.
 p. cm.—(Art reference collection, ISSN 0193-6867 ; no. 24)
 Includes bibliographical references and index.
 ISBN 0-313-30848-9 (alk. paper)
 1. Impressionism (Art)—France—Bibliography. 2. Art, French—Bibliography. 3. Art,
 Modern—19th century—France—Bibliography. 4. Art, Modern—20th
 century—France—Bibliography. 5. Women artists—France—Bibliography. 6. Cassatt,
 Mary, 1844–1926—Bibliography. 7. Morisot, Berthe, 1841–1895—Bibliography. 8.
 Bracquemond, Marie, 1841–1916—Bibliography. 9. Gonzalès, Eva,
 1849–1883—Bibliography. I. Houzé, Annick. II. Erbolato-Ramsey, Christiane, 1958– III.
 Title. IV. Series.
 Z5961.F7 C58 2000
 [N6847.5.I4]
 016.7594—dc21 99–059411

British Library Cataloguing in Publication Data is available.

Library of Congress Catalog Card Number: 99–059411
ISBN: 0-313-30848-9
ISSN: 0193-6867

First published in 2000

Greenwood Press, 88 Post Road West, Westport, CT 06881
An imprint of Greenwood Publishing Group, Inc.
www.greenwood.com

Printed in the United States of America

The paper used in this book complies with the
Permanent Paper Standard issued by the National
Information Standards Organization (Z39.48–1984).

10 9 8 7 6 5 4 3 2

To: Flavia Garcia Erbolato (1926-1998), whose gentle strokes and unwavering style made life a masterpiece.

To: Renée Henriette Marie Houzé (1913-1979)

Oh! l'amour d'une mère! Amour que nul n'oublie!
Pain merveilleux qu'un Dieu partage et multiplie!
Table toujours servie au paternel foyer!
Chacun en a sa part et tous l'ont tout entier.
Victor Hugo

Contents

Preface

"I don't think there has ever been a man who treated a woman as an equal, and that's all I would have asked for, for I know I'm worth as much as they."

– Berthe Morisot

Lending credence to the admonition never to trust an idea that you come across while sitting down, inspiration for this sourcebook on the women Impressionists came from a suggestion by Rebecca Clement while on a hike, appropriately, to the Walker Sisters' homestead in Little Greenbrier, Great Smoky Mountains National Park-a dilapidated testament in adze-scored chestnut planks to five resolute sisters. Their rugged pioneer lives parallel the hardships and struggle for acceptance of the four 19th century women artists featured here. Coincidentally, a working outline, division of labor, target completion date, and artists to include (Rosa Bonheur and Suzanne Valadon were reluctantly dropped due to a lack of significant secondary literature) were thrashed out under the shelter of an enormous yellow poplar on the same trail during a later afternoon when, as the French exclaim, it "rained ropes." We were delighted when Christiane Erbolato-Ramsey cheerfully elected to join the project in its initial stage. Ms. Erbolato-Ramsey was responsible for fetching, gathering, organizing, and writing the sections on Cassatt and Gonzalès, much of which was accomplished during a research trip to Paris in 1999.

The poignancy that underscores aspects of these women's lives and the disadvantages they faced as women artists are heightened by the consistent quality of their paintings and their high-reaching artistic aspirations. Cassatt is best known among Americans, in whose major museums she is reasonably well represented. Morisot has never fallen from recognition in France; Bracquemond and Gonzalès are much less known, in part due to their small and erratic output. The accomplishments and originality of the women Impressionists make them, in our minds, worthy equals to the pantheon of artists covered in other Greenwood bio-bibliographies and sourcebooks on late 19th and early 20th century French avant-garde colorists, namely *Paul Gauguin* (1991), *Henri Matisse* (1993), *George Bracque* (1994), *Les Fauves* (1994), *French Symbolists* (1996), and *Neo-Impressionist Painters* (1999).

This sourcebook compiles and organizes the literature on women Impressionists in general as well as sources on four individual French and American artists. Each individual

section includes a biographical sketch, chronology, primary and secondary bibliographies, and exhibition lists (individual and group). Entire careers are covered in the sourcebook, not just their Impressionist periods.

To produce the sourcebook, relevant literature was gleaned from computer and card catalogues and from printed indexes and guides to the library and archival collections of major art museums, universities, and scholarly and artistic institutes in the United States and Western Europe. Standard art indexes and abstracting services, such as the *Bibliography of the History of Art; Art Index; ART Bibliographies Modern; International Repertory of the History of Art; Répertoire d'art et d'archéologie;* Chicago Art Institute, Ryerson Library's *Index to Art Periodicals; Frick Art Reference Library Original Index to Art Periodicals; Arts and Humanities Citation Index; Humanities Index; Women Studies Index; MLA Bibliography; Worldwide Art Catalog Bulletin; 19th Century American Art Periodicals (AAI),* and *Répertoire des catalogues de ventes* were consulted, along with pertinent bibliographic databases such as RLIN, SCIPIO, WorldCat, UnCover, FirstSearch, ProQuest Direct, OCLC, and Internet sites. The sourcebook attempts to be as comprehensive as possible within time, travel, budget, and length constraints. It should not, however, be construed as exhaustive.

This guide is intended as a briefly and partially annotated bibliography, not as a critical one. Annotations are provided sporadically for entries where titles give incomplete or unclear information about works and their content. Monographs and dissertations are annotated with more regularity than periodical articles. When they appear, annotations are of necessity brief and are intended only to note the subject matter discussed, the general orientation, or the conclusion of the study. Obviously, a sentence or two can hardly represent fairly or adequately describe even a short article, to say nothing of a major book. Our apologies to authors who may feel that the annotations have misrepresented, misconstrued, misunderstood, or even distorted their work in this process of radical condensation. Our own opinions and critical judgements have in no case been conscious criteria for inclusion or exclusion. Foreign-language titles abound, particularly in French. Since a reading knowledge of French is essential for serious Impressionist research, with a few exceptions, only titles in other foreign languages are occasionally translated.

How to Use the Primary and Secondary Bibliographies

The bibliographies are divided into sections, accessible by the Contents. Entries are numbered consecutively throughout. In every section, manuscripts are listed first, followed by books, periodical articles, and exhibitions. Within each section, citations are listed alphabetically by author or chronologically, when noted. Anonymous works are alphabetized by title. When several entries are credited to the same author, they are arranged chronologically. Authors whose surnames have changed and those who have rearranged their given names or initials are generally listed as they appear in print. They may, therefore, be found in the Personal Names Index in more than one location. The Exhibitions sections contain information and publications about exhibitions, including a few sales catalogues and reviews, arranged chronologically into individual and groups exhibition categories.

The most effective use of the secondary bibliographies is by means of the Contents and Art Works and Personal Names Indexes. Entries are indexed with reference to their citation numbers. Particular publications may be located in the Personal Names Index under the author or any other persons associated with the work, such as editors and translators.

Acknowledgments

Credit and heartfelt appreciation are extended to dozens of library colleagues, art and cultural historians, curators, collectors, and Impressionist specialists who provided unstinting encouragements and assistance in the creation of this sourcebook.

Brigham Young University and the Harold B. Lee Library, in particular, Carla Kupitz and Erva Rieske, gave great institutional support. Also at BYU, Patricia Peterson and Grace Chang proofread and edited the whole manuscript. Special thanks to Kayla Willey who again provided special assistance in the final formatting of this project. We would also like to express our thanks to Martha Talman for assistance with interlibrary loan requests and general support, Tony Grover and Amy Jensen for the many hours of searching the databases. We are grateful for Brooke Webb and Emily Fluckinger who performed the tasks of some of the data entry. Research travel to France was supported by the Lee Library Creative Projects Committee.

Appreciation is likewise expressed to the Interlibrary Services staff at the John C. Hodges Library, The University of Tennessee and at the Lee Library at Brigham Young University. Supervisors whose support enabled timely completion of the project include Linda Phillips and Rita Smith at the University of Tennessee Libraries.

We are cognizant of taxing family and personal relations through preoccupation with the work and gratefully acknowledge their indulgence and endorsement during private times when our thoughts were focused elsewhere, particularly Rebecca S. Clement and Paul W. Ramsey.

Introduction

I agree: the Morisot sisters are charming. What a pity they aren't men. Still, as women, they may be able to serve the cause of painting by each of them marrying an academician and sowing discord among those doddering fools. But that would be asking them for a great self-sacrifice.

–Edouard Manet, letter to Henri Fantin-Latour, 1888

The Impressionist circle encompassed women artists of considerable abilities whose works and lives have received increasing popular attention and critical reappraisal by scholars over the past 25 years. The four women artists included in this sourcebook responded to Impressionism in individual ways. They studied, worked, and exhibited with major Impressionists including Degas, Manet, Monet, Renoir, and Pissarro. Although they never formed a cohesive common identity or group based on gender, they did associate with each other professionally and personally. They also shared the challenges of women being accepted as professional artists in late 19th century French society.

The four artists treated in *The Women Impressionists: A Sourcebook* are Mary Stevenson Cassatt (1844-1926), Berthe Morisot (1841-1895), Marie Bracquemond (1840-1916), and Eva Gonzalès (1849-1883). Cassatt, the best known female Impressionist in the United States, was born in Pittsburgh and studied with Degas, who invited her to exhibit with the Impressionists in 1879, 1880, 1881, and 1886. Morisot, a model and close friend of Manet who married his brother Eugène in 1874, was a central member of the Impressionist group and exhibited in seven of their eight shows. Bracquemond was a painter, printmaker, designer, and ceramicist admired by Renoir, Monet, and Gauguin who exhibited with the Impressionists in 1879. She married Félix Bracquemond, also an important printmaker, designer, painter, and writer who was one of the first French artists to discover and popularize Japanese prints. Gonzalès modeled for and took still-life lessons from Manet but declined to exhibit her pastels and oil paintings with the Impressionists.

The idea of studying Women Impressionism dates to the advent of feminist art criticism in the 1970s, beginning with essays by Linda Nochlin, Nancy Mowll Mathews, Griselda Pollock, Roszika Parker, and Suzanne Lindsay on Mary Cassatt. In 1986, Tamar Garb published her popular *Women Impressionists* (New York: Rizzoli), the beginning of

a steady stream of exhibition catalogues, monographs, and articles on Cassatt, Morisot, Bracquemond, Gonzalès, and other women artists associated with Impressionism. One must be mindful that one hundred years ago, and for most of this century, no one, especially the women artists themselves, conceived of a gender-based female Impressionism. As Tamar Garb cautions in *Women Impressionists*:

> *It is misleading to create, in retrospect, a common identity for four very different artists that is based on the fact of their sex. Each of the women Impressionists related in her own specific way to the artistic and political debates of their time. The four painters did not consciously identify themselves with each other, and the strongest intellectual and aesthetic collaborations that they developed were with their male colleagues rather than among themselves; important were Gonzalès's and Morisot's relationships with Manet, Cassatt's with Degas, and Bracquemond's respect for Monet's contribution to art. Friendship and professional consideration existed between Cassatt and Morisot, and Gonzalès and Morisot knew one another. Bracquemond seems to have had less contact with the others. Cassatt, of all the women Impressionists, was the most politicized about her femininity and consequently established strong ties with women artists, primarily, though, outside the Impressionist circle. This belies the popular assumption that the Impressionists were a close-knit and exclusive group, completely separate from their more conservative contemporaries. (p. 5)*

Their individual struggles for acceptance as women artists, amply documented and argued in sources in the General section of this research guide, is perhaps the most poignant element of their stories. When not ignored altogether or cursorily dismissed or ridiculed by caustic critics, the largely hostile reaction to Impressionism seemed to intensify when directed at its women practitioners. Each wrestled with balancing personal lives with the demands of art. Bracquemond withdrew entirely in her prime because of an unsympathetic husband who was jealous of her talent. Gonzalès died in childbirth at age 34. Morisot termed widowhood "the positive stage of life." Only Cassatt, a wealthy and independent spinster with a forceful personality, forged a successful and acclaimed career in her long lifetime. She had four solo exhibitions, Paul Durand-Ruel became her exclusive dealer, and she was awarded the Chevalier de la Légion d'Honneur in 1904.

Attitudes have reversed since Edouard Manet's derisive comment quoted above on the Morisot sisters. After close to a century of neglect, women artists of all periods are at the vanguard of vigorous new critical and popular attention. Both the multi-disciplinary scholarship and popular press citations represented in this sourcebook attest to the multidimensional and multilayered fascination and appeal of the women Impressionists. Appreciation of their unique contributions–as women first, as pioneer women artists, and as Impressionists–is at last beginning to be realized.

Women Impressionists Chronology, 1840–1927

This general chronology is based upon "Chronologies Comparées" in *Les Femmes impressionnistes: Mary Cassatt, Eva Gonzalès, Berthe Morisot* by Marianne Delaford and Marie-Caroline Sainsaulieu (exh. cat., Musée Marmottan; Paris: La Bibliothèque des Arts, 1993):164-8. For more information about individual artists, consult the chronologies at the beginning of each section.

1840

Birth of Marie Quiveron-Pasquiou (later Bracquemond) in Argenton, near Quimper.

1841

Birth of Berthe Morisot in Bourges.

1845

Birth of Mary Cassatt in Allegheny City (now Pittsburgh).

1849

Birth of Eva Gonzalès in Paris.

1857

Bracquemond shows for the first time at the Paris Salon.

1864

Morisot shows for the first time at the Paris Salon.

1866

Cassatt and Gonzalès enroll in the studio of Charles Chaplin; Cassatt remains only a short time.

1867

Gonzalès leaves Chaplin's studio.

1868

Morisot meets Edouard Manet and poses for *Le Balcon.*

1869

Gonzalès meets Manet, poses for a portrait and, becomes his student.

1870

Cassatt returns to Philadelphia for two years. Gonzalès shows at the Salon and escapes the Commune in Dieppe; Morisot also shows and stays in Paris. Bracquemond's son Pierre is born.

1871

Bracquemond moves to Sèvres after her husband Félix is appointed artistic director of the Haviland Limoges porcelain works in Auteuil.

1872

Cassatt returns to Europe, travels to Spain and Italy, and shows at the Salon. Gonzalès and Morisot also enter works in the Salon, where Gonzalès is noticed by Emile Zola.

1873

Morisot exhibits at the Salon and Gonzalès at the Salon des Refusés. Cassatt travels to The Netherlands.

1874

Cassatt and Bracquemond show at the Salon, where Cassatt is noticed by Degas. Following Manet's advice, Gonzalès shows works in his studio. Morisot participates in the First Impressionist exhibition and marries Edouard Manet's brother Eugène.

1875

Bracquemond begins to paint Impressionist works, much to her husband's disapproval. Cassatt enters works in the Salon.

1876

Cassatt and Gonzalès exhibit at the Salon. Morisot shows at the Second Impressionist exhibition.

1877

Morisot shows in the Third Impressionist exhibition. Degas visit Cassatt's studio.

1878

Bracquemond enters decorated dishes and her *Muses* in l'Exposition Universelle, Paris. Gonzalès shows at the Salon. Birth of Julie Manet, daughter of Morisot and Eugène Manet.

1879

Cassatt and Bracquemond enter the Fourth Impressionist exhibition but Morisot does not show. Gonzalès participates in the Salon and marries Henri Guérard, Manet's engraver.

1880

Cassatt, Bracquemond, and Morisot exhibit at the Fifth Impressionist show. Gonzalès shows at the Salon.

1881

Cassatt and Morisot exhibit at the Sixth Impressionist show. Bracquemond's career begins to decline.

1882

Morisot participates in the Seventh Impressionist exhibition where Cassatt, following Degas's counsel, does not show. Gonzalès enters the Salon.

1883

Morisot and family settle in Bougival. Gonzalès dies in Paris three weeks after giving birth to a son and one week after Edouard Manet's death.

1884

Cassatt voyages to Spain with her mother.

1885

Morisot begins her Thursday dinners, where she entertains Degas, Monet, Renoir, and the writer Stéphane Mallarmé.

1886

Bracquemond, Morisot, and Cassatt participate in the Eighth and final Impressionist exhibition.

1890

Bracquemond largely abandons painting, producing only a few works until her death in 1916.

1891

Cassatt holds her first individual exhibition at Durand-Ruel, Paris.

1892

Morisot has her first individual exhibition at Boussod et Valadon, Paris.

1895

Cassatt exhibits at Durand-Ruel, New York. Morisot dies in Paris.

1914

Cassatt shows at Durand-Ruel, Paris. Bracquemond's husband dies.

1916

Bracquemond dies in Sèvres, near Paris.

1919

Bracquemond retrospective organized by her son Pierre is held at Galerie Bernheim-Jeune, Paris.

1927

Cassatt dies in Le Mesnil-Théribus.

Common Abbreviations

cat.	catalogue
col.	color
diss.	dissertation
dist.	distributed
ed(s.)	edition(s) or editor(s)
exh.	exhibition
illus.	illustrations
min.	minutes
no. or nos.	numbers
p. or pp.	page(s)
pl.	plate(s)
rev.	revised
ser.	series
supp.	supplement
vol(s).	volumes

Women Impressionists
in General

I. Books

1. BACHMANN, DONNA G. and SHERRY PILAND. *Women Artists: An Historical, Contemporary and Feminist Bibliography*. Metuchen, NJ; London: Scarecrow Press, 1978. 323 p., illus.

Includes citations for Cassatt (pp. 157-64), Gonzalès (pp.168-9), and Morisot (pp. 187-91).

2. BAKER, ELIZABETH and THOMAS B. HESS, eds. *Art and Sexual Politics; Women's Liberation, Women's Artists, and Art History*. NY: Collier, 1973. 150 p., illus.

Anthology of essays on the historical and critical treatment of women artists with scattered references to the women Impressionists.

3. BAZIN, GERMAIN. *Les Impressionnistes au Musée d'Orsay*. Paris: Somogy, 1990. 280 p., 222 illus., 212 col.

Introduction to an exhibition of the work of 24 major Impressionist artists, including Cassatt and Morisot, held by the Musée d'Orsay, Paris. Covers the evolution of Impressionism in the 1860s to its adoption in Western Europe and the U.S. in the 1890s.

4. BLANCHE, JACQUES-EMILE. *Portraits of a Lifetime, 1870-1914. The Late Victorian Era, the Edwardian Pageant, 1870-1914.* Translated and edited by Walter Clement. Introduction by Harley Granville-Barker. London: J.M. Dent, 1937. 316 p., illus.

a. Other eds.: 1938, 1939.
b. U.S. ed.: NY: Coward-McCann, 1938.

5. BONAFOUX, PASCAL. *Les Impressionnistes, portraits et confidences: écrits, lettres et témoignages*. Geneva: Skira, 1986. 191p., illus.

a. English ed.: *The Impressionists: Portraits and Confidences, with Writings, Letters and Witness Accounts by the Painters, Their Friends and Writers and Critics of the Impressionist Period.* Geneva: Skira; NY: Rizzoli, 1986. 191 p., illus.

6. BROMBERT, BETH ARCHER. *Edouard Manet: Rebel in a Frock Coat.* Boston: Little Brown, 1996. 505 p., 67 illus.

Biography of Manet's life and career that details his relationships with Morisot and her family as well as with Eva Gonzalès.

7. BROUDE, NORMA F. and MARY D. GARRARD, eds. *Feminism and Art History: Questioning the Litany.* NY: Harper & Row, 1982. 258 p., illus. (Icon Editions)

Argues for an expanded and more balanced art history that includes female artists such as the women Impressionists.

8. CACHIN, FRANÇOISE and CHARLES S. MOFFETT. *Manet, 1832-1833.* Avec la participation de Michel Melot. Paris: Ministère de la Culture; Musées Nationaux; NY: Metropolitan Museum of Art, 1983. 544 p., illus.

Exhibition catalogue with references to Women Impressionists, held at Paris, Grand Palais (22 April-1Aug. 1983) and NY, Metropolitan Museum of Art. (10 Sept.-27 Nov. 1983).

9. CALLEN, ANTHEA. *Techniques of the Impressionists.* London: Orbis, 1982. 192 p., 30 illus.

Survey of Impressionism that focuses on individual artistics techniques, including Morisot and Cassatt. Examines 30 paintings in detail.

10. CLARK, FRANCES IDA. *The Position of Women in Contemporary France.* London: P.S. King. 1937. 259 p.

a. U.S. ed.: Westport, CT: Hyperion Press, 1981. 259 p.

11. CLARK, TIMOTHY J. *The Painting of Modern Life: Paris in the Art of Manet and his Followers.* NY: Knopf; London: Thames & Hudson, 1985. 338 p. , illus., 31 pl.

Cultural history with references to Morisot and other 19th century women painters.

12. COLLET, GEORGES-PAUL. *George Moore et la France.* Geneva: Librairie Droz, 1957. 231 p.

13. COURTHION, PIERRE. *Autour de l'impressionnisme: Bazille, Boudin, Mary Cassatt, Fantin-Latour, Guigou, Lebourg, Guillaumin, Jongkind, Lépine, Berthe Morisot, Prins, Sisley.* Paris: Nouvelles Editions Françaises, 1964. 53 p., illus., 48 col. pl.

14. CUNARD, NANCY. *G.M. : Memories of George Moore.* London: Rupert Hart-Davis, 1956. 206 p., illus.

15. DENVIR, BERNARD, ed. *The Impressionists at First Hand.* NY; London: Thames and Hudson, 1987. 221 p., illus., some col. (World of Art)

16. DOV, GEN. *Women and Visual Culture in Nineteenth-Century France, 1800-1852.* London and NY: Leicester University Press, 1998. 277 p. 32 pl.

Examines women's art history following the French Revolution in context of bourgeois ideology, conformity, and contradictions. Includes information on Cassatt and Morisot.

17. DURET, THEODORE. *Les Peintres impressionnistes: Claude Monet, Sisley, C. Pisarro* [sic], *Renoir, Berthe Morisot.* Avec un dessin de Renoir. Paris: Librairie Parisienne, 1878. 35 p., 1 illus.

18. FENEON, FELIX. *Les Impressionnistes en 1886.* Paris: Publications de la Vogue, 1886. 42 p.

19. FINE, ELSA HONIG. *Women and Art: A History of Women Painters and Sculptors from the Renaissance to the 20th Century.* London: Prior; Montclair, NJ: Allanheld & Schram, 1978. 240 p., illus.

See Chapter 6, "The Impressionist Period," for sections on Morisot, Cassatt, Gonzalès, and Suzanne Valadon.

20. GARB, TAMAR. *Women Impressionists.* Oxford: Phaidon; NY: Rizzoli, 1986. 78 p., 40 illus., 32 col.

Survey of lives, careers, and influence of Berthe Morisot, Mary Cassatt, Eva Gonzalès, and Marie Bracquemond, four women Impressionists who exhibited with their male colleagues but whose works are largely forgotten. In her introduction, Garb explains how it is misleading to group these women artists together simply by gender and discusses their individual responses to 19th century avant-garde French art. Reproduces, annotates, and provides full catalogue entries for 32 representative paintings.
a. German ed.: *Frauen des Impressionismus: die Welt des farbigen Lichts.* Stuttgart; Zurich: Belser, 1987. 80 p., 40 illus., 32 col.
Reviews: C. Cruise, *Art Monthly* 103(Feb. 1987):27; B. Thomson, *Burlington Magazine* 129:1009(April 1987):254-5; N. Mathews, *Woman's Art Journal* 101:1(Spring-Summer 1989):46-9.

21. GARB, TAMAR. *'Sœurs de pinceaux': The Formation of a Separate Women's Art World in Paris, 1881-1897.* Ph.D. thesis, University of London, Courtauld Institute, 1991. 466 p., illus., 29 pl.

Details the early history of l'Union des femmes peintres, sculpteurs, graveurs, décorateurs, with reference to the difficulties and challenges that women had in establishing themselves as serious artists in the late 19th century.

22. GARB, TAMAR. *Sisters of the Brush: Women's Artistic Culture in Late Nineteenth-Century Paris.* New Haven; London: Yale University Press, 1994. 215 p., 62 illus.

Details the history of l'Union des femmes peintres, sculpteurs, graveurs, décorateurs and the portrayal of women in 19th century French art. Includes references to the women Impressionists. Bibliography, pp. 192-201.
Review: M. Lewis, *Art Journal* 53:3(Fall):90-2.

23. GARB, TAMAR. *Bodies of Modernity: Figure and Flesh in fin-de-siècle France.* London: Thames and Hudson, 1998. 240 p., illus. (Interplay)

Investigation of gender representation in late 19th century French art that includes analysis and discussion of works by Morisot and Cassatt. Bibliography, pp. 221-31.

24. GEFFROY, GUSTAVE. *Claude Monet, sa vie, son temps, son œuvre.* Cinquante-quatre illustrations hors-texte en noir et en couleur. Paris: G. Crès, 1922. 362 p., 54 illus., pl.

a. Other eds.: 1924; Edition critique présentée par C. Judrin. Paris: Editions Macula, 1980. 544 p., illus., 8 pl. (Artistes d'hier et d'aujourd'hui)

25. GIGOUX, JEAN. *Causeries sur les artistes de mon temps.* Paris: C. Lévy, 1885. 297 p., pl. (Bibliothèque contemporaine)

26. GREER, GERMAINE. *The Obstacle Race: The Fortunes of Women Painters and Their Work.* NY: Farrar, Straus, Giroux, 1979. 373 p., illus., 16 pl.

Mentions Morisot and Cassatt.
a. English ed.: London: Secker & Warburg, 1979.

27. HARRIS, ANN SUTHERLAND and LINDA NOCHLIN. *Women Artists, 1550-1950.* Los Angeles: Los Angeles County Museum of Art; dist. by Random House, 1976. 368 p., illus.

Catalogue of a traveling exhibition held in 1975-77 at four venues. Bibliography, pp. 362-5.
a. Italian ed.: *Le Grandi pittrici, 1550-1950.* Traduzione di Margherita Leardi. Milan: Feltrinelli, 1979. 383 p., illus.
b. French ed.: *Femmes peintres, 1550-1950.* Traduit par Claude Bourguignon, Pascaline Germain, Julie Pavesi et Florence Verne. Paris: Des Femmes, 1981. 366 p., illus.

28. HELLER, NANCY G. *Women Artists, an Illustrated History.* NY: Abbeville, 1987. 224 p., 178 illus., some col.

Section on women Impressionists includes Gonzalès, Morisot, and Cassatt (pp. 94-9).

29. HUYSMANS, JORIS-KARL. *L'Art moderne.* Paris: G. Charpentier, 1883. 277 p.

a. Other eds.: 1902, 1903, 1908, 1911, 1919, 1969, 1975, 1986.

30. LUCIE-SMITH, EDWARD. *Impressionist Women.* London: Weidenfeld and Nicolson, 1989. 160 p., 128 illus., 79, col.

Analyzes the role and representation of women in Impressionist art, including Degas' purported misogyny and Morisot's and Cassatt's empathy.

31. MATHEWS, NANCY MOWLL, ed. *Cassatt and her Circle; Selected Letters*. NY: Abbeville Press, 1984. 360 p., illus.

Includes 208 selected letters describing Cassatt's life, and offers insight into her character. Letters to and from friends and family span her student days, early years as a professional, Impressionist period, and late international fame. Includes 54 reproductions, chronology, genealogy, bibliography (p. 355), and list of sources for her works (pp. 349-54).
Reviews: A. Faxon, *Woman's Art Journal* 6:2(Fall-Winter 1985-6):50-3; J. Gambrell, *Art in America* 72:11(Dec. 1984):24-7; N. Hale, *Archives of American Art Journal* 24:3(1984):24-5); B. Shapiro, *Print Collector's Newsletter* 16:1(Mar-Apr.1985):27-9; L. Wolfangel, 11:1(Winter 1986):27-8.

32. MATHEY, FRANÇOIS. *Les Femmes peintres: Berthe Morisot, Eva Gonzalès, Séraphine Louis, Suzanne Valadon, Maria Blanchard, Marie Laurencin*. Paris: Les Editions du Chêne, 1951. 14 p. illus., 16 col. pl.

33. MAUCLAIR, CAMILLE. *The French Impressionists, 1860-1900*. Trans. by P. G. Konody. London: Duckworth, 1902.

34. MAUCLAIR, CAMILLE. *L'Impressionnisme, son histoire, son esthétique, ses maîtres*. Paris: Librairie de l'Art Ancien et Moderne, 1904.

35. MELOT, MICHEL. *The Impressionist Print*. New Haven; London: Yale University Press, 1996. 296 p., 300 illus., 60 col.

Focuses on Impressionist printmaking, including examples by Cassatt, Morisot, and Bracquemond, among other artists.

36. MOFFETT, CHARLES S. *The New Painting: Impressionism 1874-1886*. San Francisco: Fine Arts Museums of San Francisco, 1986. 500 p., illus., some col.

Exhibition catalogue that included paintings shown in the eight original Impressionist exhibitions.

37. MONNERET, SOPHIE. *L'Impressionnisme et son époque: dictionnaire international*. Paris: Robert Laffont; Editions Denoël, 1978. 2 vols.

38. MOORE, GEORGE. *Confessions of a Young Man*. London: S. Somenschein, Lowrey, 1888. 357 p.

Describes a painting of young girls by Morisot shown at an Impressionist exhibition, probably one in the 1880s. Moore (1852-1933) was an Irish poet and novelist.
a. Other eds.: 1889, 1904, 1907, 1915, 1917, 1918, 1920, 1923, 1925, 1928, 1933, 1939, 1952, 1959, 1961, 1972.

b. French eds.: *Confessions d'un jeune anglais.* Paris: A. Savine, 1889. 286 p.; Paris: Stock, 1925.

39. MUNSTERBERG, HUGO. *A History of Women Artists.* NY: Clarkson N. Potter, dist. by Crown, 1975. 150 p., illus.

Covers Morisot (pp. 53-7) and Cassatt (pp. 53-9).

40. PETERSEN, KAREN and J. J. WILSON. *Women Artists: Recognition and Reappraisal from the Early Middle Ages to the Twentieth Century.* NY: Harper & Row, 1976. 212p., illus.

Under Impressionists, includes sections on Cassatt, Morisot, and Suzanne Valadon (pp. 87-97).

41. POLLOCK, GRISELDA and ROZSIKA PARKER. *Old Mistresses: Women, Art and Ideology.* London: Routledge & Kegan Paul, 1981. 184 p.

Explores women's place in the history of art and how women have been represented and misrepresented. See especially pages 38-44 and 146 for information on the women Impressionists.

42. POLLOCK, GRISELDA. *Differencing the Canon: Feminist Desire and the Writing of Art's History.* London and NY: Routledge, 1999. 345 p., 109 illus. (Re Visions)

Explores problems of interpreting the traditional art canon from a feminist perspective, including questions of sexuality and cultural differences, with examples and discussion drawn largely from 19th century European artists. See particularly Chapters 8-9 for discussion and analysis of Morisot, Cassatt, Bracquemond, and Gonzalès.

43. REWALD, JOHN. *The History of Impressionism.* New York: Museum of Modern Art, 1946. 474 p., illus.

Standard authoritative survey of French Impressionism.
a. Other eds.: 1955, 1961, 1973.
b. Chinese ed.: *Yin hsiang hua pai shih.* Pei-ching: Jen min mei shu chu pen she, 1983. 355 p., illus.
c. French eds.: *Histoire de l'impressionnisme.* Paris: Albin Michel, 1955, 1959, 1965, 1966, 1976.
d. German eds.: *Die Geschichte des Impressionismus.* Köln: M. Dumont Schauberg, 1965; 1979.
e. Italian ed.: *Storia dell'impressionismo.* Prefazione di Roberto Longhi, traduzione a cure di Antonio Boschetto. Firenze: Sansoni, 1949; Milano: A. Mondadori, 1976.
f. Polish ed.: *Historia impresjonizmu.* Przelozyla Justyna Guze Warszawa: Państwowy Instytut Wydawniczy, 1985. 554 p., illus.
g. Portuguese ed.: *História do impressionismo.* Tradução Jefferson Luís Camargo. Sao Paulo: Martins Fontes, 1991. 560 p., illus.
h. Romanian ed.: *Istoria impresionismului.* Traducere de Irina Maurodin. Bucuresti:

Meridiane, 1974. 2 vol., illus.
i. Russian ed.: *Istóriia impressionízma.* P.V. Melkóvoi. Leningrad: Gos. izd-vo Iskússtuo, 1959. 453 p. illus., some col.
j. Spanish ed.: *Historia del impresionismo.* Barcelona: Seix Barral, 1972. 2 vol., illus.

44. ROGER-MARX, CLAUDE. *Maîtres d'hier et d'aujourd'hui.* Paris: Calmann-Lévy, 1914. 342 p.

45. SCHNEIDER, PIERRE. *The World of Manet, 1832-1883.* New York: Time-Life Books, 1968. 192 p., illus., some col.

Popularized biography that mentions Morisot, Gonzalès, and Cassatt.
a. Another ed. 1979.
b. French ed. *Manet et son temps, 1832-1993.* Trans. from the American by Jean-Louis Crémieux-Brilhac. Amsterdam: Time-Life Books International (Nederland), 1972.
c. Japanese ed. *Mane, 1832-1883.* Tokyo: Taimu-Raifu Bukkusu, 1974. 193 p. illus.

46. SENZOKU, NOBUYUKI. *Les Femmes impressionnistes: Morisot, Cassatt, Gonzalès.* Japan: Art Life Ltd., 157 p., illus., some col.

47. TABARANT, ADOLPHE. *Manet et ses œuvres.* Paris: Librairie Gallimard, 1947. 622 p., illus.

48. TABARANT, ADOLPHE. *La Vie artistique au temps de Baudelaire.* Paris: Mercure de France, 1942.

a. Another ed. 1963.

49. VENTURI, LIONELLO. *Les Archives de l'impressionnisme: lettres de Renoir, Monet, Pissarro, Sisley et autres. Mémoires de Paul Durand-Ruel. Documents.* Paris; NY: Durand-Ruel, 1939. 2 vols.

50. VOLLARD, AMBROISE. *Souvenirs d'un marchand de tableaux.* Paris: Albin Michel, 1937.

a. English ed.: *Recollections of a Picture Dealer.* Trans. by Violet Macdonald. London: Constable; Boston: Little Brown, 1936. 326 p., illus., pl.

51. WALLER, SUSAN. *Women Artists in the Modern Era: A Documentary History.* Metuchen, NJ and London: Scarecrow Press, 1991. 392 p.

Includes correspondence from Cassatt (pp. 254-6) and Morisot (pp.272-81), along with scattered references to other women Impressionists.

52. WHITE, BARBARA EHRLICH. *Impressionists Side by Side: Their Friendships, Rivalries and Artistic Exchanges.* NY: Knopf, 1996. 292 p., illus., some col., 1 col. Map.

Analyzes relationships between pairs of Impressionist artists: Degas and Manet, Monet and

Renoir, Cézanne and Pissarro, Manet and Morisot, Cassatt and Degas (pp. 183-212), Morisot and Renoir, and Cassatt and Morisot (pp. 259-65). Includes 14 color reproductions by Cassatt, chronology, and bibliography (pp. 281-4).

53. WYZEWA, TEODOR DE. *Peintres de jadis et d'aujourd'hui*. Paris: Perrin et cie, 1903. 392 p., illus. pl.

54. YELDHAM, CHARLOTTE. *Women Artists in Nineteenth Century France and England. Their Art Education, Exhibition Opportunities and Membership of Exhibiting Societies and Academies, with an Assessment of the Subject Matter of Their Work and Summary Biographies.* NY; London: Garland Publishing Co., 1984. 2 vols., illus. (Outstanding Theses from the Courtauld Institute of Art)

Discusses women's art education, exhibition opportunities, societies of women artists, one-woman exhibitions, and membership in exhibiting societies and academies in France and England. Biographical section includes Cassatt (pp. 357-64) among other women artists. Includes tables of women's exhibitions in France and England.

II. Articles

55. BROUDE, NORMA F. "Degas's 'Misogyny.'" *Art Bulletin* 159(March 1977).

56. BROUDE, NORMA F. "Will the Real Impressionists Stand Up?" *ARTnews* 85(May 1986):84-9. 6 col. Illus.

Appreciation of works by Cassatt, Bracquemond, and other women Impressionists.

57. BUETTNER, STEWART. "Images of Modern Motherhood in the Art of Morisot, Cassatt, Modersohn-Becker, Kollwitz." *Woman's Art Journal* 7:2(Fall 1986-Winter 1987):14-21.

Concerns the theme of mother-and-child in the work of these four women artists.

58. BUMPUS, JUDITH. "What a Pity They Aren't Men." *Art & Artists* 201(June 1983):9-10. 2 illus.

Overview of women artists' contributions to Impressionism that emphasizes Berthe Morisot's role and circle, including Cassatt, Gonzalès, Edma Morisot, and Suzanne Valadon.

59. FENEON, FELIX. "Souvenirs sur Manet." *Bulletin de la vie artistique* (15 Oct. 1920).

60. GARB, TAMAR. "L'Art féminin: The Formation of a Critical Category in Late Nineteenth-Century France." *Art history* 12(March 1989):39-65.

61. HIGONNET, ANNE. "Imaging Gender" in *Art Criticism and its Institutions in Nineteenth-Century France*, ed. by Michael R. Orwicz (Manchester; NY: Manchester University Press; dist. in the U.S.A and Canada by St. Martin's Press, 1994):146-61.

Discusses gender-specific characteristics identified by French critics in the works of Morisot, Cassatt, Camille Claudel, and other women artists.

62. LEWIS, MARY TOMPKINS. "Women Artists." *Art Journal* 53:3(Fall 1994):90-2. 2 illus.

Review of the exhibition catalogue, *Les Femmes impressionnistes* (Paris, Musée Marmatton, 1993), and of the book, Tamar Garb, *Sisters of the Brush: Women's Artistic Culture in Late Nineteenth-Century Paris* (New Haven; London: Yale University Press, 1994).

63. NICOLSON, BENEDICT. "Degas as a Human Being." *Burlington Magazine* 105(June 1963).

64. NORD, PHILIP G. "Manet and Radical Politics." *Journal of Inderdisciplinary History* 3 (Winter 1989):447-80.

65. PIGUET, PIERRE. "Les Femmes impressionnistes." *L'Oeil* 457(Dec. 1993):91.

Review of the exhibition, *Les Femmes impressionnistes* (Paris, Musée Marmatton, 1993).

66. SMITH, DAVID LOEFFLER, "Observations on a Few Celebrated Women Artists." *American Artist* 26(Jan. 1962):52-5, 78-81. Illus.

Survey of historical women artists.

III. Exhibitions

1918, 6-7 November	Paris, Hôtel Drouot. *Catalogue des estampes anciennes et modernes: œuvres de Bracquemond, Mary Cassatt, Daumier, Eug. Delacroix, Gauguin, Gavarni, Ingres, Legros, Manet, Berthe Morisot, Pissarro, Whistler, etc.*; composant la collection Edgar Degas dont la vente aux enchères publiques, après son décès... 1 vol., illus.
	Public auction of Degas' private collection, held a year after his death.
1930, May	Paris, Galerie d'Art Pleyel. *Exposition du syndicat des artistes femmes, peintures et sculptures.* 12 p.
1979-80, 2 November-6 January	Ann Arbor, University of Michigan, Museum of Art. *The Crisis of Impressionism, 1878-1882.* Catalogue by Joel Isaacson, with the collaboration of Jean-Paul Bouillon, Dennis Costanzo, Phylis Floyd, Laurence Lyon, Matthew Rohn, Jacquelyn Baas Slee, Inga Christine Swenson. 220 p., 78 illus., 6 col. 56 works shown.

Exhibition of paintings, prints, and sculpture that appeared in the 1879-82 Impressionist exhibitions that included works by Morisot, Bracquemond, and Cassatt, among other Impressionists.

1983, 29 March-
14 August

Nagoya, Musée Préfectoral d'Aichi. *Six femmes peintres: Berthe Morisot, Eva Gonzalès, Mary Cassatt, Suzanne Valadon, Marie Laurencin, Nathalia Gontcharova.* Preface by Jacques de Mons. Tokyo: Asahi shimbum, 1983. 190 p., illus., some col. 123 works shown.

Also shown Tokyo, Takashimaya Art Gallery (21 April-16 May); Osaka, Takashimaya Art Gallery (19-31 May); Tochigi, Prefectural Museum of Fine Arts (5 June-3 July); Kumamoto, Prefectural Museum of Fine Arts (14 July-14 Aug.). Included paintings, drawings, and one portrait bust.

1993, 13 October-
31 December

Paris, Musée Marmatton. *Les Femmes impressionnistes: Mary Cassatt, Eva Gonzalès, Berthe Morisot.* Marianne Delaford, Marie-Caroline Sainsaulieu. Préface par Arnaud d'Hauterives. Paris: Bibliothèque des Arts, 1993. 174 p., 87 col. illus. 90 works shown.

Reviews: P. Piguet, *L'Oeil* 457(Dec. 1993):91; M. Roullet, *Gazette des Beaux-arts* ser. 6, 123(Jan. 1994:4; M. Lewis, *Art Journal* 53:3(Fall 1994):90-2.

1995, 2 March- 20
August

Tokyo, Isetan Bijutsukan. *Inshoha no hana: Morizo, Kasatto, Gonzaresu ten.* Also shown Hiroshima, Hiroshima Bijutsukan (16 April-21 May); Osaka, Takashimaya 7-kai Guarando Horu (31 May-13 June); Hakodate, Hokkaidoritsu Hakodate Bijutsukan (1 July-20 Aug.). Catalogue by Nobuyuki Senzoku, Marc Restellini, Delphine Montalant, and Claire Durand-Ruel Snollaerts. Tokyo: Ato Raafu, 1995. 157 p., illus., some col. 96 works shown.

Mary Cassatt

Biography

It was Stéphane Mallarmé, the poet, – one of the critics I know, who took me to see the Impressionist pictures at the gallery of Boussod et Valadon & Cie., on the Boulevard Montmartre, and at both the gallery and house of M. Durand-Ruel. M. Mallarmé wrote me a list of living Impressionist masters, roughly in order of their importance. It reads thus: Claude Monet, Renoir, Degas, Sisley, Pissarro, Mme Berthe Manet (Morisot) and Raffaëlli. Having handed me this list, he took it back again, and added the name of an American lady, Miss Mary Cassatt, who was of too much consequence, so he said, to be ignored in selecting his chosen few.

– Lousie Chandler Moulton, *Lazy Tours in Spain and Elsewhere*, 1896.

Best known for her portraits of mother and child, Mary Stevenson Cassatt was a key figure in the representation of the world of women in late nineteenth-century Paris, when it was the center of the art world. The only American woman member of the Impressionist group, she studied painting in the United States, France, Italy, and Spain, and exhibited several times at the Salon in Paris. Invited by Degas to exhibit with the Impressionist group, she managed to keep her individual and independent style. Cassatt was one of the few women artists who gained international recognition during her lifetime.

The fourth child of Robert and Katherine Johnston Cassatt, Mary was born in Allegheny City (now part of Pittsburgh), on May 22, 1844. The family moved to Philadelphia, and spent four years in Europe, between Paris and Germany. When Mary was 17, she enrolled at the Pennsylvania Academy of Fine Arts, one of the first academies to open doors to women. In 1866, after four years of drawing from life and copying paintings, she went to Europe in order to study the Old Masters. She spent time in Parma, Italy studying the works of Correggio and Parmigianino; in Spain, where she was fascinated with the works of Murillo; and in Antwerp, where she studied Rubens. In 1874, she settled permanently in Paris and soon became acquainted with Degas, an important influence in her work and life.

In Paris, Cassatt tried to adapt to current styles of genre painting and fashionable portraiture, but became increasingly interested in the new techniques developed by the Impressionists. She captured the life of modern Parisians in nineteenth-century society,

particularly of women in public or private places and activities. During this early period, she not only displayed her subjects with loose brushstrokes and bright colors, but represented their inner strength and individuality. *Little Girl in a Blue Armchair* (1878) exemplifies the unusual cropping of the asymmetrical composition, close vantage point, and abstract background surrounding the central figure. *Lydia Reading the Morning Paper* (1878) displays her interest in the effects of light and nature of colors.

Degas had been impressed with Cassatt's *Ida,* represented in the 1874 Salon. In 1877, after five consecutive years of having works accepted by the Paris Salon, Cassatt's works were rejected and she was advised to tone down her colors. She immediately accepted an invitation from Degas to exhibit with a group of 30 artists, who called themselves the "Impressionists." Cassatt did not like the term and preferred to call herself an "Independent." Later in her career, she even turned down the prestigious Lippincott Prize in order to stay true to her independent and unattached principles. She continued to exhibit with the Impressionists until 1882. In support of Degas, who had also withdrawn from the exhibition, she joined in the protest against Renoir, Cailllebotte and others' reluctance to welcome newcomers to the group. In 1886, Cassatt showed *Girl Arranging Her Hair* in the Eighth and final Impressionist Exhibition.

Lydia Seated at an Embroidery Frame (1880) represents a series of intimate portraits of women indoors, occupied with peaceful and dignified activities typical of women in Cassatt's social circle. The late 1880s brought images of women in public places, likely influenced by Degas, such as the pastel *At the Theatre* (1880). After her sister Lydia's death in 1882, mothers embracing children became the main subject of Cassatt's work. *Mother and Child* (1889) portrays a mother and daughter in an intimate moment. Interest in this subject was certainly fed by constant visits from her nieces and nephews. She began to work mainly in pastel and print, where lines became prominent, and her style began to take new directions.

In 1890, Cassatt visited an exhibition of Japanese prints at l'Ecole des Beaux-arts, in Paris. The works of Utamaro and Tokyokuni inspired her series of 10 drypoint, aquatint, and etching prints executed between 1890 and 1891. The famous *Child's Bath* (1893) is also evidence of the Japanese influence and her progression towards linearity, flatness of surface, and decorative patterning of background. Already considered a famous painter, in 1893 Cassatt was commissioned to paint a mural for the Woman's Building at the World's Columbian Exposition in Chicago. Cassatt's eyesight began to slowly fail, and after many unsuccessful cataract operations, she was virtually blind in 1921. After both her father and sister died, Mary moved with her mother to a country house at Mesnil-Théribus, France, where she remained until her death in 1926.

Cassatt's first official biography, *Mary Cassatt: Un Peintre des enfants et des mères* by Achille Ségard (Paris, 1913) was written with her cooperation but did not give her the credit of an independent and innovative artist. The next major work about her was produced by Adelyn D. Breeskin, who curated the first Cassatt retrospective held in Baltimore in 1936. Breeskin later compiled two catalogues raisonnés: one of prints (1948) and one of paintings, pastels, watercolors, and drawings (1970). Frederick Sweet was also instrumental in adding to Cassatt scholarship with his 1966 *Miss Mary Cassatt: Impressionist From Pennsylvania*. He placed Cassatt in the context of her American contemporaries such as Sargent and Whistler.

Nancy Hale's 1975 *Mary Cassatt: A Biography of the Great American Painter* is an important psychological study. Other contributions include Barbara Shapiro's *Mary Cassatt: The Color Prints* (1989), Griselda Pollock's *Mary Cassatt* (1980) addressing issues

of gender, and Nancy Mowll Mathews who provided significant contributions with her 1980 dissertation examining Cassatt's Madonna theme. Mathews later published *Mary Cassatt and Her Circle: Selected Letters* (1984), *Mary Cassatt: A Life* (1994), and *Mary Cassatt: A Retrospective* (1996). Judith Barter's recent *Mary Cassatt: Modern Woman* (1998) includes the first complete list of exhibitions with works by Cassatt.

Mary Cassatt
Chronology, 1844–1926

Information for this chronology was gathered from *The Dictionary of Art*, ed. Jane Turner (New York: Grove, 1996)5:921-3; *Dictionary of Women Artists,* ed. Delia Gaze (Chicago: Fitzroy Dearborn, 1997)1:366-71; Adelyn Dohme Breeskin, *Mary Cassatt: A Catalogue Raisonné of the Oils, Pastels, Watercolors, and Drawings* (Washington, D.C.: Smithsonian Institution Press, 1970); Nancy Mowll Mathews, *Mary Cassatt* (NY: Abrams in association with The National Museum of American Art, Smithsonian Institution, 1987):152-3; Nancy Mowll Mathews, *Cassatt: A Retrospective* (Southport: Hugh Lauter Levin, 1996):13-7; Griselda Pollock, *Mary Cassatt* (New York: Harper & Row, 1980):28-9; *Mary Cassatt: Modern Woman,* ed. Judith A. Barter (NY: Art Institute of Chicago, in association with H.N. Abrams, 1998):328-52, among other sources.

1844

Mary Stevenson Cassatt is born on May 22 at Allegheny City, Pennsylvania, to Robert Simpson Cassatt (1807-1891), a Pittsburgh banker, and Katherine Kelso Cassatt (1816-1895). The couple have five children: Lydia, Alexander, Robert, Mary, and Joseph (known by his middle name, Gardner).

1851-58

The Cassatts travel to Paris, Heidelberg, and Darmstadt to find treatment for 9-year-old son Robbie, who dies in 1855 of bone cancer. Brother Alexander remains in Darmstadt, studying engineering for another five years. The family moves back to the United States, to West Chester, Pennsylvania.

1860

Mary enrolls in the Antique Class at the Pennsylvania Academy of the Fine Arts. Training consists of copying antique casts from the Academy's collection and attending anatomy lectures at the Pennsylvania Medical University. Only male students are allowed to draw from live models. She studies drawing with Christian Schussele and painting with Peter Rothermel.

1861

The Cassatt family builds a country house on their land in Cheyney, Pennsylvania. The American Civil War begins with the bombardment of Fort Sumpter, South Carolina.

1862

Mary and classmate Eliza Haldeman copy a portrait of Johann Bernhard Wittkamp's *Deliverance of Leyden* at the Academy. In April, the Cassatts move to the new country house and Mary stops her studies at the Academy.

1865

Robert Cassatt opens the brokerage office Cassatt & Company in Philadelphia. In December, Mary, her mother Katherine, and Eliza Haldeman travel to Paris. The Civil War ends and Lincoln is assassinated.

1866-67

Katherine Cassatt returns to the United States. Robert sells the Cheyney property and moves to Renovo, in central Pennsylvania. In France, Mary and Eliza study figure painting at Courances, south of Paris. They also travel north of Paris to Ecouen to study with genre painters Pierre- Edouard Frère and Paul- Constant Soyer. In May, their paintings are refused by the Salon. They attend Charles Chaplin's art classes for women where they work from models and also copy masterworks at the Louvre. Mary becomes a private student of the famous academic painter Jean-Léon Gérôme. In October, Mary travels to "Bains de mer," a resort at St.-Valéry-sur-Somme on the Normandy coast.

1868

Mary and Eliza visit Barbizon, where Mary becomes acquainted with the Barbison style of landscape painting. In May, Mary's *Mandolin Player* is accepted by the Salon. The painting is signed "Mary Stevenson." She travels to Villiers-le-Bel to study with the famous painter Thomas Couture. On June 7, the *New York Times* reviews the Paris Salon and mentions both Cassatt and Haldeman. Mary works on a painting (now lost) based on Tennyson's poem, "Mariana of the Moated Grange." In December, Eliza returns to the United States.

1869

The Salon rejects Mary's entry, along with Cézanne, Monet, and Sisley. In July and August, she travels to the south of France (Beaufort-sur-Doron, in Savoy) to paint. In December, her mother Katherine arrives in Paris.

1870

Mary and her mother travel to Rome, where Mary studies with French artist Charles Bellay. She prepares her submission in Bellay's Rome studio. The painting (now lost), *Una Contadina di Fobello; val Sesia (Piedmont)*, is accepted by the Paris Salon. Because of the

Franco-Prussian War, Mary returns temporarily to Pennsylvania to live with her family. She sets up a studio and places two paintings (now destroyed) with the New York branch of the Parisian gallery Goupil & Co. She meets Emily Sartain, daughter of the engraver John Sartain.

1871

In May, the Cassatts move to Hollidaysburg, Pennsylvania to be close to son Alexander. Mary exhibits two paintings at Goupil's, New York and in Chicago, where they are destroyed by the great fire. In September, Mary is asked by Pittsburgh Bishop Michael Domenec to paint copies of Correggio's *Madonna of Saint Jerome* and *Coronation of the Virgin* for the city's cathedral. In December, she leaves for Europe with Emily Sartain. They go to London, Paris, Turin, and Parma.

1872

In Parma, Mary and Emily study printmaking with Carlo Raimondi, engraving professor at Parma's Academy. Mary studies the paintings of Correggio and Parmagianino, copying Correggio's *Coronation of the Virgin* from a copy by Anibale Carracci. Her first work exhibited at the Paris Salon is the 1872 *On the Balcony During the Carnival*. In October she travels to Spain, where she stays for six months. She is fascinated by the Prado Museum and the work of Murillo. She then goes to Seville, where she establishes a studio in the historic Casa de Pilatos, palace of the dukes of Medinaceli. Her *Torero and Young Girl* is accepted by the Salon and she goes to Paris to see the exhibition.

1873

Mary meets her mother and Emily Sartain in Paris. They visit the American expatriate William Hood Stewart's art collection, who holds a salon for artists every Thursday. On May 15, the Salon des refusés opens in Paris at the requests of artists such as Cézanne, Fantin-Latour, and Manet. Mary's *Offering the Panal to the Bullfighter* is her second work to be exhibited at the Salon, now under the name Mary Stevenson Cassatt. In June, Mary and her mother travel to The Hague, then to Antwerp where she meets Joseph-Gabriel Tourny, Edgar Degas' friend. Mary studies Rubens and introduces light and clear color in her work.

December 27
In Paris, a group of 30 artists forms the Société anonyme cooperative des artistes peintres, sculpteurs, graveurs, etc. commonly known by 1877 as the "Impressionists."

1874

April 15-May 15
The first Impressionist exhibition is organized by 30 artists, in the former studio of the photographer Nadar at 35, boulevard des Capucines. Mary is in Rome at the time but shows *Ida* at the Salon. *Ida* is caricatured in *Le Journal amusant* and attracts Degas' attention. Her two previous works exhibited at the Salon are shown at the National Academy of Design in New York. During the Summer, Mary settles in Paris, where she shows *A Musical Party* at

a gallery on the boulevard Haussmann. Later, she continues to study with Couture, in Villiers-le-Bel. She meets Louisine Elder, later to become Mrs. Henry O. Havemeyer.

1875

Emily Sartain returns to Philadelphia, after disagreeing with Mary about art instructors. In August, Mary rents a studio at 19, rue Laval, near the place Pigalle in Paris. She becomes acquainted with Degas' work, an important marker in her artistic career.

1876

The second Impressionist exhibition is held at Galerie Durand-Ruel, and Mary's *Portrait of Lydia* (1875) along with another female portrait are accepted by the Salon.

1877

The Society of American Artists is founded in New York.

April 1-30
The third Impressionist exhibition is held across the street from Galerie Durand-Ruel. For the first time, the participating artists accept the term "Impressionists." In May, Mary meets Degas and agrees to exhibit with the Impressionist group. Mary's Salon entries are rejected. During this time, Mary advises Louisine Havemeyer in her first purchase of modern art, Degas' *Rehearsal of the Ballet.* Mary's sister Lydia and parents settle permanently in Paris and Lydia becomes ill.

1878

Mary appears in Degas' list of 13 artists included in the Impressionist exhibition. On May 1, l'Exposition universelle opens in Paris and Mary's *Tête de femme* is exhibited in the American Pavilion. The jury does not accept *Portrait of a Little Girl.* Mary sends four paintings to H. Teubner, a Philadelphia dealer: *A Seville Belle, Offering the Panal to Bullfighter, A Musical Party,* and *At the Français, a Sketch.* She is awarded a silver medal by the Massachusetts Charitable Mechanic Association for her contribution to their 13th annual exhibition.

1879

In April, Mary shows *Lydia in a Loge, Wearing a Pearl Necklace* and *The Cup of Tea* at the Fourth Impressionist Exhibition. The show features 246 works by 16 artists. When Degas asks several artists not to show at the Salon, Cézanne, Renoir, and Sisley decline to participate. Mary's works are well received by critics and two of her works are purchased: Antonin Proust purchases *Woman Reading* and Alexis Rouart buys *Woman in a Loge.* Mary contacts Berthe Morisot about exhibiting in the show and starts a long friendship with her. Mary also sends paintings to the Society of American Artists Exhibition, the first Impressionist show in America. Degas recruits Cassatt, Pissarro, and Félix Bracquemond to contribute to the journal *La Jour et la nuit,* which he intends to establish but never does. Mary begins to purchase works by her peers. In September, Mary travels with her father

through the Swiss and Italian Alps. They meet her mother in Lausanne and proceed to Divonne-les-Bains, on the Geneva Lake.

1880

Shows a pastel that later belongs to Gauguin at the Fifth Impressionist Exhibition, which opens April 1 at 10, rue des Pyramides. Renoir, Monet, Cézanne and Sisley do not participate. Brother Alexander comes for a long visit and his children pose for many of her works. The Cassatts rent a house at Marly-le-Roi where Alexander and his family join them.

1881

Shows 11 works in the Sixth Impressionist Exhibition, held at 35, boulevard des Capucines, including the portrait of her sister *Lydia Crocheting in the Garden at Marly.* Paul Durand-Ruel, prominent art dealer, becomes Mary's agent. *Reading*, a portrait of her mother reading to her grandchildren, sells to Moïse Dreyfus, causing family disagreement. Dreyfus later returns the painting to Alexander Cassatt.

1882

Employs Mathilde Valet, a housekeeper who remains with the household until Mary's death in 1926. Following Degas' advice, Mary does not participate in the Seventh Impressionist Exhibition, held at 251, rue St.-Honoré. Her absence supports Degas' protest against Renoir, Cailllebotte and others' reluctance in welcoming newcomers to the group. Her younger brother Gardner marries Eugenia Carter and in November, her younger sister Lydia dies of Bright's disease.

1883

Gardner takes his bride to visit the family in Paris. Three of Cassatt's works are exhibited at Dowdeswell's in London in an exhibition by members of the Impressionist group. In London, Alexander and Lois Cassatt commission James McNeill Whistler to paint a portrait of Lois. Whistler visits the Cassatts in Paris. Mary acquires several paintings by Manet for Alexander. In London, she visits Whistler's studio to see the progress of Lois' portrait. Despite Lois' displeasure, Mary approves of it. In October, Mary paints *Lady at the Tea Table*, a portrait of Mary Dickinson Riddle featuring a Japanese tea service given by Riddle to Mary. Mrs. Riddle does not like it and refuses it.

1884

Travels to Spain with her mother.

1886

Shows *Girl Arranging her Hair* in the Eighth and last Impressionist Exhibition. Two paintings are lent by Alexander to the Impressionist exhibition in New York, organized by Durand-Ruel.

1887

Moves to an apartment at 10, rue de Marignan, her Paris residence for the rest of her life.

1890

Visits the great Japanese print exhibition, "Exposition de la gravure japonaise," at l'École des Beaux-arts in Paris. The Japanese prints make a strong impression on her and mark a turning point in her style.

1891

She is excluded from exhibitions of La Societé des peintres-graveurs français because of her American citizenship. This fact prompts her first individual exhibition of paintings, pastels, and prints. She resides at Château Bachivillers on the river Oise, where she sets up an etching press and works on the set of ten color prints. Her father dies on December 9. In April, she holds her first one-woman show at Galerie Durand-Ruel, Paris. It includes the set of 10 color prints plus 2 oils and 2 pastels: *The Quiet Time, Baby's First Caress, Hélène of Septeuil*, and one other mother-and-child subject.

1892

Mrs. Potter Palmer commissions Mary to do a large mural for the Woman's Pavilion at the Columbian Exposition in Chicago (now lost). It is executed at Bachivillers and shipped to Chicago.

1893

In November, holds a major retrospective at Galerie Durand-Ruel, Paris. Her second individual exhibition includes 16 oils, 14 pastels, the series of 10 color prints with 4 more added, a set of 12 drypoints, 38 other drypoints, and 1 lithograph.

1894

Stays with her mother at Villa "La Cigaronne," Cap d'Antibes, where she executes *The Boating Party*. She buys and renovates the Château Beaufresnes at Mesnil-Théribus, near Beauvais, 27 miles from Paris. It becomes her permanent summer home. Berthe Morisot dies of influenza, saddening Mary and the art community. Mary's mother's health worsens.

1895

Durand-Ruel holds her first individual exhibition in New York, with 26 paintings, 9 pastels, 1 gouache, and 18 prints. Her mother dies on October 21.

1898-99

Mary returns to the United States for her first visit in over 20 years since living permanently in France. She visits Philadelphia, New York, Boston, and Naugatuck, Connecticut to join

other artists. In Connecticut she meets Theodate Pope, an important friend and correspondent for many years. She returns to France at the end of the summer.

1901

Accompanies Mr. and Mrs. Henry O. Havemeyer to Spain and Italy, advising them to purchase paintings by El Greco and Goyà, many of which are now in the Metropolitan Museum of Art, NY.

1903

One-woman exhibition at Durand-Ruel, New York, with 15 paintings and 10 pastels.

1904

The Caress at the Seventy-Third Annual Exhibition of the Pennsylvania Academy of the Fine Arts is her first work shown in her former hometown. She is awarded the Lippincott Prize for *The Caress*, but declines all awards and prizes. She is guest of honor at the opening of the annual American Exhibition at the Art Institute of Chicago and is made Chevalier of the Légion d'Honneur by the French Government.

1905

Enters the competition for a mural project for the new women's lounge of the statehouse in Harrisburg, Pennsylvania, but withdraws because of alleged graft related to the commission. She breaks the long-standing contract with Durand-Ruel over the fact that he had omitted her from an Impressionist exhibition in London. She turns to another well-known dealer, Ambroise Vollard.

1906

John G. Johnson gives *On the Balcony* to Philadelphia's municipally administered W. P. Wilstach Collection, her first work to enter a public collection in America. Brother Alexander dies on December 28.

1907

One-woman show at Ambroise Vollard's gallery in Paris and shows six works in Manchester, England in a group show of French Impressionists.

1908-09

Visits the United States for the last time, mainly to be with brother Gardner and his family in Philadelphia, and to visit friend Louisine Havemeyer.

1910-11

Travels with her family to the Near East and Egypt. Brother Gardner becomes ill and dies

abroad on April 5, 1911. Mary suffers a nervous breakdown and is diagnosed with diabetes. She stops printmaking because of failing eyesight.

1912

Accompanies friend James Stillman to Cannes. The writer Achille Ségard interviews her for his book, *Une peintre des enfants et des mères: Mary Cassatt* (Paris: Librairie Paul Ollendorf, 1913). She rents the Villa Angeletto in Grasse, Southern France, where she spends at least six months a year from 1912-24. Renews her friendship with Renoir.

1914

With the outbreak of World War I, fighting near Beauvais forces Mary to flee Beaufresne for the villa in Grasse for the remainder of the war. She is awarded a Gold Medal of Honor by the Pennsylvania Academy of the Fine Arts but stops painting due to progressive blindness. She is diagnosed with cataracts and for the next five years undergoes a series of unsuccessful operations.

1915

Participates in an exhibition organized by Mrs. Henry O. Havemeyer at Knoedler in New York, entitled *Suffragette Loan Exhibition of Old Masters and Works by Edgar Degas and Mary Cassatt.* She is practically blind due to cataracts in both eyes.

1917

Degas dies on September 27.

1920

Lois Cassatt dies and her collection of Impressionist paintings is dispersed to her children and to the art market.

1921

Another operation of cataracts is unsuccessful and Mary becomes virtually blind.

1923

Finds a group of copper printmaking plates at Mesnil-Beaufresne that she had worked in drypoint, which she believes had never been painted before. She has them printed in Paris and puts several editions on sale. When museums and collectors discover that the plates had been previously printed and tell her, she takes offense. The argument endangers her lifelong friendship with Louisine Havemeyer.

1926

Mary Cassatt dies on June 14 at Beaufresne and is buried in the family tomb in the cemetery

at Mesnil-Théribus, with her parents, Lydia, and brother Robert. Memorial exhibitions of her work are held in the United States and France over the next five years.

Mary Cassatt

Bibliography

I. Primary Works

67. CASSATT, MARY. *Mary Cassatt Collection*, 1871-1955. 1 linear foot (1 35mm microfilm reel, 1410 frames). Frames 1-869 donated by the Thayer family to the Philadelphia Museum of Art, 1967. Frames 1180-1440 donated to the Archives of American Art, Smithsonian Institution, Washington, D.C. by Alexander J. Cassatt, great-nephew of Mary Cassatt, in 1986 and re-microfilmed on reel 3684. Microfilm label: Frederick A. Sweet Papers. Researchers must use microfilm copy, available for use at the Archives of American Art offices and through interlibrary loan. Microfilm inventory available at all Archives of American Art offices. Authorization to publish, quote or reproduce must be obtained from the owners of the letters.

Mary Cassatt and Cassatt family papers collected by Frederick Arnold Sweet (b. 1903) for research on Mary Cassatt. Includes Cassatt family correspondence; a typescript of a family history written by Cassatt's father, Robert Cassatt; genealogical and biographical material; letters from Cassatt to Cecilia Beaux, Electra Havemeyer Webb, Bertha Honore Palmer, Theodate Pope, Mary Gardner Smith, Carroll S. Tyson, Ambroise Vollard, Harris Whittemore, and others. Lent for microfilming in 1955 by Sweet, author of the exhibition catalogues *Sargent, Whistler, and Mary Cassatt* (1954) and *Miss Mary Cassatt, Impressionist from Pennsylvania* (1966).

68. CASSATT, MARY. *Correspondence with Emily Sartain*, ca. 1872-74. 15 letters (1 partial 35mm microfilm reel). Frames 1011-55 on reel 3658. Originals held at the Pennsylvania Academy of the Fine Arts, Philadelphia. Lent for microfilming in 1985. The

source of the letters is unknown, although it is likely through the estate of Harriet Sartain.

Emily Sartain (1841-1927) was the daughter of artist John Sartain. She studied art with her father and Christian Schussele at the Pennsylvania Academy and taught at the Philadelphia School of Art and Design. Collection includes 14 letters from Cassatt to Emily Sartain and one letter from Sartain to Cassatt, discussing a trip the two had planned to Europe and references by Cassatt to her artistic development in Spain and Italy. Dates on the correspondence are by an unknown hand and are questionable.

69. CASSATT, MARY. *Letters*, 1882-1925. 50 items (.2 linear feet of 35mm microfilm reel). Lent for microfilming in 1985 by Alexander J. Cassatt, great-nephew of Mary Cassatt and subsequently donated in 1896. This collection is also microfilmed on reel C-1 as part of the Mary Cassatt papers lent by Frederick A. Sweet. Researchers must use microfilm, available for use at the Archives of American Art offices and through interlibrary loan.

Includes 47 letters from Mary Cassatt in Paris to her nephew, Robert Kelso Cassatt, and his wife, Minnie Drexel Fell Cassatt; two letters from Grandmother and Grandfather Cassatt to "Robbie"; and Mary's obituary from an unidentified French newspaper.

70. CASSATT, MARY. *Letters*, 1892-1925. 18 items (3 partial 35mm microfilm reels). Microfilm reels D8, N70-7, and 2787 available for use at the Archives of American Art offices and through interlibrary loan. Material on reel D8 was donated 1955-62 by Charles E. Feinberg; material on reel N70-77 was lent for microfilming in 1970 by Ann Donohue at the National Arts Club, NYC; material on reel 2787 was transferred in 1980 from the National Museum of Modern Art. Research must use microfilm copies.

Reel D8 includes a letter from Cassatt in response to "Peter's" request for an autograph and a letter with a typescript translation in French inscribed "to the dealer Ambroise Vollard," in which she describes her painting of a little girl seated on a blue armchair and her upcoming plans in Paris.
Reel N70-7 includes a letter from Cassatt to Eugène Vail; two letters to her friend Mabel, 1924-5; and an undated letter in French to Cassatt from Mathilde Valet. Reel 2787 includes ten letters from Cassatt, 1892-1918, to Miss Lamb of Boston, William Thomas Evans, Esq. of Montclair, New Jersey, and Miss Stillman of New York City.

71. CASSATT, MARY. *Vertical File Material*, 1943-. 7 folders. Located at the Whitney Library, Whitney Museum of American Art, New York and on microfilm at the Archives of American Art, Smithsonian Institution, Washington, D.C.

Ongoing resource file on Cassatt that includes provenance documentation, articles, biographies, bibliographies, photographs, reviews, small catalogues, invitations, and correspondence.

II. Secondary Works

72. BREESKIN, ADELYN DOHME. *Papers*, 1934-78. 2.2 linear feet (2 partial 35mm microfilm reels). Available at the Archives of American Art, Smithsonian Museum,

Washington, D.C. and through interlibrary loan. Researchers must use microfilm copy.

Adelyn Dohme Breeskin (1896-1986) was an art historian, curator, and director of the Baltimore Museum of Art (1947-62). This collection relates primarily to research on artists Loren MacIver (b. 1909) and Mary Cassatt.

73. BREESKIN, ADELYN DOHME. *Oral History Interview*, 1975. Transcript, 44 p.; tape cassette (110 min.). Interviewed by Paula Rome. Located at the Maryland Historical Society, Baltimore.

Topics include the Baltimore Museum of Art's print collection, Mary Cassatt, museum development, the National Collection of Fine Arts, and the Washington Gallery of Modern Art.

74. BROOKLYN MUSEUM. *Records*, 1823-1963. 25 reels of 35mm microfilm. Located at the Brooklyn Museum and available at the Archives of American Art, Smithsonian Museum, Washington, D.C., and through interlibrary loan. Researchers must use microfilm copy.

Includes extensive records of the Brooklyn Museum, exhibitions, artists' files, memoirs, and correspondence, including a letter from Mary Cassatt dated 1903 (reels BR21-22).

75. CASSATT, ALEXANDER JOHNSTON. *Letterbook Index*, 1896-98, 1898-1903. Located at the American Philosophical Society Library, Philadelphia. Microfilmed selections available at the Archives of American Art, Smithsonian Institution, and through interlibrary loan. Presented by Bessy L. Greenawald in 1979.

Alexander Johnston Cassatt (1839-1906), brother of Mary Cassatt, was a civil engineer and president of the Pennsylvania railroad (1899-1906). Indexes contain individual, corporate, and subject entries which include descriptive notations of letters received and sent concerning civil engineering, the Pennsylvania Railroad, and personal business. Volume I includes notations of exhibits of paintings by Mary Cassatt (p. 269) and notations on paintings by Thomas Eakins, John Singer Sargent, and James McNeill Whistler. The repository does not hold the letters themselves and does not know of their whereabouts.

76. DEGAS, EDGAR. *Letters*, 1880-98. 15 items. Holographs, signed. Located at The Getty Research Institute for the History of Art and the Humanities, Special Collections, Los Angeles.

Letters comment on a variety of matters including an exhibition of Gauguin's work, travel in the Midi, his own career as an artist, a pastel by Delacroix, Mary Cassatt's experiments in engraving, work on Degas' journal *Le Jour et la nuit*, as well as work in progress on fans and waxes. Correspondents include Camille Pissarro, Henri Rouart, Louis Braquaval, the dealer Adrien Beugniet, Maria Valadon, Albert Bartholomé, Evariste de Valernes, and Georges Charpentier.

77. Durand-Ruel Galleries, New York. *Durand-Ruel Galleries, New York, Exhibition Catalogs,* ca. 1915-18. 5 items (1 partial 35mm microfilm reel). In miscellaneous art

exhibition catalog collection, 1887-1934. Microfilm reel 4858, frames 927-47. Researchers must use microfilm copy, available at the Archives of American Art offices and through interlibrary loan.

Includes undated catalogues for single-artist exhibitions of George Bellows (exhibited under direction of Marie Sterner), Mary Cassatt, and Claude Monet; one joint exhibition of Claude Monet and Pierre-Auguste Renoir; and *Exhibition of a Series of Paintings of the Avenue of the Allies by Childe Hassam, from November 15th to December 7th, 1918*. Durand-Ruel Galleries, New York was located at 389 Fifth Avenue and 12 East 57th Street, New York.

78. DUVEEN, ALBERT. *Albert Duveen Art Reference Files*, ca. 1831-1950. ca. 1,000 items (5 35mm microfilm reels). Microfilm reels NDU1-NDU3 (arranged alphabetically by artist and subject); NDU4-NDU5 (publications and miscellany). Lent for microfilming in 1958 by Albert Duveen. Researchers must use microfilm copy, available at the Archives of American Art offices and through interlibrary loan.

Duveen was a New York-based art dealer and collector. Includes files on approximately 150 American artists and art subjects, selected from Duveen's art reference files, including a file on Mary Cassatt. Also includes photographs of paintings in other collectors, auction and exhibition catalogues, and miscellaneous publications.

79. GIMPEL, RENE. *Papers*, 1897-1957. ca. 1,925 items (7 35mm microfilm reels). Microfilm reels 415-6 (diaries, access restricted); 270 (correspondence); 417-9 (writings, stockbook and price lists, exhibition catalogues); 918 (typed translations of letters and postcards to Gimpel). Material on reel 270 donated in 1971 by Lawrence S. Jeppson, who received credit from Jean Gimpel (René Gimpel's son) for Jean's book on art dealers. Material on reel 918 donated by Jean Gimpel in 1972. Material on reels 415-9 microfilmed in London through authorization of Jean Gimpel in 1972; originals in the possession of Jean Gimpel. Reels 270 and 918 available for use at the Archives of American Art offices and through interlibrary loan. Researchers must use microfilm copies.

Gimpel (1881-1944) was a Parisian art dealer. Includes correspondence, photographs, diaries, printed material, and writings. Reels 415-9 and 918 include correspondence with Mary Cassatt.

80. HALDEMAN, ELIZA. *Correspondence*, ca. 1860-68. 32 items (1 partial 35mm microfilm reel). Reel 3658, frames 1056-1133 available at the Archives of American Art offices, through interlibrary loan, and at the Pennsylvania Academy of Fine Arts and the Free Library of Philadelphia. Originals in the Pennsylvania Academy of Fine Arts, Philadelphia. Researchers must use microfilm.

Haldeman (1843-1910) was a painter who studied at the Pennsylvania Academy of Fine Arts, Philadelphia. Includes letters from Haldeman to her family describing her life as an art student in Philadelphia and mentions her friendship with Mary Cassatt. Three letters from Cassatt to Haldeman are included.

81. HALE, NANCY. *Nancy Hale Research Material on Mary Cassatt*, 1970-75. 3 linear feet. Unmicrofilmed. Donated by Nancy Hale Bowers in 1976. Located at the Archives of

American Art, Smithsonian Institution, Washington, D.C. Use requires an appointment and is limited to the Washington, D.C. storage facility.

Hale (1908-88), daughter of the painter Philip Leslie Hale, was the author of *Mary Cassatt* (Garden City, NY: Doubleday, 1975). Includes files relating to the writing and publication of the work, correspondence, note cards, photographs, and printed material.

82. HELLER, EUGENIE M. *Papers*, 1878-1936. 35 items (1 partial 35mm microfilm reel). Originals in the New York Public Library, Manuscript Division. Reel N4, frames 1154-1242 available for use at the Archives of American Art offices and through interlibrary loan. Microfilmed in 1956 by the Archives of American Art. Researchers must use microfilm copy.

Heller (1868-1952) was a painter and craftsperson who studied and worked in New York and Paris. During World War I she served on the staff of the American Red Cross. Includes correspondence with Mary Cassatt and other artists and a one-page autobiographical sketch, dated 1936.

83. Hirschl & Adler Galleries, New York. *Hirschl & Adler Galleries Photographs of Works of Art and Records*, 1921-ca. 1990. 10.8 linear feet; .6 linear feet addition. Unmicrofilmed. Use requires an appointment. Authorization to publish or reproduce must be obtained from the current owners of the works via Hirschl & Adler Galleries, 21 East 70th Street, New York, New York 10021.

Includes photographs and transparencies of works of art, including paintings by Cassatt.

84. JACCACI, AUGUSTO FLORIANO. *Papers*, 1903-14. 8.4 linear feet (9 partial 35mm microfilm reels). Reels D118-26 available from the Archives of American Art, Smithsonian Institution, Washington, D.C. Researchers must consult microfilmed portion on microfilm; use of unmicrofilmed portion requires an appointment and is limited to the Washington, D.C. storage facility.

Jaccaci (1857-1930), a mural painter and writer, was born in France and came to the United States in the 1880s. He and painter John La Farge (1835-1910) were editors of what was hoped would be a multi-volume series called Noteworthy Paintings in Private Collections. The first volume was published in 1907, but Jaccaci abandoned the project following the untimely death of La Farge. Includes letters, mostly concerning Jaccaci's joint editorship with La Farge, typescript pages of research materials relating to the book, and 48 photographs (unmicrofilmed) of works of art. Accompanying papers relate to the single published volume and unrealized volumes. Correspondents include information on the following collections: Angus, Baker, Narney, Belmont, Blair, Burke, Byers, Davis, Drummond, Elkins, Ellsworth, Frick, Gardner, Gates, Gould, Hanna, Havemeyer, Hay, Hill, Hutchinson, Hyers, Johnson, Lodge, Logan, McCormick, McFadden, McMillan, Mather, Morgan, Morison, Pope, Ross, Ryerson, Sprague, Taft, Terrell, Thomas, Vanderbilt, Van Horne, Wade, Whittemore, and Widener. Unmicrofilmed photographs of works of art are from the Frick, Van Horne, and Widener files.

85. LAMB, ROSE. *Papers*, 1870-1961. .4 linear feet (2 35mm microfilm reels). Reels

1309 and 3888 available at the Archives of American Art offices and through interlibrary loan. Donated in 1980-85 by Aimee and Rosamond Lamb, nieces of Rose Lamb. Researchers must use microfilm copies.

Rose Lamb (1843-1927) was a portrait painter active in Boston. Around 1876, Lamb began studying with William Morris Hunt and became a highly regarded student, specializing in portraits of children. She gave up painting around 1900 due to an illness. Includes a diploma (1881); letters (undated and 1890-1961) from Mary Cassatt (photocopies) and other correspondents; 14 charcoal, watercolor, and oil sketches; a sketchbook (ca. 1870); and photographs of Lamb and her paintings. Original Cassatt and Childe Hassam letters are located at the Museum of Fine Arts, Boston.

86. MCVITTY, ALBERT ELLIOTT. *Papers Concerning McVitty's Art Collection*, 1902-71. .4 linear feet (1 35 mm microfilm reel). Donated by Mrs. Elsie Regan Kerney, friend of McVitty's son, Albert E. McVitty, Jr. Reel 2520 available at the Archives of American Art offices and through interlibrary loan. Researchers must use microfilm copy.

McVitty (1876-1948) was an art collector from Bryn Mawr, Pennsylvania. Includes letters from Mary Cassatt, Winslow Homer, Mrs. John Twachtman, J. Alden Weir, art dealers and others; photographs of works of art; writings in the collection; business records; a scrapbook containing photographs of works of art in the collection; exhibition catalogs and clippings, and other printed material.

87. Metropolitan Museum of Art, New York. *Miscellaneous Collection*, 1781-1949; 1830-1947 (bulk). .8 cubic feet. Located at the Thomas J. Watson Library, Metropolitan Museum of Art, New York.

Contains assorted letters of artists, including Mary Cassatt, and others as well as news clippings, documents, and 46 autographed invitation cards sent to artists soliciting participation in the exhibition, *Speak Their Language*.

88. PALMER, BERTHA HONORE. *Correspondence*, 1891-99. .8 linear feet (1 box and 4 vols. of indexed photocopies). Located at the Libraries, The Art Institute of Chicago. Researchers are requested to use photocopies in four volumes.

Collection of letters from Bertha Palmer (1849-1918) to Mrs. Potter Palmer, Sara Hallowell and others (including Cassatt) concerning art for the World's Columbian Exposition; also personal letters concerning her activities and art collection. Photocopied letters are arranged by subject, and correspondent's name.

89. RIDDLE, THEODATE POPE. *Papers*, 1865-1946 (bulk 1885-1920). 24 linear feet. In part, photocopies. Located at the Hill-Stead Museum, Farmington, Connecticut. Finding aid in repository.

Riddle (1867-1946) was an architect in Farmington, Connecticut, born and known professionally as Theodate Pope. She married John Wallace Riddle, a diplomat. Includes correspondence, diaries, postcards, printed materials, many photos, and other papers of Riddle, her father, Alfred Atmore Pope, industrialist and art collector, mother, Ada Brooks

Pope, husband, John Wallace Riddle, diplomat, and other family members. Of special interest are Theodate Pope's diary documenting the education of a young woman in the 1880s, including a description of the family's "grand tour" of Europe; transcriptions of sittings and correspondence relating to spiritualism and psychic research; and receipts for French impressionist art collected by Alfred Atmore Pope. Correspondents include Mary Cassatt, Anna Roosevelt Cowles, Helena Gleichen, Alice Hamilton, Augusto Jaccaci, Henry James, William James, Belle Sherwin, Marina Van Rensselaer (Mrs. Schuyler Van Rensselaer), and James McNeill Whistler. Contains no drawings and only minimal references to Riddle's architectural career and her husband's business and diplomatic career.

90. SARTAIN. *Family Papers*, 1795-1944 (6 35mm microfilm reels). Reels 2727, 4235, and 4562-5, available for use at the Archives of American Art offices and through interlibrary loan. Reel 4235 also available at the Pennsylvania Academy of Fine Arts and the Free Library of Philadelphia. Reels 4562-5 also available at the Historical Society of Pennsylvania, Philadelphia. Researchers must use microfilm copies. Authorization to publish, quote, or reproduce material from reel 2727 must be obtained from the Librarian, Moore College of Art, 20th and Race Streets, Philadelphia, PA 19130.

The Sartains were a family of engravers and painters in Philadelphia. Reel 2727 includes correspondence from Emily Sartain (1841-1927) to her father John Sartain about her European travels with Mary Cassatt.

91. SWEET, FREDERICK ARNOLD. *Research Materials on Mary Cassatt and James A. McNeill Whistler*, 1872-1975. 1 linear foot (5 35mm microfilm reels). Reels 2054-6 and 2082-3 available for use at the Archives of American Art offices and through interlibrary loan. Donated in 1975 by Frederick Sweet. Researchers must use microfilm copies.

Sweet (b. 1903) was a Chicago art historian and museum administrator. Includes manuscripts and notes; correspondence; Cassatt family biography and family tree; copies and transcripts of letters written by Cassatt; drafts of *Miss Mary Cassatt – Impressionist from Pennsylvania* (Chapters I-XII) and other drafts; exhibition catalogs; clippings and copies of clippings; announcements; and photographic prints of Cassatt, her family, and home (location of originals unknown) and of art by Cassatt and Whistler (photos on film reels 2082-3).

92. WEITENKAMPF, FRANK. *Letters*, 1889-1942. Ca. 1,000 items (2 partial 35mm microfilm reels). Reels N3, frames 230-1478 and N25, frames 1369 and 1381 available for use at the Archives of American Art offices and through interlibrary loan. Originals in the New York Public Library, Manuscript Division. Microfilmed in 1956.

Weitenkampf (1866-1962) was curator and chief of the Prints Division, New York Public Library. Includes letters to Weitenkampf, mainly from artists (including Mary Cassatt) and collectors concerning examples of their works in the Library's collection. List of correspondents available at the Archives of American Art offices and at the New York Public Library, Manuscript Division.

93. Whitney Museum of American Art, New York. *Whitney Museum of American Art Artists' Files and Records*, 1914-66. 75 35mm microfilm reels. Reels N591-7, N599-N609,

N646-94, NWH1-7. Available at the Archives of American Art offices and through interlibrary loan. Originals in the Whitney Museum of American Art, New York. Lent for microfilming in 1964-67. Researchers must use microfilm copies.

Includes photographs, exhibition catalogues, scrapbooks, records, and artists' files (reels N646-N694 include information on Mary Cassatt). Founded as the Whitney Studio Club by Gertrude Vanderbilt Whitney, the Whitney Museum of American Art formally opened in 1931.

94. Whitney Museum of American Art, New York. *Central Administrative Records*, 1930-39. 35 folders. Access by permission of Librarian, Whitney Museum of American Art, 945 Madison Ave., New York, NY 10021.

Central administrative files were maintained by the museum secretary for records of all offices from 1930 until ca. 1960, then dispersed and partially reassembled in later years. From 1930-1939, they contain all surviving records of the Whitney Museum except for general accounting records, and most records relating to exhibitions and object registration. The museum developed an ambitious publication program in 1931 designed principally to present brief monographs and catalogues raisonées of American painters and sculptors. The records include correspondence, drafts, and object sheets.

Series I: Book sales and inventory reports, 1932-37.
Series II: American Graphic Humor (Murrell Fisher): including a draft of vol. I, correspondence, copyright papers and photographs (dummies).
Series III: Shaker furniture, correspondence.
Series IV: Catalogs of the collection, 1932, 1937.
Series V: Critical introduction to American painting (Virgil Baker), correspondence.
Series VI: American Artists Series. Includes a list of monographs and photographs along with general correspondence related to the formation of the project, 1931. Object sheets, correspondence, and drafts for the volume on Mary Cassatt (file 85).

III. Books

95. BACHMANN, DONNA G. and SHERRY PILAND. *Women Artists: An Historical, Contemporary, and Feminist Bibliography*. Metuchen, NJ: Scarecrow, 1978. 323 p., illus.

Bibliography of books and articles about various women artists from the 15th to the 20th centuries. Bibliography on Cassatt, pp.200-209.

a. Another ed.: 1994, ed. by Sherry Piland. 454 p., illus.

96. BAZIN, GERMAIN. *Les Impressionnistes au Musée d'Orsay*. Paris: Somogy, 1990. 280 p., 222 illus., 212 col.

Presents the works of 24 major Impressionists whose works are part of the collection of the Musée d'Orsay in Paris, including Mary Cassatt and Berthe Morisot. Discusses the history of Impressionist painting from its origins in France to its parallels in the United States.

97. BENEDETTI, MARIA TERESA. *L'Impressionnisme*. Paris: Gründ, 1983. 240 p., col. illus.

Overview of the works of major Impressionist artists including Morisot and Cassatt.

98. BIDDLE, GEORGE. *An American Artist's Story*. Boston: Little, Brown and Co., 1939. 326 p., illus.

99. BOYLE, RICHARD J. *American Impressionism*. Boston: New York Graphic Society, 1974. 236 p., illus., some col.

100. BOYTE, LINDA ANNE. *Cecilia Beaux and Mary Cassatt: A Comparison*. 44 leaves, illus. M.A. Thesis, Emory University, 1982.

101. BREESKIN, ADELYN DOHME. *The Graphic Work of Mary Cassatt: A Catalogue Raisonné*. NY: H. Bittner, 1948. 91 p., 101 pl., 1 col. 500 copies.

Authoritative compilation of Cassatt's graphic works. Includes biographical chronology (pp. 29-30) and definitions of technical methods used by the artist. Includes 220 reproductions, "Recently Found Prints" (pp. 183-9), and a supplement of "Soft-Ground Working Drawings and Documentary Illustrations." Also includes list of public collections and early exhibitions which included prints.
a. 2nd rev. ed.: *Mary Cassatt: A Catalogue Raisonné of the Graphic Work*. Washington, D.C.: Smithsonian Institution Press, 1979. 189 p., illus., some col.

102. BREESKIN, ADELYN DOHME. *Mary Cassatt: A Catalogue Raisonné of the Oils, Pastels, Watercolors, and Drawings*. Washington, D.C.: Smithsonian Institution Press, 1970. 322 p., illus., some col.

Monumental work by prominent Cassatt scholar; includes reproductions and many unsigned works. Illustrates 943 works mostly in black and white. Each entry contains description, technical details, notes, provenance, and exhibition record. Includes index of owners, titles, and sitters as well as a biographical chronology. Bibliography on pp. 307-9.
a. Another ed.: 1991.
Review: R. Pickvance, *Burlington Magazine* 848:115(Nov. 1973):745-6.

103. BRENNAN, ANNE G. and DONALD FURST. *Cassatt, Degas, and Pissarro: A State of Revolution*. Wilmington, NC: St. John's Museum of Art, 1992. 20 p., illus., some col.

104. BREUNING, MARGARET. *Mary Cassatt, 1845-1926*. NY: Hyperion, 1944. 48 p., chiefly illus., some col.

Interesting selection of reproductions of Cassatt's works in oil, pastel, and prints. Edited by Aimée Crane, includes brief biographical information.

105. BRONFMAN, BEVERLY. *The Artist and the Opera: Manet, Degas, Cassatt*. M.A. Thesis, McGill University, 1992. 2 microfiches.

106. BROOKS, PHILIP. *Mary Cassatt: An American in Paris*. NY: F. Watts, 1995. 63 p., illus., some col.

107. BROUDE, NORMA and MARY D. GARRARD. *The Expanding Discourse: Feminism and Art History*. NY: Icon Editions, 1992. 518 p., 8 illus.

Important collection of feminist art historical essays. Examines issues and artists from the Renaissance to the present. The chapter "Modernity and The Spaces of Femininity" by Griselda Pollock offers a rich discussion of Morisot and Cassatt's works in terms of representation of masculine and feminine figures in public spaces.

108. BULLARD, EDGAR JOHN. *Mary Cassatt, Oils and Pastels*. NY: Watson-Guptill, 1972. 87 p., illus., 32 col. pl.

Derived from the exhibition at the National Gallery of Art in 1970, the largest Cassatt retrospective to date. Many works appear in color for the first time. Includes discussions about each work and biographical information from Cassatt's letters from the Havemeyer collection, now at the National Gallery in Washington, D.C.
a. English ed.: Oxford: Phaidon, 1976.
Reviews: R. Iskin, *Womanspace Journal*, 1 (April-May 1973):13-4, 34; A. Breeskin, *Art Journal*, 33:3(Spring 1974):280-2.

109. BUNOUST, MADELEINE. *Quelques femmes peintres*. Paris: Librairie Stock, 1936. 126 p., illus.

One of the first compilations of contemporary women artists, listing women who won the Grands Prix de Rome, Beaux-Arts, in Sculpture, Painting, Printmaking and Music, from 1911 to 1934. Includes brief biographical profiles of 19 women including Morisot and Cassatt.

110. CAIN, MICHAEL. *American Women of Achievement: Mary Cassatt*. Introductory essay by Martina S. Horner. NY: Chelsea House, 1989. 111 p., illus., some col.

111. CALLEN, ANTHEA. *Techniques of the Impressionists*. London: Orbis, 1982. 192 p., 30 illus.

Discusses techniques of Impressionism in 30 selected works of art by artists including Mary Cassatt, Berthe Morisot, Degas, Manet, Pissarro, Renoir, Monet, Seurat, Van Gogh, Gauguin, Matisse, and others. Cassatt's *Woman in Black* (ca. 1882) is analyzed in terms of brushwork, breakdown of Cassatt's probable color palette, and composition.

112. CARSON, JULIA MARGARET HICKS. *Mary Cassatt*. NY: David McKay, 1966. 193 p., illus.

Biographical overview of Cassatt, with selected reproductions of paintings and color prints.

113. CARY, ELISABETH LUTHER. *The Art of Mary Cassatt*. NY: no publisher, 1905. 5 p.

114. CARY, ELISABETH LUTHER. *Artists Past and Present: Random Studies.* NY: Moffat, Yard, and Co., 1909. 176 p., illus.

115. CONSTANTINO, MARIA. *Mary Cassatt.* NY: Barnes & Noble, 1995. 128 p., illus., some col.

116. CORTISSOZ, ROYAL. *American Artists.* NY: Charles Scribner's Sons, 1923. 363 p., illus.

Discusses how Mary Cassatt spoke freely with Achille Segard and contains biographical facts obtained by Segard about Cassatt (pp. 183-9).

117. COURTHION, PIERRE. *Autour de l'impressionnisme: Bazille, Boudin, Mary Cassatt, Fantin-Latour, Guigou, Lebourg, Guillaumin, Jongkind, Lépine, Berthe Morisot, Prins, Sisley.* Paris: Nouvelles Editions françaises, 1964. 53 p., 48 col. plates. illus., ports.

118. COURTHION, PIERRE. *Manet raconté par lui-même et par ses amis.* Geneva: P. Cailler, 1953. 2 vols.

Collection of letters written by Edouard Manet and his friends. Includes articles by contemporary critics and documents never published before. Pages 8 and 69 contain excerpts of Antonin Proust's and Edmond Bazire's memoirs, briefly mentioning Cassatt's presence in the Impressionist scenario of their time.
a. English ed: *Portrait of Manet by himself and his Contemporaries.* Trans. by Michael Ross. London: Cassell, 1960. 238 p.

119. CRAZE, SOPHIA. *Mary Cassatt.* Leicester: Magna, 1990. 112 p., chiefly col. illus.

a. U.S. eds.: NY: Crescent Books, distributed by Crown Publishers, 1990; NY: Knickerbocker Press, 1998.

120. DAVIS, PATRICIA. *End of the Line: Alexander J. Cassatt and the Pennsylvania Railroad.* NY: Neale Watson, 1978.

Examines the involvement of Alexander, Mary Cassatt's brother, with the railroad.

121. DE VRIES-EVANS, SUSANNA. *The Impressionists Revealed: Masterpieces from Private Collections.* London: Little, Brown; Glenfield, New Zealand: David Bateman, 1990. 192 p., illus., some col.

Examines Impressionist works housed in private collections, including criticism and possible history of their ownership, anecdotes, and information on collectors. Mary Cassatt is mentioned among the "First Impressionists." Reproduces in color: *Dorothy in a Very Large Bonnet and a Dark Coat* (c. 1904), *The Cup of Chocolate* (1898), and *Summertime* (1894).
a. Another ed: Niwot, Colorado: Roberts Rinehart in association with David Bateman, New Zealand, 1992.

122. DILLON, MILLICENT. *After Egypt: Isadora Duncan and Mary Cassatt.* NY: Dutton,

1990. 403 p., illus., 32 p. of plates, some col.

123. DISTEL, ANNE. *Impressionism: the First Collectors*. Trans. by Barbara Perroud-Benson. NY: H. N. Abrams, 1900. 284 p., illus, some col.

124. DUNHAM, CECILY JEAN. *Japonisme and the Prints of Mary Cassatt*. M.A. Thesis, University of Iowa, 1978. 84 leaves, illus.

125. DUNSTAN, BERNARD. *Painting Methods of the Impressionists*. NY: Watson-Guptill, 1976, 184 p., illus.

a. Another ed.: 1983. 160 p., 201 illus.

126. DURET, THEODORE. *Manet and the French Impressionists*. Philadelphia: Lippincott, 1912.

127. EFFENY, ALISON. *Cassatt*. London: Studio, 1991. 144 p., illus., some col.

a. Another ed.: 1993.
b. Chinese ed.: *Kashate*. Taipei: Kuochuchu pan she, 1993. 143 p., illus., some col.

128. EISENMAN, STEPHEN F. *Nineteenth Century Art: A Critical History*. London: Thames and Hudson, 1994. 376 p., 369 illus., 51 col.

129. ELLIOT, BRIDGET and JO-ANN WALLACE. *Women Artists and Writers: Modernist (In)positionings*. London, NY: Routledge, 1994. 204 p., illus.

130. ELLIOTT, MAUD HOWE. *Art and Handicraft in the Woman's Building of the World's Columbian Exposition, Chicago, 1893*. Chicago: Rand, McNally, 1894.

131. FAIN, KARIN TERESA. *Mary Cassatt: Images of the Philadelphia and Paris Experience in the Late Nineteenth Century*. M.L.S. Thesis, University of Oklahoma, 1985. 149 p.

132. FELDSTEIN, JANICE J. and MAUREEN SMITH. *The Art of Chicago: 100 Masterpieces*. Chicago: The Institute, distributed by Rand McNally. 1978. 159 p., illus., some col.

133. GARB, TAMAR. *Women Impressionists*. NY: Rizzoli, 1986. 80 p., illus.

a. German ed.: *Frauen des Impressionismus: die Welt des farbigen Lichts*. Stuttgart; Zurich: Belser, 1987. 80 p., 40 illus., 32 col.
b. English ed.: Oxford: Phaidon, 1986.
Reviews: C. Cruise, *Art Monthly* 103(Feb. 1987):27. B. Thomson, *Burlington Magazine* 1009(April 1987):254-5.

134. GARB, TAMAR. "Gender and Representation" in *Modernity and Modernism: French Painting in the Nineteenth Century*, ed. by Francis Frascina, et al. New Haven: Yale

University Press in association with the Open University, 1993. 297 p., illus, some col.

135. GERDTS, WILLIAM H. *American Impressionism.* Seattle: The Henry Art Gallery, University of Washington, 1980. 180 p., 51 illus., 27 col.

Contains summary of Cassatt's artistic development on pp. 44-9.
a. Another ed.: NY: Abbeville, 1984.

136. GERDTS, WILLIAM H. *Masterworks of American Impressionism.* Lugano, Switzerland: Thyssen-Bornemisza Foundation; dist. by Harry N. Abrams, NY, 1990. 163 p., 79 illus., 66 col.

137. GERDTS, WILLIAM H. *Women Artists of America, 1707-1964.* Newark: The Newark Museum, 1965.

138. GERSTEIN, MARC S. *Impressionism: Selections from Five American Museums.* Introduction by Richard R. Brettell. NY: Hudson Hills, 1989. 202 p., illus., 84 col.

Provides panoramas of Impressionism and Post-Impressionism, with selections from 21 artists, including Cassatt and Morisot. Shows the chronological and stylistic development of each artist.

139. GETLEIN, FRANK and SHERMAN LEE. *Mary Cassatt: Paintings and Prints.* NY: Abbeville, 1980. 154 p., illus., 72 col.

Reviews: N. Mathews, *Women's Art Journal* 1(Spring-Summer 1981):57-60; J. Turano, *American Art Journal* 2(Spring 1981):92.

140. GIMPEL, RENE. *Journal d'un collectionneur: marchand de tableaux.* Paris: Calmann-Lévy, 1963. 500 p., illus.

a. English ed.: *Diary of an Art Dealer.* NY: Farrar, Straus & Giroux, 1966.

141. GUITROOY, GERHARD. *Mary Cassatt: An American Impressionist.* NY: Smithmark, 1996.

142. HALE, NANCY. *Mary Cassatt: A Biography of the Great American Painter.* Garden City, NY: Doubleday, 1975. 333 p., illus.

Biographical treatment from a psychological point of view. Includes 49 black and white reproductions, portraits, bibliography (pp. 293-5), and notes (pp. 297-315).
a. Another ed.: Reading, Massachusetts: Addison-Wesley,1987.
Reviews: G. Henry, *ARTnews* 74:9(Nov. 1975):50-3; N. Mathews, *Woman's Art Journal* 2:1(Spring-Summer 1981):57-60; N. M. Mathews, *Feminist Art Journal* 5:3(Fall 1976):39-40; A. Silver, *Museum News* 54:5(May-June 1976):75; A. Wright, *Carnegie Magazine* 40:1(Jan. 1976):38-41.

143. HARRIS, ANN and LINDA NOCHLIN. *Women Artists, 1550-1950.* NY: Alfred A.

Knopf and Los Angeles County Museum, 1976.

Information about Cassatt, pp. 57-8, 66, 90, 197, 233, 237-44, 282, and 351-2.

144. HAVEMEYER, LOUISINE W. *Sixteen to Sixty: Memoirs of a Collector*. Edited by Susan Alyson Stein. NY: Metropolitan Museum of Art, 1961.

Havemeyer's memoirs include advice by Cassatt regarding their collection of art, which today is part of the Metropolitan Museum of Art, New York.

145. HELLER, NANCY. *Women Artists: An Illustrated History*. NY: Abbeville, 1987. 224 p., illus., some col.

Contains general information on Cassatt, pp. 94, 97-9.
a. Another ed.: 1997.

146. HILLS, PATRICIA. *The Painters' America: Rural and Urban Life, 1810-1919*. Organized for the Whitney Museum of American Art by Patricia Hills. NY: Praeger, 1974. 160 p., illus., some col.

147. HOOPS, DONELSON F. *The American Impressionists*. NY: Watson-Guptill, 1972. 159 p., illus.

148. IVES, COLTA FELLER. *The Great Wave: The Influence of Japanese Woodcuts on French Prints*. Greenwich, Connecticut: New York Graphic Society; NY: Metropolitan Museum of Art, 1975. 116 p., 114 illus.

149. JOHNSON, DEBORAH J. *Whistler to Weidenaar: American Prints, 1870-1950*. Providence: Museum of Art, Rhode Island School of Design, 1987. 128 p., illus.

150. JOLLES, ARNOLD. *The Charlotte Dorrance Wright Collection*. Philadelphia, 1978. 48 p., 50 illus., 4 color.

151. *A Kaleidoscope of Art: the Sunny and Roussel Norman Collection*. Essays by Alice Rae Yelen. New Orleans: New Orleans Museum of Art, 1987. 146 p., illus., some col.

152. KENDALL, RICHARD and GRISELDA POLLOCK. *Dealing with Degas: Representations of Women and the Politics of Vision*. NY: Universe, 1992. 224 p., illus.

Analyzes images of women in Degas' works. Contains essays by art historians including Griselda Pollock and Linda Nochlin, discussing imagery and the question of ambiguity, as well as position and perspective. Pollock's "Women with Binoculars – A Question of Difference" focuses on Cassatt's portrayal of the relationship between mother and child.

153. KENDALL, RICHARD. *Degas Landscapes*. New Haven; London: Yale University Press, 1993. 272 p., 230 illus., 170 col.

154. KING, JOAN. *Impressionist: A Novel of Mary Cassatt*. NY: Beaufort, 1983. 320 p.

Review: J. Shanks, *Women Artists News* 8:5-6(Summer 1983):23-4.

155. KING, PAULINE. *American Mural Painting.* Boston: Noyes, Platt and Co., 1902. 264 p., illus.

Includes two chapters about the mural projects generated by the 1893 Columbian Exposition. Considerable commentary about Cassatt's mural, including 2 black-and-white reproductions.

156. KRAMER, HILTON. *The Age of the Avant-Garde.* NY: Farrar, Straus and Giroux, 1972. 565 p., illus.

157. LINDSAY, SUZANNE GLOVER. *Mary Cassatt and Philadelphia.* Philadelphia: Philadelphia Museum of Art, 1985. 96 p., illus., some col.

158. LOVE, RICHARD H. *Cassatt: The Independent.* Chicago: The Author, 1980. 270 p., 69 illus., some col.

159. LUCIE-SMITH, EDWARD. *Impressionist Women.* London: Weidenfeld and Nicolson, 1989. 160 p., 128 illus., 79 col.

Includes biographical information and bibliographical references on Cassatt.

160. MCCARTHY, KATHLEEN D. *Women's Culture: American Philanthropy and Art, 1830-1930.* Chicago: University of Chicago Press, 1991. 324 p., illus.

161. MCKOWN, ROBIN. *The World of Mary Cassatt.* NY: Crowell, 1972. 253 p., illus.

Biographical study describing Cassatt's associations and her role in Paris as an American artist. Includes few black-and-white reproductions and a partial list of works by Cassatt and the museums where they are located.
a. Another ed.: NY: Dell, 1972. 192 p.

162. MCMURRER, MARY KATHRYN. *The Influences of the Uktyo-e Printmakers on the Prints of Mary Cassatt.* M.A. Thesis, University of Iowa, 1985. 25 p., 6 illus.

163. MANCOFF, DEBRA N. *Mary Cassatt: Reflections of Women's Lives.* NY: Stewart, Tabori & Chang, 1998. 96 p., col. illus.

Examines social, private, and public worlds inhabited by women, as seen in the works of Mary Cassatt. Focuses on women's spaces in terms of solitude, social and public appearances, and motherhood. Includes 50 color reproductions.

164. MARMOR, MICHAEL F. *The Eye of the Artist.* St. Louis: Mosby, 1997. 229 p., illus., some col.

165. MATHEWS, NANCY MOWLL. *Cassatt: A Retrospective.* NY: Hugh Lauter Levin, 1996. 357 p., col. illus.

Brings together major authoritative writings on Cassatt, with reproductions illustrating the documentation from articles, letters, and important articles. Includes compilations from many bibliographies, including exhaustive lists of letters, source notes (p. 349), books, and articles. Includes a bibliography (pp. 11-2), a chronology (pp.13-7), and a genealogy (p. 18). Review: J. Hewgley, *Library Journal* 122:7(April 1997):76.

166. MATHEWS, NANCY MOWLL, ed. *Cassatt and her Circle, Selected Letters*. NY: Abbeville, 1984. 360 p., illus.

Includes 208 selected letters describing Cassatt's life, and offers insight into her character. Letters to and from friends and family span her student days, early years as a professional, Impressionist period, and late international fame. Includes 54 reproductions, chronology, genealogy, bibliography (p. 355), and list of sources for her works (pp. 349-54).
Reviews: A. Faxon, *Woman's Art Journal* 6:2(Fall-Winter 1985-6):50-3; J. Gambrell, *Art in America* 72:11(Dec. 1984):24-7; N. Hale, *Archives of American Art Journal* 24:3(1984):24-5; B. Shapiro, *Print Collector's Newsletter* 16:1(March-April 1985):27-9; L. Wolfangel, *Women Artists News* 11:1(Winter 1986):27-8.

167. MATHEWS, NANCY MOWLL. *Mary Cassatt*. NY: Abrams, in association with The National Museum of American Art, Smithsonian Institution, 1987. 160 p., illus. some col.

Reproduces 134 works and includes rich biographical overview of Cassatt's life and career. Bibliography, p. 154.
a. Another ed.: NY: Rizzoli, 1992. 24 p., 30 illus., 13 col.

168. MATHEWS, NANCY MOWLL. *Mary Cassatt: A Life*. NY: Villard Books, 1994. 383 p., 133 illus.

Examines Cassatt's life and events directly related to her artistic career. Offers a psychological analysis of documentary materials such as letters and memoirs. Includes bibliography, pp. 357-61.
a. Another ed.: New Haven: Yale University Press, 1998.
Review: P.H. Simpson, *Woman's Art Journal* 16:2(Fall 1995-Winter1996):50-2.

169. MATHEWS, NANCY MOWLL . *Mary Cassatt: the Color Prints*. NY: H. N. Abrams, 1989. 207 p., illus., some col.

170. MATHEWS, NANCY MOWLL. *Mary Cassatt and the 'Modern Madonna' of the Nineteenth Century*. Ph.D. diss., New York University, 1980. 318 p., illus.

171. MATHEWS, NANCY MOWLL. *A Passion for Line and Color: The Life of Mary Cassatt*. NY: Villard Books, 1994. 383 p., illus.

172. MELOT, MICHEL. *The Impressionist Print*. New Haven: Yale University Press, 1996. 296 p., 300 illus., 60 col.

173. MEYER, SUSAN F. *Mary Cassatt*. NY: Abrams, 1990. 92 p., 46 illus., 28 col.

174. MILLER, DAVID C. *American Iconology: New Approaches to Nineteenth-Century Art and Literature*. New Haven: Yale University Press, 1993. 344 p., illus.

Examines the cultural context of 19th century American painting, sculpture, and literary works. Chapter by Harriet Scott Chessman, "Mary Cassatt and the Maternal Body" (pp. 239-58) discusses the true value of a woman in times of changing social roles. Analyses five of Cassatt's works in terms of chosen imagery and spacial relationships.

175. *Mistresses of the Graphic Arts: Famous and Forgotten Women Printmakers, 1550-1950*. North Aston, England: Elizabeth Harvey-Lee, 1995. 126 p., 359 illus.

176. MOFFETT, CHARLES S. *The New Painting, Impressionism 1874-1886*. San Francisco: The Fine Arts Museums, 1986. 512 p., 279 illus., 213 col.

177. *Mrs. H. O. Havemeyer's Remarks on Edgar Degas and Mary Cassatt*. NY: Knoedler, 1915. 13 p.

178. MULLER, NANCY C. *Paintings and Drawings at the Shelburne Museum*. Shelburne, VT: Shelburne Museum, 1976. 200 p., 503 illus., 41 color.

179. MUNRO, ELEANOR C. *Originals, American Women Artists*. NY: Simon and Schuster, 1979. 528 p., 183 illus, 40 col.

Psychological study of successful women artists of the 20th century, looks at pioneer artists such as Cassatt (pp. 59-74) and O'Keeffe. Includes selected artists' bibliography (p. 504-12) and seven reproductions, including a portrait of Cassatt.
Reviews: E. Frank, *Art in America* 68:4(Aug. 1980):19,21; A. Frankenstein, *ARTnews* 79:2(Feb 1980):31; J. Hobhouse, *New York Times Book Review* (17 June 1979):13,28; E. Janis, *Print Collector's Newsletter* 10:5(Nov.-Dec. 1979):168-9; J. Turano, *American Art Journal* 11:4(Oct. 1979):95-6.

180. MUNSTERBERG, HUGO. *History of Women Artists*. NY: Clarkson N. Potter, 1975. 150 p., illus., some col.

Information about Cassatt on pp. 53, 55, 56-9, 65, 104, 105, 109, 110, 146.

181. MYERS, ELISABETH P. *Mary Cassatt: A Portrait*. Chicago: Reilly & Lee Books, 1971. 138 p., illus.

182. NAGLE, GERALDINE. *The Arts: World Themes*. Dubuque, IA: W.C. Brown and Benchmark, 1993. 352 p., 286 illus., 53 col.

183. National Gallery of Canada, Ottawa. *Mary Cassatt Colour Prints, the Crummond Bequest*. Ottawa: NGC, 1993. 1 folded sheet (10 p.): illus. (some col.)

184. *National Museum of Women in the Arts*. NY: Abrams, 1987. 253 p., illus., 69 col.

Museum catalogue showing 239 works from the collection, from the 16th century to the mid

1900s. Cassatt is represented by *The Bath* (1891) and 4 black-and-white drawings (p. 166-7).

185. OPFELL, OLGA S. *Special Visions: Profiles of Fifteen Women Artists from the Renaissance to the Present Day*. Jefferson, NC: McFarland, 1991. 223 p., illus.

186. PARKER, ROZSIKA and GRISELDA POLLOCK. *Old Mistresses: Women, Art and Ideology*. NY: Pantheon, 1981.

Examines the role of women as artists and how they have been misrepresented throughout the history of art. Analyzes the relationship among women, art, and ideology and discusses Cassatt's involvement with the Independents as a struggle for freedom (pp. 38-41). Reproduces *Lydia at a Tapestry Frame* (ca. 1881).

187. PASSERON, ROGER. *Impressionist Prints: Lithographs, Etchings, Drypoints, Aquatints, Woodcuts*. London: Phaidon, 1974. 222 p., illus.

Surveys the history of French printmaking through the works of Impressionist artists including Berthe Morisot and Mary Cassatt. Contains large reproductions of Cassatt's *In the Opera Box, Repose, In the Omnibus, The Letter, The Toilette, Maternal Caress, Mother Rose Nursing her Child, The Crochetting Lesson, Under the Horse Chestnut Tree*. Information for each work includes provenance, location, and reference to entries in Breeskin's *The Graphic Work of Mary Cassatt* (1948) and her 1967 catalogue compiled for the Museum of Graphic Art.

188. PEET, PHYLLIS. *American Women of the Etching Revival*. Atlanta: High Museum of Art, 1988. 72 p., 45 illus.

189. PETERS, LISA N. *American Impressionist Masterpieces*. NY: Hugh Lauter Levin Associates: dist. by Macmillan, NY, 1991. 119 p., illus., 48 col.

190. PETERSEN, KAREN and J. J. WILSON. *Women Artists: Recognition and Reappraisal from the Early Middle Ages to the Twentieth Century*. New York: New York University Press, 1976. 212 p., illus.

Discusses Cassatt's career and role as a feminist artist in Impressionist Paris (pp. 87-90). Presents her independent style as an expression of women's lives and relationship to their environment. Includes few black-and-white illustrations and bibliography.
a. English ed.: London: The Women's Press, 1978.

191. PETTIT, MARTHA. *Mary Cassatt and Berthe Morisot: Women Impressionist Painters, Master's Essay*. M.A. Thesis, University of Michigan, 1976. 70 p., illus.

192. PISANO, RONALD G. *Idle Hours: Americans at Leisure, 1865-1914*. Boston: Little, Brown, 1988. 130 illus., 45 col.

193. PLAIN, NANCY. *Mary Cassatt: An Artist's Life*. NY: Dilon; Toronto: Maxwell Macmillan, 1994. 168 p., illus., some col.

194. POLLOCK, GRISELDA. *Mary Cassatt*. NY: Harper & Row, 1980. 119 p., 53 illus., 32 col. pl.

Scholarly biographical study of Cassatt, discusses her style, choice of subject matter, and events of the time in Paris. Includes chronology and bibliography (pp. 30-1)
a. English ed.: London: Jupiter Books, 1980.
Reviews: N. Mathews, *Woman's Art Journal* 2:1(Spring-Summer 1981):57-60; J. Turano, *American Art Journal* 13:2(Spring 1981):93.

195. POLLOCK, GRISELDA. *Mary Cassatt: Painter of Modern Women.* Thames and Hudson, 1998. 224 p., 184 illus., 55 col. (World of Art)

Compact and well illustrated study of Cassatt. Includes list of art history terms explained for the introductory reader. Discusses Cassatt in light of recent feminist theory, suggesting that she intentionally painted domestic themes in order to portray female power.
Review: *Library Journal* (Jan. 1999):90.

196. POLLOCK, GRISELDA. *Vision and Difference: Femininity and the Histories of Art*. London: Routledge, 1988.

197. RANDALL, LILLIAN M. C. *The Diary of George A. Lucas: An American Art Agent in Paris, 1857-1909*. 2 vols. Princeton: Princeton University Press, 1979.

Contains journal entries describing details of Lucas' dealings. Briefly mentions encounters with Cassatt and notes the receipt of a drawing from Miss Cassatt. No illustrations.

198. REWALD, JOHN. *The History of Impressionism*. NY: Museum of Modern Art, 1961.

199. RIGAL, LAURA. *American Iconology: New Approaches to Nineteenth-century Art and Literature*. New Haven: Yale University Press, 1993. 344 p., illus.

200. ROBERTS, KEITH. *The Impressionists and Post-Impressionists: 105 Reproductions*. London: Phaidon, 1975. 96 p., 105 illus.

a. Another ed.: 1977.

201. RODRIGUEZ ROQUE, OSWALDO. *Directions in American Painting, 1875-1925; Works from the Collection of Dr. and Mrs. John J. McDonough*. Pittsburgh: Museum of Art, Carnegie Institute, 1982. 112 p., illus., some col.

202. ROOS, JANE MAYO. *Early Impressionism and the French State (1866-1874)*. Cambridge, England; NY; Melbourne: Cambridge University Press, 1996. 300 p., 158 illus.

Examines the politics of the Salon in the years preceding the 1874 Impressionist exhibition. Discusses the group that later became known as the Impressionists, and briefly mentions Mary Cassatt.

203. ROUDEBUSH, JAY. *Mary Cassatt*. Translated from the French by Alice Sachs. NY:

Crown, 1979. 95 p., illus., some col.

a. Swiss ed.: Naefels, Switzerland: Bonfini, 1979.
b. French ed.: trad. from English, Marie-Hélène Agüeros. Paris: Flammarion, 1989.
Reviews: N. Mathews, *Woman's Art Journal* 2:1(Spring-Summer 1981):57-60; J. Turano, *American Art Journal* 11:3(July 1979):90.

204. RUBINSTEIN, CHARLOTTE STREIFER. *American Women Artists: From the Early Indian Times to the Present*. Boston: G. K. Hall, 1982. 560 p., illus.

205. SEGARD, ACHILLE. *Un Peintre des enfants et des mères: Mary Cassatt.* Paris: Librairie Paul Ollendorff, 1913. 207 p., 37 leaves of plates., illus.

Interviews with Cassatt, who had designated Segard as her official biographer.
a. U.S. ed.: NY: Burt Franklin.

206. SHEPHERD, DON. *Women in History*. Los Angeles: Mankind, 1973. 252 p., illus.

207. SILLS, LESLIE. *Visions: Stories about Women Artists*. Morton Grove, IL: A. Whitman, 1993. 58 p., illus., some col.

208. SLATKIN, WENDY. *The Voices of Women Artists*. Englewood Cliffs, NJ: Prentice Hall, 1993. 340 p., illus.

209. SLATKIN, WENDY. *Women Artists in History: From Antiquity to the Present*. Upper Saddle River, NJ: Prentice Hall, 1985. 240 p., illus.

Brief overview of women artists throughout the whole history of art. Includes general discussion of Cassatt's life and career on pp. 139-41. Includes 2 reproductions.
a. Other eds: 1990, 1997.

210. SLOCOMBE, GEORGE. *Rebels of Art*. NY: Arts and Decoration Book Society, 1939. 304 p., illus.

211. SPARROW, WALTER SHAW. *Women Painters of the World: From the Time of Caterina Vigri, 1413-1463 to Rosa Bonheur and the Present Day.* London: Hodder & Stoughton, 1905. 332 p., illus.

Beautifully illustrated book, contains a collection of essays about the "genius" of women artists throughout history, from 15th century Italy to early British, French, Belgian, Dutch, German, Austrian, and Finnish women artists. Reproduces Cassatt's *Childhood in a Garden* and *Mother and Two Children* (p. 327); and *Baby's Toilette* (p. 157).

212. SPASSKY, NATALIE. *Mary Cassatt*. NY: Metropolitan Museum of Art, 1984. 32 p., 14 col. illus.

213. STEINHART, RUTH CAROL. *The Color Prints of Mary Cassatt*. M.A. Thesis, University of Iowa, 1971. 45 p., 12 illus.

214. STODDARD, HOPE. *Famous American Women.* NY: Crowell, 1970. 461 p., illus.

215. STONEBRAKER, CHARLOTTE R. *Mary Cassatt: Feminist Artist of the Nineteenth Century.* 28 p., illus., some col.

216. STUCKEY, CHARLES F. and WILLIAM P. SCOTT. *Berthe Morisot, Impressionist.* With the assistance of Suzanne G. Lindsay. NY: Hudson Hills; dist. by Rizzoli, 1987. 228 p., illus.

Study of Morisot's life and career, including relationship with Cassatt and the Impressionist group. Contains five reproductions by Cassatt.

a. English ed.: London: Sotheby's Publications, 1987.
b. French ed.: Traduit par Marie-Odile Probst, 1987.
c. Italian ed.: Milan: A. Mondadori, 1987. 227 p.
Reviews: C. Brightman, *New York Times Back Review* (March 1988):39; C. Movalli, *American Artist* 52(March 1988):18; P. Piguet, *L'Oeil* 398(1988):75; N. Mathews, *Woman's Art Journal* 10:1(Spring-Summer 1989):46-9.

217. SWEET, FREDERICK ARNOLD. *Miss Mary Cassatt: Impressionist from Pennsylvania.* Norman: University of Oklahoma Press, 1966. 242 p., illus.

Scholarly biography of Mary Cassatt. Includes many of her translated letters, with long footnotes. Bibliography, pp. 222-8.

218. TATE, PENELOPE C. *The Influence of Japanese Woodcuts on the Prints and Paintings of James A. McNeill Whistler and Mary Cassatt.* M.A. Thesis, Florida State University, 1969. 153 p.

219. THOMAS, AUDREY. *Latakia.* Vancouver; Los Angeles: Talonbooks, 1979. 172 p.

Novel by Canadian author depicts the alienation of women artists in society, with reference to paintings by Morisot and Cassatt.
a. Italian ed.: Trans. by Adriana Trozzi. Marina di Patti: Pungitopo, 1993. 202 p.

220. TOBEY, SUSAN BRACAGLIA. *Art of Motherhood.* NY: Abbeville, 1981. 180 p., illus. (some col.)

221. TUFTS, ELEANOR. *American Women Artists, 1830-1930.* Washington, D.C.: National Museum of Women in the Arts, 1987. 256 p., 144 illus., 130 col.

222. TUFTS, ELEANOR. *American Women Artists, Past and Present: A Selected Bibliographic Guide.* New York: Garland, 1984-89. 2 vols.

Lists 500 women artists. Pages 51-3 offer short general bibliography on Cassatt. Volume 2 has additional artists and more information on artists listed in the first volume, with a total of 1,200 entries. Cassatt's entry in volume 2 offers an additional 18 references.

223. VALERIO, EDITH. *Mary Cassatt*. Paris: G. Crès, 1930. 11 p., illus., 32 pl. (Les Nouveaux artistes)

224. VAN HORNE, WILLIAM CORNELIUS, SIR. *Twenty Distinguished Modern Paintings by Daumier, Cézanne, Renoir, Delacroix, Corot, Toulouse-Lautrec, Cassatt, Ryder and Other French & American Masters*. NY: Parke-Bernet Galleries, 1946. 32 p., chiefly illus.

225. VAROLI-PIAZZA, ROSALIA. *Mary Cassatt, as an American in Paris*. M.A. Thesis, State University of New York at Binghamton, 1976. 1 vol., illus.

226. VENTURI, LIONELLO. *Les Archives de l'impressionnisme: lettres de Renoir, Monet, Pissarro, Sisley et autres, mémoires de Paul Durand-Ruel: documents*. Paris; NY: Durand-Ruel, 1939. 2 vols., illus.

Volume two contains letters from Mary Cassatt to Durand-Ruel.

227. WATSON, FORBES. *Mary Cassatt*. NY: Whitney Museum of American Art, 1932. 60 p., illus, some col. (American Artists Series)

Watson describes meeting Cassatt and includes brief biographical notes. Includes bibliography, pp. 19-20.

228. WEBER, BRUCE. *Drawn from Tradition: American Drawings and Watercolors from the Susan and Herbert Adler Collection*. NY: Hudson Hills, 1989. 176 p., 97 illus., 16 col.

229. WEIMANN, JEANNE MADELINE. *The Fair Women*. Chicago: Academy Chicago, 1981. 611 p., 437 illus.

Discusses Cassatt's mural for the 1893 World's Columbian exposition.

230. WEITENKAMPF, FRANK. *The Dry-Points of Mary Cassatt*. NY: Far Gallery, 1962. 16 p., illus.

231. WEITZENHOFFER, FRANCES. *The Havemeyers: Impressionism Comes to America*. NY: Abrams, 1986. 288 p., 96 p. of plates, illus.

Written by a student of the Impressionist scholar John Rewald. Describes the history and activities of the Durand-Ruel Galleries and their role in bringing Impressionism to America. Includes genealogy of the Havemeyers, friends of the Cassatts, and considers Cassatt highly responsible for the existence of the collection. Includes 15 reproductions of Cassatt's works, bibliography (pp. 271-8), and references to many unpublished documents about the Impressionists.

232. WELTON, JUDE. *Impressionism*. London; NY; Stuttgart: Dorling Kindersley, in association with the Art Institute of Chicago, 1993. 64 p., 277 illus., 225 col.

233. WELTON, JUDE. *Impressionist Gardens*. London: Studio, 1993. 64 p., illus, 28 col.

234. WHITE, BARBARA EHRLICH. *Impressionists Side by Side: Their Friendships, Rivalries, and Artistic Exchanges.* NY: Knopf, 1996. 292 p., illus., some col., 1 col. map.

Analyzes relationships between pairs of Impressionist artists: Degas and Manet, Monet and Renoir, Cézanne and Pissarro, Manet and Morisot, Cassatt and Degas (pp. 183-212), Morisot and Renoir, and Cassatt and Morisot (pp. 259-65). Includes 14 color reproductions by Cassatt, chronology, and bibliography (pp. 281-4).

235. WHITFORD, FRANK. *Japanese Prints and Western Painters.* London: Studio Vista. 264 p., 190 illus.

236. WHITTEMORE, HARRIS. *The Etched Work of Whistler and Mary Cassatt, From the Well-known Collection of the Late Harris Whittemore.* NY: Parke-Bernet Galleries, 1949. illus.

237. WILMERDING, JOHN. *American Masterpieces from the National Gallery of Art.* NY: Hudson Hills, 1980. 180 p., 169 illus., 65 col.

Includes seven reproductions of Cassatt's works, two in color.
Review: A. Berman, *ARTnews* 80:7(Sept. 1981):29.

238. WILMERDING, JOHN. *Essays in Honor of Paul Mellon: Collector and Benefactor.* Washington D.C.: National Gallery of Art, dist. by Trevor Brown Associates, London, 1986. 427 p., 240 illus., 23 col.

239. WILSON, DORIS JEAN. *Mary Cassatt and Charles Griffes: American Impressionists in an Era of Change.* M.A. Thesis, Northeast Missouri State University, 1980.

240. WISER, WILLIAM. *The Great Good Place: American Expatriate Women in Paris.* NY: Norton, 1991. 336 p.

Includes biographies of Mary Cassatt, Edith Wharton, Caresse Crosby, Zelda Fitzgerald, and Josephine Baker describing their relationships and development of artistic careers in Paris.

241. WITZLING, MARA ROSE. *Mary Cassatt: a Private World, Paintings from the National Gallery of Art.* NY: Universe, 1991. 80 p., illus., some col.

242. WITZLING, MARA ROSE. *Voicing Our Visions: Writings by Women Artists.* NY: Universe, 1991. 390 p., illus.

Compilation of writings by twenty 19th and 20th century women artists. Each entry has a brief biographical sketch with the artist's goals, achievements, themes, and writings. The section on Cassatt (pp. 77-93) includes excerpts from Cassatt's correspondence.
a. English ed.: London: Women's Press, 1991.

243. YAEGASHI, HARUKI. *Cassatt.* Text by Haruki Yaegashi, Takeshi Kashiwa. Tokyo: Senshukai, 1978. 87 p., col. illus. Text in Japanese.

244. YELDHAM, CHARLOTTE. *Women Artists in Nineteenth Century France and England.* NY; London: Garland Publishing Co., 1984. 2 vols., illus. (Outstanding Theses from the Courtauld Institute of Art)

Discusses women's art education, exhibition opportunities, societies of women artists, one-woman exhibitions, and membership in exhibiting societies and academies in France and England. Biographical section includes Cassatt (vol. 1, pp. 357-64) among other women artists. Includes tables of women's exhibitions in France and England.

245. YOUNG, KATHRYN ANN. *The Spinster's Madonna: Poetry on the Paintings and Life of Mary Cassatt.* Fort Wayne, IN: IPFW Arts Group, 1996.

246. YOUNG, MAHONRI SHARP. *American Realists: Homer to Hopper.* NY: Watson-Guptill, 1977. 208 p., 168 illus., some col.

Cassatt is the only woman included in the group (pp. 52-61), with nine black-and-white reproductions. Describes her as a realist, like her mentor Degas, and asserts that she actually painted few Impressionist works.
Reviews: D. Sutton, *Apollo* 107:191(Jan. 1978):72; C. Betsky, *Art in America* 65:3(May-June 1978):19-21.

247. ZACZEK, IAIN. *Impressionist Interiors.* London: Studio, 1993. 64 p., illus., 28 col.

IV. Juvenile Books

248. HYDE, MARGARET E. *Cassatt for Kids.* Santa Monica, CA: Budding Artists, 1996. 1 vol., unpaged, col. illus.

249. KRULL, KATHLEEN. *Lives of the Artists: Masterpieces, Messes (and What the Neighbors Thought).* San Diego: Harcourt, Brace & Co., 1995. 95 p., illus.

Humorous book narrates peculiar facts from famous artists' lives, including Mary Cassatt. Illustrated by Kathryn Hewitt.

250. LEIPOLD, L. EDMOND. *Famous American Artists.* Minneapolis: T. S. Denison, 1969. 83 p., illus.

Brief biographical sketch of lives and careers of ten men and women who depicted their native land. Artists include James McNeill Whistler, Benjamin West, Grant Wood, Winslow Homer, and Mary Cassatt, among others. No reproductions.

251. MÜHLBERGER, RICHARD. *What Makes a Cassatt a Cassatt?* NY: Metropolitan Museum of Art, Viking, 1994. 48 p., col. illus.

Presents a simplified but well researched overview of Cassatt's life and career, through twelve of her major works. Discusses the influence of Spanish and Japanese art, the portrayal of intimacy between mother and child, and the cropping of scenes in unexpected ways.

a. Another ed.: 1995.
b. Chinese ed.: *Chiasatewei shen mo shih ta shih Chiasate?* tso che Lich a Muerhpoko; i che Yu Yuti. Chupan. Taipei shih: Ching lin kuo chi chupan ku fen yu hsien kung ssu, 1995.

252. SCHEADER, CATHERINE. *Mary Cassatt*. Chicago: Campus Publications, 1977. 80 p., illus. (They Found a Way).

Well-researched portrayal of Cassatt showing her Impressionist paintings of women and children. Includes photographs of her as well as of other students at The Pennsylvania Academy of the Fine Arts. Contains fictional dialogue about events in Cassatt's life.

253. STREISSGUTH, THOMAS. *Mary Cassatt: Portrait of an American Impressionist*. Minneapolis: Carolrhoda Books, 1999. 112 p., illus., some col.

General overview of Cassatt's life and career.

254. TURNER, ROBYN MONTANA. *Mary Cassatt*. Boston: Little, Brown, 1992. 32 p., illus., some col. (Portraits of Women Artists for Children)

Well-researched biographical treatment of Mary Cassatt. Chronological presentation of her major works, including color reproductions of the two postage stamps issued in her honor.

255. WILSON, ELLEN JANET. *American Painter in Paris: A Life of Mary Cassatt*. NY: Farrar, Straus & Giroux, 1971. 205 p., 29 illus.

Biographical study of Cassatt's life and career. Includes few-black-and-white reproductions of her major works.
Review: A. Breeskin, *Art Journal* 33:3(Spring 1974):28.

V. Articles

256. ADLER, KATHLEEN. "Angles of Vision." *Art in America* 78(Jan. 1990):138-43. 6 illus., some col.

Examines Degas' representation of women and their relationship with modern viewers. Includes reproduction of his etching *Mary Cassatt at the Louvre* (1879-80).

257. ADLER, KATHLEEN. "*Objects de Luxe* or Propaganda?: Camille Pissarro's Fans." *Apollo* 136:369(Nov. 1992):301-5. 4 illus.

Discusses Pissarro's designs for fans, which were regarded by artists including Mary Cassatt and Degas as true works of art.

258. ALEXANDRE, ARSENE. "La Collection Havemeyer et Miss Cassatt." *La Renaissance de l'art français et des industries de luxe* 13(Feb. 1939):51-6.

259. ALEXANDRE, ARSENE. "Miss Mary Cassatt, aquafortiste." *La Renaissance de l'art*

français et des industries de luxe 7:3(March 1924):127-33.

260. ALLARA, PAMELA. "What is American about American Art?" *ARTnews* 83:1(Jan. 1984):88-93. 6 illus.

Reviews the Fall 1983 exhibition, *A New World: Masterpieces of American Painting, 1760-1910*, at the Boston Museum of Fine Arts. The aim of the exhibition was to identify the concept of "American" in 19th century American painting. Cassatt is among the artists represented.

261. "American Woman's Unique Achievement in Modern Art." *Current Opinion* 62(June 1917):426-7.

262. "Art y Ceramica." *Ceramica* 41(1990):10-25. 31 illus., 12 col.

Discusses the history of ceramic sculpture from its beginnings to the present day. Presents artists who worked in ceramic sculpture, including Rodin, Cassatt, Gauguin, Léger, Chagall, and others.

263. BELLEFEUILLE, SUZANNE and JEAN LACROIX. "Le Musée de Shelburne: le 'Smithsonian' du nord!" *Magazine d'art* 8:1(Autumn 1995):42-4. 7 col. illus.

Describes the Impressionist collection at the Shelburne Museum, Vermont. Includes paintings by artists such as Degas, Cassatt, and Manet. The museum was formerly the home of the art collector Electra Havemeyer Webb, whose parents were among the first Americans to collect Impressionist paintings, largely on advice by Mary Cassatt.

264. BERMAN, AVIS. "Adelyn Breeskin: Fifty Years of Excellence, Part I." *The Feminist Art Journal* 6:2(Summer 1977):9-14. 3 illus.

Interviews art scholar Adelyn Breeskin and discusses her life and career up to her appointment as acting director of the Baltimore Museum in 1942. Portrays Breeskin's interest in Mary Cassatt.

265. BEURDELEY, Y. R. *"Miss Cassatt." L'Art dans les deux mondes* (22 Nov. 1890).

266. BIDDLE, GEORGE. "Some Memories of Mary Cassatt." *The Arts* 10:2(Aug. 1926):107-11.

Author recounts his last encounter with Cassatt, at the end of her life. Mentions various other conversations and impressions about the artist.

267. BISHOP, BUD HARRIS. "Nineteenth-Century American Paintings at the Columbus Museum of Art." *Antiques* 120:5(Nov. 1981):1172-83. 16 illus.

Describes the paintings in the museum executed after 1864. Portraits by Whistler, Sargent, and Cassatt appear side by side with examples of typical American Impressionism by Childe Hassam and of realism by Thomas Eakins.

268. BODELSON, MERETE. "Gauguin's Cassatt." *Burlington Magazine* 109:769 (Apr. 1967):226-7.

Discusses the provenance of one of Cassatt's paintings, which was once part of Gauguin's private art collection.

269. BOIME, ALBERT. "Maria Deraismes and Eva Gonzalès: A Feminist Critique of *Une Loge au Théâtre des Italiens.*" *Woman's Art Journal* 15:2(Fall-Winter, 1994-95):31-7. 4 illus., 1 col.

Discusses Deraismes' contribution to the evolution of feminism in France in the late 19th century. Compares Gonzalès's *Une Loge au Théâtre des Italiens* (ca. 1874) with other impressionist views of women at the theater, including Cassatt's 1882 *The Loge*, in which two young women are portrayed together.

270. BOONE, M. ELIZABETH. "American Artists and the Spanish Experience." *American Art Review* 11:1(Jan./Feb. 1999):120-31.

Examines the influence of Spain on American artists between 1860 and 1920 on the occasion of the exhibition *Espana: American Artists and the Spanish Experience,* at the New Britain Museum of American Art, Connecticut.

271. BOONE, M. ELIZABETH. "Bullfights and Balconies: Flirtation and Majismo in Mary Cassatt's Spanish Paintings of 1872-73." *American Art* 9:1(Spring 1995):55-71. 14 illus., 3 col.

Analyzes the iconography and style of Cassatt's works painted during her visit to Spain in 1872. Mentions the influence of Goyà, Manet, and Murillo on Cassatt's paintings.

272. BOUILLON, JEAN-PAUL. "Degas, Bracquemond, Cassatt: actualité de l'Ingrisme autour de 1880." *Gazette des Beaux-arts* 3:6(Jan.-Feb. 1988):125-7. 2 illus.

Discusses the close relationship between Degas, Bracquemond, and Cassatt, three artists who actively participated in the Impressionist movement. Mentions that Degas' published correspondence includes 14 letters addressed to Bracquemond, verifying their friendship and appreciation for each other's work.

273. BOYLE, RICHARD J. "American Impressionism." *Apollo* 150:100(Aug. 1974):160-1. 3 illus.

Discusses the differences between American and French Impressionist style. Mentions Cassatt as the first American artist to adopt the Impressionist palette. Describes the 1898 exhibition as a "show of ten American painters," depicting the variations in style among the exhibitors.

274. BOYLE, RICHARD J. "Some Observations on American Impressionist Drawing." *Drawing.* 12:1(May-June 1990):1-5. 9 illus.

Surveys American Impressionist drawing and defines what it meant to American artists. Questions whether there truly was American Impressionist drawing or whether it should be called drawing by American Impressionists. Mentions artists such as Cassatt, Whistler, and Benson.

275. BREESKIN, ADELYN DOHME. "The Graphic Works of Mary Cassatt." *Printa* 7:2 (Dec. 1936):63-71.

276. BREESKIN, ADELYN DOHME. "The Line of Mary Cassatt." *Magazine of Art* 35:I (Jan. 1942):29-31.

277. BREESKIN, ADELYN DOHME. "Little Girl in a Blue Armchair–1878" in *Essays in Honor of Paul Mellon, Collector and Benefactor*, ed. by John Wilmerding. (Washington, D.C.: National Gallery of Art, 1986):246 p., 100 illus., some col.

278. BREESKIN, ADELYN DOHME. "Mary Cassatt: Her Life and her Art." *Arts in Virginia* 21:3(Spring 1981):2-15. 7 illus.

Surveys Cassatt's life and career from her home in Philadelphia to her life in Paris, where she was influenced by artists such as Manet and his circle. Focuses on her graphic work and friendship with Degas.

279. BREUNING, MARGARET. "Cassatt and Morisot." *Magazine of Art* 32:12(Dec. 1939):732-3.

280. BRINTON, CHRISTIAN. "The Concept of Color." *Scribner's Monthly Magazine* 62(Oct. 1919):513-6.

281. BRINTON, CHRISTIAN. "Concerning Miss Cassatt and Certain Etchings." *International Studio* 27:105(Nov. 1904):1-7. 6 illus.

Discusses how the women Impressionists gave the movement a touch of humanity by portraying personal spaces. Analyzes Cassatt's renditions of mother and child and the influence of Degas in her work.

282. BRODSKY, J. K. "Some Notes on Women Printmakers." *Art Journal* 35:4(Summer 1976):374:7. 1 illus.

283. BROUDE, NORMA F. "Miriam Shapiro and 'Femmage': Reflections on the Conflict Between Decoration and Abstraction in 20th Century Art." *Arts Magazine* 54:6(1980):83-7. 1 illus.

284. BROUDE, NORMA F. "Will the Real Impressionists Please Stand Up?" *ARTnews* 85:5(May 1986):84-9. 6 illus.

With reference to the exhibition *The New Painting: Impressionism 1874-86* (Washington, D.C., National Gallery of Art, 1986), Broude presents a new appreciation of Impressionism through the works of Cassatt, Caillebotte, and Raffaëlli.

285. BROWN, HILTON. "Looking at Paintings." *American Artist* 45:467(June 1981):40-1, 98-7, 102. 4 illus.

Analyzes Cassatt's *Margot in Blue* (1902) and her method of building up impasto layers on the fibrous paper of her pastel work.

286. BUETTNER, STEWART. "Images of Modern Motherhood in the Art of Morisot, Cassatt, Modersohn-Becker, Köllwitz." *Woman's Art Journal* 7:2(Fall-Winter 1986-87):14-21. 9 illus.

Discusses motherhood as depicted in the works of Morisot, Cassatt, Modersohn-Becker, and Köllwitz. Compares the psychological content and types of models used by each artist.

287. BULLARD, EDGAR JOHN. "An American in Paris: Mary Cassatt." *American Artist* 37:368 (March 1973):41-7, 75-6. 10 illus.

Biographical survey of Mary Cassatt, from her first years in Pennsylvania to her successful career in Paris. Mentions how she was influenced by the Impressionists, Degas, and Japanese art from the 1890 exhibition in Paris.

288. BULLARD, EDGAR JOHN. "New Acquisition: A Painting by Mary Cassatt." *Arts Quarterly* 1(Jan.-March 1983):14-5. 1 illus.

Features Cassatt's *Mother and Child in the Conservatory* (1906), a recent acquisition of the New Orleans Museum of Art.

289. BUTTERFIELD, JAN. "Replacing Women Artists in History." *ARTnews* 76:3(March 1977):40-4. 5 illus.

Discusses issues of education, training, and the need for mentoring in the works of women artists.

290. CALLEN, ANTHEA. "The Unvarnished Truth: Mattness, 'Primitivism' and Modernity in French painting, c. 1870-1907." *Burlington Magazine* 136:1100(Nov. 1994):738-46. 10 illus.

Discusses the issue of varnish on the surface of Impressionist and Fauve paintings. Examines the techniques used by various artists, and the influence of early Italian frescoes on Degas and Cassatt.

291. CARR, CAROLYN KINDER. "Mary Cassatt and Mary Fairchild MacMonnies: The Search for Their 1893 Murals." *American Art* 8:1(Winter 1994):53-69. 11 illus.

Examines the possible whereabouts of Cassatt's mural *Modern Woman,* created for the 1893 World's Columbian Exposition in Chicago to celebrate women's progress and achievements.

292. CARY, ELIZABETH LUTHER. "The Art of Mary Cassatt." *The Script* I:1(Oct.1905):1-5. 1 illus.

Overview of Cassatt's artistic career and influences.

293. CARY, ELIZABETH LUTHER. "Painting, Health, and Sanity." *Good Housekeeping* 58:2(Feb. 1914):152-8.

294. CATE, PHILLIP DENNIS. "The Japanese Woodcut and the Flowering of French Color Printmaking." *ARTnews* 74:3(March 1975):26-9. 6 illus.

Discusses the influence of Japanese prints in French printmaking in the late 19th century. Compares Cassatt's works to Harunobu and Utamaro in terms of composition and use of color.

295. CHILD, THEODORE. "Art Gossip from Paris." *Art Amateur* 18:3(1888):58-9. Illus.

Mentions the French artist Philippe Rousseau's death and discusses the artistic atmosphere of the times. Also discusses Cassatt's etchings.

296. CIOLKOWSKA, MURIEL. "Painters' Ideals of Childhood." *International Studio* 78:322(March 1924):481-5.

297. CONANT, CORNELIA W. "An Art Student in Ecouen." *Harper's New Monthly Magazine* 70:417(Feb. 1885):388-99.

298. CORTISSOZ, ROYAL. "M. Degas and Miss Cassatt, Types once Revolutionary which now seem Almost Classical." *New York Tribune* (April 4, 1915):3.

299. CUSTER, A. "Archives of American Art: Group of MS and other Documents of Mary Cassatt Microfilmed." *Art Quarterly* 18:4(1955):391.

300. DAVIS, ELLIOT BOSTWICK. "Mary Cassatt's Color Prints." *Antiques* 154:4(Oct. 1998):484-93.

Discusses several of Cassatt's color prints in light of the exhibition entitled *Mary Cassatt: Drawings and Prints in the Metropolitan Museum of Art* (1998-99).

301. DEEDS, DAPHNE ANDERSON. "American Impressionism from the Sheldon Memorial Art Gallery." *American Art Review* 5:1(Summer 1992):104-13, 145. 11 illus.

Brief history of the gallery's collection located in Lincoln, Nebraska at the University of Nebraska) of American Impressionism and of the Impressionist movement in the United States.

302. DENISOFF, DENNIS. "The Rare Space of the Female Artist: Impressionism in Audrey Thomas' *Latakia*." *Mosaid* 26:4(Autumn 1993):69-86. 5 illus.

Discusses the Canadian novelist Audrey Thomas' novel *Latakia* (Vancouver; Los Angeles: Talonbooks, 1979). The novel depicts the alienation of women artists in society, and makes reference to paintings by Morisot and Cassatt.

303. DUMAS, ANNE. "The Prints: Degas' Collection of French Nineteenth-Century Prints." *Apollo* 144(Sept. 1996):53-63.

Examines Degas' collection of prints, which included works by Mary Cassatt.

304. DUNSTAN, BERNARD. "The Birmingham Art Gallery." *Artist* 83:3(May 1972):81-3. 7 illus.

Discusses how Alabama's Art Gallery, which traditionally has represented Pre-Raphaelites, now displays some lesser known 19th century artists.

305. DUNSTAN, BERNARD. "Looking at Paintings." *American Artist* 434:42(Sept. 1978):50-1. 2 illus.

306. DURAND-RUEL, CAROLINE. "Quand les Havemeyers aimaient la peinture française." *Connaissance des arts* 544(Nov. 1997):100-9.

Discusses the Havemeyer French art collection, on occasion of the exhibit at the Musée d'Orsay, Paris. Notes the influence of Mary Cassatt in the acquisition of the collection at the turn of the century.

307. DURET, ROBERT F. "Le Goût des Havemeyer." *Connaissance des arts* 375(May 1983):62-9. 10 illus.

Describes the history of the art collection formed by Henry Osborne Havemeyer, as well as his marriage to Louisine Waldron Elder in 1883. Duret describes how Louisine met Cassatt, who encouraged her to appreciate and buy Impressionist paintings.

308. DUTHY, ROBIN. "American Visions: As Investments, The Paintings of Our Impressionists are Leaving the French in the Dust." *Connoisseur* 214(July 1984):110-2. 3 illus.

Examines the performance of works by "The Ten" and "The Eight" in the art market. Mentions how international appreciation for Cassatt's works has increased the prices for her works.

309. DUTHY, ROBIN. "The Impressionist Market (Renoir, Cézanne, Degas, Sisley, Pissarro, Monet)" *Connoisseur* 208:835(1981)

310. "Edgar Degas and Mary Cassatt." *The Atlantic Monthly* 272:5(Nov. 1993):137.

Presents a glimpse into the friendship between Edgar Degas and Mary Cassatt. Discusses their mutual admiration of each others' work and their friendship of 40 years.

311. ENDE-SAXE, SHIRLEY. "Primarily Cassatt: Art Appreciation for Primary Grades." *School Arts* 91:1(Sept. 1991):22-4.

Discusses Cassatt as an artist who painted themes of family, mothers and children. Proposes

that her work is, therefore, an excellent choice to be used in the art education of children in the primary grades.

312. ERMITE, KALOPHILE. "Chronique des arts: Galerie Durand-Ruel– peintures, pastels, dessins et gravures de Miss Mary Cassatt." *L 'Ermitage* 4:12(Dec. 1893):373.

313. FAXON, ALICIA. "New Light on Cassatt: Reviews." *Woman's Art Journal* (Fall 1985- Winter 1986):50-3.

314. FAXON, ALICIA. "Painter and Patron: Collaboration of Mary Cassatt and Louisine Havemeyer." *Woman's Art Journal* 3:2(Fall 1982-Winter 1983):15-20. 2 illus.

Describes the collaboration of Mary Cassatt and Louisine Havemeyer in the purchase of art works for museums in the U.S., including excerpts from their letters on the subject.

315. FENEON, FELIX. "Cassatt, Pissarro." *Chat Noir* (April 11, 1891):1728.

316. FINK, LOUIS MARIE. "Children as Innocence from Cole to Cassatt." *Nineteenth Century* 3:4(Winter 1977):71-5. 14 illus.

Discusses how the portrayal of children suffered a radical change in 19th century art and literature. From innocent and idealized depictions, their representation developed into more personal, adult, and realistic images, as in the works of Cassatt.

317. FITZGERALD, MICHAEL. "Beyond the Body." *Vogue* 186:10(Oct. 1996):331-5, 379. 2 illus.

Examines Degas' frequent depiction of women's bodies in bathing, dancing, or merely standing. Discusses how his obsession with the subject is even more pronounced in his later years. Mentions rumors of his relationship with Mary Cassatt.

318. FLINN, YEH S. "Mary Cassatt's Images of Women." *Art Journal* 35:4(1975):359-63. 6 illus.

319. FRASER, KENNEDY. "Patron Saints." *Vogue* 183:3(March 1993):428-9. 11 illus.

Describes the influence of Mary Cassatt on Louisine Havemeyer in collecting art of their time.

320. FULLER, SUE. "Mary Cassatt's Use of Soft-Ground Etching." *Magazine of Art* 43:2 (Feb. 1950):54-7.

Studies Cassatt's revolutionary use of soft-ground technique in her works.

321. GABHART, ANN and ELIZABETH BROUN. "Old Mistresses: Women Artists of the Past." *The Bulletin of the Walters Art Gallery* 24:7(April 1972):1-7.

322. GARDNER, PAUL. "What Would you ask Michelangelo?" *ARTnews* 85:9(Nov. 1986):96-102, illus.

Thirteen art historians submit questions they would ask an artist who has been a focus of their study. Includes Adelyn Breeskin's question to Mary Cassatt.

323. GARFINKLE, CHARLENE G. "Lucia Fairchild Fuller's 'Lost' Woman's Building Mural." *American Art* 7:1(Winter 1993):2-7. 5 illus.

Describes *The Women of Plymouth*, a mural painted by Lucia Fairchild Fuller for the World's Building at the 1893 World's Columbian Exposition in Chicago. This mural was thought to be lost, along with the five other murals, including one by Mary Cassatt.

324. GEFFROY, GUSTAVE. "Femmes artistes–un peintre de l'enfance—Miss Mary Cassatt." *Les Modes* 4:38(Feb. 1904):4-11.

325. GIESE, LUCRETIA H. "*A Visit to the Museum*." *Bulletin of the Museum of Fine Arts* 76(1978):43-53.

Discusses Degas' painting *A Visit to the Museum*, in the Museum of Fine Arts, Boston. Examines its dating, intention, and identification of sitters. Proposes Ellen André as the model for the standing woman, instead of Mary Cassatt, as previously thought.

326. GORDON, MARY. "Mary Cassatt." *Art & Antiques* (Dec. 1985):46-53.

327. GRABENHORST-RANDALL, TERRE. "The Woman's Building." *Heresies* 1:4(Winter 1978):44-6.

Study including floor plans of the Woman's Building in the World's Columbian Exposition in Chicago.

328. GRAFLY, DOROTHY. "In Retrospect—Mary Cassatt." *American Magazine of Art* 18:6 (June 1927):305-12. 8 illus.

Questions the categorization of Cassatt as an Impressionist, and discusses her relationship with Degas. Includes Mrs. Louisine Havemeyer's comments on Cassatt's life.

329. H., T. B. "The Degas-Cassatt Story." *ARTnews* 46:9(Nov. 1947):18-20, 52-3.

330. HALEVY, LUDOVIC. "Les Carnets de Ludovic Halévy." Rédaction par Daniel Halévy. *Revue des deux mondes* 37(15 Feb. 1937):823, 826.

331. HANKS, DAVID A. "American Paintings at the Art Institute of Chicago. Part II: The Nineteenth Century." *Antiques* 104:5(Nov. 1973):895-905, illus.

Describes the Art Institute's collection of 19th century American paintings, in which Cassatt is strongly represented.

332. HAVEMEYER, ANN. "Cassatt: The Shy American." *Horizon* 24:3 (March 1981):56-63. 9 illus.

Louisine Havemeyer's great granddaughter presents an overview of Cassatt's artistic career. Discusses her early interest in naturalism, her later use of bright colors, and further association with the Impressionists. Examines the influence of Degas and Japanese prints on her work, and speculates on the close friendship with Degas.

333. HAVEMEYER, LOUISINE W. "Courbet, Manet, Degas, and Mary Cassatt." *L'Oeil, Magazine International d'Art* 490(Nov. 1997):48-59. 10 illus.

334. HAVICE, CHRISTINE. "The Artist in her own Words." *Woman's Art Journal* 2:2(Fall 1981-Winter 1982):1-7.

Examines the lives of several women artists through their own writings and correspondence. Artists discussed include Berthe Morisot, Mary Cassatt, Cecilia Beaux, Rosa Bonheur, and Käthe Kollwitz among others.

335. HERZOG, MELANIE. "Intimacy in Pastel: Mary Cassatt." *School Arts* 91:1(Sept. 1991):31-4, illus.

Discusses Cassatt's use of pastel in her depictions of women and children. Analyzes the emotional bond represented in their interaction, and also discusses child art education.

336. HILLS, PATRICIA. "Turn of the Century America" *American Art Review* 4:4(Jan. 1978):66-73, 94-7. 14 illus.

Discusses major late 19th century realist painters, including Winslow Homer, Thomas Eakins, and Mary Cassatt. Examines the variety of artists who portrayed the social changes of the time, as seen in the Columbian Expositions from 1893 to 1908.

337. HOEBER, ARTHUR. "*The Century*'s American Artist Series: Mary Cassatt." *The Century* 57:5(March 1899):740-1.

338. HOOPES, DONELSON F. "American Impressionism." *Portfolio* 3:1(Jan.-Feb. 1981):52-61. 12 illus.

Discusses the development of Impressionism in America since its beginnings with exhibitions by Paul Durand-Ruel in New York in 1886. Mentions important artists including Whistler, Cassatt, and Hassam.

339. HORTON, J. "Japanese Influences on Western Art." *Artist* 97:1(Jan. 1982):20-3. 7 illus.

Examines the influence of Japan's Edo period on western art in the 1880s, primarily in the work of Impressionist artists such as Cassatt. Horton proposes that the main elements borrowed from Japanese art were the different use of perspective and the decorative quality found in Japanese prints.

340. HOWAT, JOHN K. "Mary Cassatt: *Lilacs in a Window* (*Vase de lilas à la fenêtre*)." *The Metropolitan Museum of Art Bulletin* 56:2(Fall 1998):58.

Presents the museum's new acquisition of Cassatt's painting dating to around 1880-83.

341. HUTH, HANS. "Impressionism Comes to America." *Gazette des Beaux-arts* 29(April 1946):225-56.

Scholarly narrative of the beginnings of Impressionism in America as well as early appreciation of Mary Cassatt's works.

342. HUTTON, JOHN. "Picking Fruit: Mary Cassatt's *Modern Woman* and the Woman's Building of 1893." *Feminist Studies* 20:2(Summer 1994):319-48.

Extensive analysis of Cassatt's mural *Modern Woman*, shown at the World's Columbian Exposition in 1893, Chicago. Asserts that Cassatt embodied the active role for women in society, through her use of bright colors and bold forms.

343. HYSLOP, FRANCIS E., JR. "Berthe Morisot and Mary Cassatt." *College Art Journal* 13:3(Spring 1954):179-84.

344. ISKIN, RUTH. "Mary Cassatt's Mural of *Modern Woman*." Paper presented at the College Art Association Conference, Washington, D.C., Jan. 1975.

345. IVES, COLTA FELLER. "The Great Wave: Translations from the Japanese." *ARTnews* 74:3(March 1975):30-5. 11 illus.

Compares Japanese depictions of the world of entertainment and daily pastimes to similar Impressionist representations. Shows illustrations and notes of works by Cassatt, Gauguin, Bonnard, and Toulouse-Lautrec.

346. IVES, COLTA FELLER. "Edgar Degas: The Painter as Printmaker." *The Print Collector's Newsletter* 16(March-April 1985):23-5.

347. IVINS, WILLIAM M., JR. "New Exhibition in the Print Galleries: Prints by Mary Cassatt." *Bulletin of the Metropolitan Museum of Art* 22:1(Jan. 1927):8-10.

348. JOHNSON, DEBORAH J. "Cassatt's Color Prints of 1891: The Unique Evolution of a Palette." *Source: Notes in the History of Art* 9:3(Spring 1990):31-9. 3 illus.

Analyzes Cassatt's etching and aquatint series, proposing that the color scheme was based on faded Japanese prints of the 1790s and from damaged Utamaro impressions available to her.

349. JOHNSON, PAUL. "Is it Getting Cold in that Bath, Madame Bonnard?" *The Spectator* 280(Mar. 1998):26.

Study of Mary Cassatt's major works.

350. JOHNSON, UNA E. "The Graphic Art of Mary Cassatt." *American Artist* 9:9(Nov. 1945):18-21.

Overview of Cassatt's career, influences, as well as subject and technique in her print work

351. JOHNSTON, PATRICIA. "Impressionist Mary Cassatt: A Philadelphia Artist Abroad." *American History Illustrated* 18(Dec. 1983):24-9. 7 illus.

Biographical study of Cassatt that discusses her most famous works.

352. JUDD, TULLY. "The Attraction of Prints." *Art and Auction* 21:14(April 1-14, 1999):44-51.

Discusses the art market and compares the prices of prints and paintings.

353. KARSHAN, DONALD. "American Printmaking, 1670-1968." *Art in America* 56:4(1968):22-55, illus.

Provides a historical overview of American printmakers and the state of printmaking in America, from its beginnings to the late 1960s. Mentions two American artists who left the country: Mary Cassatt and James McNeill Whistler. Includes a color reproduction of Cassatt's *Woman Bathing* (1891).

354. KARSHAN, DONALD. "U.S. Printmaking: From Realism to Abstraction." *Dialogue* 6:1(1973):51-61. 13 illus.

Traces the evolution of printmaking in the U.S. from early realistic woodcuts to avant-garde experiments with new materials and abstractions of the 1970s. Illustrates and discusses the works of a wide range of artists including Mary Cassatt.

355. KOTZ, MARY LYNN. "Art in the White House." *ARTnews* 93:7(Sept. 1994):138-43. illus.

Discusses the paintings selected by President and Hillary Rodham Clinton for display in their quarters and State offices, from the White House art collection. Analyzes the Clintons' choices, noting that Mrs. Clinton chooses mostly works by women artists, while Bill prefers historical subjects. Mentions Cassatt's *Young Mother and Two Children* (1908).

356. KYSELA, JOHN D., S.J. "Mary Cassatt's Mystery Mural and the World's Fair of 1893." *Art Quarterly* 29:2(1966):128-45. illus.

Documents the circumstances of Cassatt's commission, critical response to the mural, and information regarding its disappearance. Contains excellent reproductions and bibliographical sources.

357. LANT, ANTONIA "Purpose and Practice in French Avant-Garde Printmaking of the 1880's." *Oxford Art Journal* 6:1(1983):18-29. 10 illus.

Examines Impressionist printmaking, suggesting that the "snap-shot" technique seems to contradict the concept of the print. Lant proposes that Impressionism should be redefined to reflect the interest in recording various impressions of the same subject.

358. LLOYD, CHRISTOPHER. "Mary Cassatt." *Print Quarterly* 7:2(June 1990):196-7.

359. LOWE, DAVID. "Mary Cassatt." *American Heritage* 25:1(Dec. 1973):11-13, 21, 96-100. 6 illus.

Looks at the life and work of Cassatt, particularly in terms of Degas' influence on her work as well as details of important events in her life.

360. LOWE, JEANNETTE. "The Women Impressionist Masters: Important Unfamiliar Works by Morisot and Cassatt." *ARTnews* 38:5(4 Nov. 1939):9, 17.

Discusses Morisot's and Cassatt's lack of fame and recognition, with reference to a joint exhibition held at Durand-Ruel, New York.

361. LUCAS, E. V. "Mary Cassatt." *Ladies Home Journal* 44:27(Nov. 1927):24, 161.

Provides brief biographical sketch of Cassatt and mentions Achille Segard's 1913 biography of the artist.

362. MACCHESNEY, CLARA. "Mary Cassatt and Her Work." *Arts and Decoration* 3:8(June 1913):265-7.

363. MCCHESNEY, CLARA. "Mary Cassatt and Her Work." *Arts and Decoration* 3(June 1913):265-67.

364. MCCLELLAND, DONALD R. "Discoveries in American Art." *Studio International* 1005:197(1984):4-9. 13 illus.

Discusses art works from a variety of American artists, including Mary Cassatt, from the 18th century to the present. Mentions painters who specialized in portraits, landscapes, and abstract art and notes the influence of European Impressionism on them.

365. MARCUS, G. H. "Philadelphia and the Second Empire." *Philadelphia Museum of Art Bulletin* 322:74(Sept. 1978):2-8. 10 illus.

Compares Philadelphia to the second empire in France (1852-78), making reference to buildings built in the style of the Louvre in Paris. Mentions artists going to study in Paris, particularly Mary Cassatt and Thomas Eakins.

366. MARTINEZ, ANDREW. "A Mixed Reception for Modernism: The 1913 Armory Show at the Art Institute of Chicago." *Museum Studies* 19:1(1993):30-57. 19 illus.

Discusses the impact of the 1913 Armory Show in New York, the first exhibition of European modern art in the United States. Examines the reasons for the unwelcome

reception of modern art in Chicago in 1893, which included works by Cassatt among other artists.

367. "Mary Cassatt's Achievement: Its Value to the World of Art." *The Craftsman* 19:6(March 1911):540-6.

368. MATHEWS, NANCY MOWLL. "Beauty, Truth, and the Artist's Mirror: A Drypoint by Mary Cassatt." *Source: Notes in the History of Art* 4:2-3(Winter-Spring 1985):75-9. 3 illus.

Discusses Cassatt's *The Bonnet* (1890), an original portrayal of the "toilette" theme. Examines her use of the mirror as a reflection of ordinary subjects, and proposes the influence of Degas, Courbet, and Manet.

369. MATHEWS, NANCY MOWLL. "Mary Cassatt and the 'Modern Madonna' of the Nineteenth Century." Dissertation abstract in *Marsyas* 20(1979-80):89-90.

370. MAUCLAIR, CAMILLE. "Un peintre de l'enfance: Mary Cassatt." *L'Art décoratif* 4 (April 1902):177-85.

371. MAURIS, MAURICE. "The Fan." *Scribner's Monthly Magazine* 14:3(Sept. 1877):589-99.

372. MAUVIEUX, M. "Mary Cassatt" *Revue du Louvre et des Musées de France* 38:1(1988):66-7. Reprinted in *Nouvelles de l'estampe* 97(1988):31-2.

Reviews the Cassatt exhibition held at the Musée d'Orsay, Paris (7 March-5 June, 1988), with attention to her copper engravings.

373. MAZUR, MICHAEL. "The Case for Cassatt." *The Print Collector's Newsletter* 20:6(Jan.-Feb. 1990):197-201. 7 illus.

Discusses the importance of Cassatt's prints produced in collaboration with the printer Monsieur Leroy. Mazur argues that the set of ten prints (1891) may be her best print work, surpassing even Degas. Notes how at each stage of printing, Cassatt improved the images and showed the influence of Japanese art and Degas.

374. MEECH, PEKARIK J. "Early Collectors of Japanese Prints and the Metropolitan Museum of Art." *Metropolitan Museum of Art Journal* 17(1982):93-118.

History of how the Metropolitan Museum of Art, New York built its European and Japanese paintings collections at the end of the 19th and early 20th centuries. Discusses the Havemeyers' role in purchasing works upon the advice of Mary Cassatt.

375. MELLERIO, ANDRE. "Mary Cassatt." *L'Art et les artistes* 12(Nov. 1910):69-75.

376. MELOT, MICHEL. "Jean-François Raffaëlli, l'oublié (1850-1924)." *Nouvelles de l'estampe* 128(May 1993):19-30. 19 illus.

Overview of the life and career of the French engraver Jean-François Raffaëlli. Considers the style and working methods of the artist, and notes his association with the original Impressionist printmakers such as Mary Cassatt.

377. MERRICK, LULA. "The Art of Mary Cassatt: Talent, Intelligence, Industry and Poetic Feeling Have Placed an American Girl in the Front Rank of Contemporary Painters." *Delineator* 74:2(Aug. 1909):121-32.

378. MERRILL, RICHARD. "Mary Cassatt: American's First Lady of Art." *Mankind* 1:12(1969):62-5.

379. MILLER, FLORENCE F. "Art in the Women's Section of the Chicago Exhibition." *Art Journal* 45(1893)supp. 13-6.

380. MITCHELL, MARILYN HALL. "Sexist Art Criticism: Georgia O'Keeffe– A Case Study." *Signs* 3:3(1978):681-7.

Discusses the sexism in most art criticism, using Georgia O'Keeffe as an example. Notes how critics of O'Keeffe have not been as overtly sexist as critics of Mary Cassatt.

381. MOFFETT, CHARLES S. "Mr. and Mrs. H. O. Havemeyer as Collectors of Degas." *The Nineteenth Century Philadelphia* 3:1(1977):22-9.

Details the Havemeyers' collection of 105 Degas paintings and drawings, acquired from 1875 into the 1920s, on the advice of Mary Cassatt and willed to the Metropolitan Museum of Art, New York.

382. MORRIS, HARRIS S. "American Portraiture of Children." *Scribner's Monthly Magazine* 30:6(Dec. 1901):641-56.

383. NEVE, CHRISTOPHER. "Sit Still for Miss Cassatt: Mary Cassatt among the Impressionists." *Country Life* 153:3941(4 Jan. 1973):10-1. 3 illus.

Examines Cassatt's depictions of children and the relationship with their surroundings. Discusses the closeness between adults and children, and how Cassatt encouraged her friends to buy works from the Salon des indépendants.

384. NEWMAN, GEMMA. "Mary Cassatt: das Glück liegt im Gesicht eines Kindes." *ART: das Kunstmagazin* 3(March 1995):80-1. 2 illus., 1 col.

Considers Cassatt's *The Boating Party* (1893-4), describing the composition of the work and discussing the relationship between the male rower and the female passenger.

385. NOCHLIN, LINDA. "By a Woman Painted: Eight Who Made Art in the Nineteenth Century." *Ms.* 3(July 1974):68-75, 103. Col illus.

386. NOCHLIN, LINDA. "Why have there been no Great Women Artists?" *ARTnews* 69(January 1971):22-39, 67-71.

387. O'TOOLE, JUDITH HANSEN and CARLA S. HERLING. "Treasures from the Westmoreland Museum." *American Art Review* 11:1 (Jan./Feb. 1999):132-43.

Discusses works by artists of Western Pennsylvania in the museum collection, on occasion of the exhibition *A Feast for the Eyes: Treasures from the Westmoreland Museum of American Art* at the Woodmere Art Museum, Philadelphia.

388. "Our Art Clubs, III, The Society of American Artists." *Art Union* 2:4(1885):79. 12 illus.

Discusses Cassatt's membership in The Society of American Artists.

389. PEET, PHYLLIS. "The Art Education of Emily Sartain." *Woman's Art Journal* 11:1(Spring/Summer 1990):9-15. 9 illus.

Surveys Sartain's (1841-1927) life and work, focusing on her training in drawing at the Pennsylvania Academy (Philadelphia). Notes that her friendship with Cassatt ended over Cassatt's decision to follow Impressionism.

390. "Philadelphia: Three Centuries of American Art." *Antiques* 110:1(July 1976):136-45. 22 illus.

Presents reproductions of 19th century paintings, drawings, prints and sculptures by Philadelphian artists including Mary Cassatt.

391. PICA, VITTORIO. "Artisti contemporanei–Berthe Morisot e Mary Cassatt." *Emporium* 26:151(July 1907):3-16.

392. POHL, FRANCES K. "Historical Reality or Utopian Ideal? The Woman's Building at the World's Columbian Exposition, Chicago, 1893." *International Journal of Women's Studies* 5(Sept.-Oct. 1982):289-311.

393. POLLACK, BARBARA. "Misattributing Mary." *ARTnews* 95(May 1996):47.

Reports Sotheby's settlement reached with collector William C. Foxley. Foxley had sued Sotheby's in 1994 for the misattribution of Cassatt's *Lydia Reclining on a Divan*.

394. POLLOCK, GRISELDA. "The Gaze and the Look: Women with Binoculars, a Question of Difference" in *Dealing with Degas: Representations of Women and the Politics of Vision* (London: HarperCollins, 1992):106-30. 10 illus., 1 col.

Feminist and psychoanalytical study of the gaze of women and its implied sexual difference. Compares works by Cassatt and Degas.

395. POLLOCK, GRISELDA. "Modernity and the Spaces of Femininity" in *Expanding Discourse: Feminism and Art History* (NY: HarperCollins,1992):244-67.

Analyzes the subject of women as portrayed by Cassatt and Morisot. Examines the spaces

represented in their works, including mostly private and domestic areas. Compares these spaces with the bars and entertaining places depicted by male artists.

396. PRESTON, STUART. "The Confident Culture of Philadelphia." *Apollo* 175:104(Sept. 1976):198-207. 17 illus.

Reviews the exhibition *Philadelphia: Three Centuries of American Art* at the Philadelphia Museum of Art (1976), which illustrated the opulence of 18th and 19th century Philadelphian society. Cassatt is briefly mentioned.

397. QUINN, MICHAEL. "Concepts of Theatricality in Contemporary Art History." *Theatre Research International* 20:2(Summer 1995):106-13.

Discusses the idea of theatricality in modern art history. Discusses the image of the theatre in works by Cassatt, Manet, Degas, and Renoir.

398. RADYCKI, DIANE JOSEPHINE. "The Life of Lady Art Students: Changing Art Education." *Art Journal* 42:1(Spring 1982):9-13. 8 illus.

Considers the art education available for female art students at the turn of the century. Mentions how women artists of late 19th century "escaped the trap of the academy."

399. RAMBAUD, YVELING B. "Miss Cassatt." *Art dans les deux mondes* 1(Nov. 22, 1889):1, 7.

400. RAND, HARRY. "American Impressionism."*Arts Magazine* 50:9(May 1976):13. 1 illus.

Proposes that American Impressionism was not comparable to the French and was moving away from conservative art into a "dead end." Refers to painters including Cassatt.

401. REESE, ALBERT. "Whistleriana." *Print Quarterly* 8:3(Sept. 1991):291-3.

Compares the appraised 1941 prices of prints by artists including Cassatt to prices paid at auction from the 1970s through 1990.

402. RICHARDS, BILL. "Art Plight: The Philadelphia Triangle." *Art in America* 64:4(July-Aug. 1976):74-7. 7 illus.

Discusses the "strange disappearances" of artists and art institutions from Philadelphia, and the reasons behind them.

403. RICHARDS, LOUISE S. "Cassatt's Drawing of *The Visitor." Bulletin of the Cleveland Museum of Art* 65:8(Oct. 1978):268-77, 9 illus.

Account of Cassatt's prints and drawings, written in connection with the Cleveland Art Museum's acquisition of *The Visitor* (ca. 1880).

404. RICHARDSON, E. P. "Sophisticates and Innocents Abroad: Sargent, Whistler and Mary Cassatt in Metropolitan Loan Show." *Art News* 53(April 1954):20-3.

405. RIORDAN, ROGER. "Miss Mary Cassatt." *Art Amateur* 38:6(May 1898):130. 5 illus.

Discusses the Impressionist exhibitions at the National Academy of Design and The Society of American Artists.

406. RODRIGUEZ ROQUE, OSWALDO. "American Impressionist Paintings in the Collection of Dr. and Mrs. John J. McDonough." *Antiques* 128:5(Nov. 1985):1004-11. 16 illus., 11 col.

Discusses the McDonoughs' collection of American Impressionist paintings and outlines the history of American Impressionism through the works of artists including Mary Cassatt and others who worked in Paris in the 1870s and 1880s.

407. ROGER-MARX, CLAUDE. "Mary Cassatt et les femmes peintres." *Revue de Paris* 67 (Jan. 1960):45-9.

408. SAUVAGE, CLAUDE. "L'Impressionnisme." *Magazine d'art* 3:1(Sept. 1990):90-2. 2 col. illus.

Overview of the Impressionist movement and its emphasis on outdoor painting, the effects of light, and the importance of color over subject matter. Features major Impressionist artists, including Morisot and Cassatt.

409. SELLIN, DAVID. "The First Prose: Howard Roberts, Thomas Eakins, and a century of Philadelphia Nudes." *Philadelphia Museum of Art Bulletin* 70:311-12(Spring 1975):5-56. 47 illus.

Examines nudes in art and the influence of public attitude in America during the late 19th century. Among the careers of several artists, discusses the experience of Philadelphia art students in Paris, such as Mary Cassatt.

410. SILBERMAN, ANDREW. "Postal Inspiration." *Writer's Digest* 75:10(Oct 1995):6.

Writer Silberman draws inspiration from Wendell Wilkie and Mary Cassatt whenever he receives a rejected short story. Wilkie and Cassatt appeared on the postage stamps of the envelopes of his rejected stories.

411. SILVER, LARRY. "A New World-Masterpieces of American Painting, 1760-1910." *Pantheon* 42(April/June 1984):198-200.

412. SOREL, NANCY CALDWELL. "Edgar Degas and Mary Cassatt." *Atlantic Monthly* 272:5(Nov. 1993):137.

Briefly mentions Cassatt's relationship with Degas.

413. STANTON, HOWARD W. "Mother and Child, by Mary Cassatt." *Harper's Monthly Magazine* 123:736(Sept. 1911):596-7.

414. STEPHENS, HENRY G. "Impressionism: The Nineteenth-Century's Distinctive Contribution to Art." *Brush and Pencil* II:4(Jan. 1903):279-97.

415. STRAHAN, EDWARD. "Works of American Artists Abroad: The Second Philadelphia Exhibition." *Art Amateur* 6:1(Dec. 1881):4-6.

416. SUND, JUDY. "Columbus and Columbia in Chicago, 1893: Man of Genius meets Generic Woman." *The Art Bulletin* 75(Sept. 1993):443-66.

417. SUTTON, DENYS. "Degas and America." *Gazette des Beaux-arts* 116:1458-59(July-Aug. 1990):29-40. 12 illus.

Examines Degas's 1872-73 visit to America and the response of American critics. Degas spent several months in New Orleans, where he painted some important family portraits.

418. SWEET, FREDERICK A. "A Chateau in the Country." *Art Quarterly* 21:2 (Summer 1958):202-15.

419. SWEET, FREDERICK A. "Paintings and Pastels by Mary Cassatt in the Collection of the Art Institute and in Chicago Collections." *Museum Studies* 2(1967):32-49.

420. SYNDER-OTT, JOELYNN. "Women's Place in the Home (that she Built)" *Feminist Art Journal* 3:3(Fall 1974):7-8, 18. 3 illus.

Examines the representation of women artists in the World's Columbian Exhibition in Chicago. Mentions how Cassatt's two murals for the Women's Building were intended to promote the notion of women in the arts and sciences.

421. TARBET, URANIA-CHRISTY. "One Artist's Experience." *American Artist* 53:564(July 1989):36-7. 3 illus., 2 col.

Describes how Tarbet, a pastel artist, founded the Cassatt Pastel Society, which aims to help artists to gain professional recognition in galleries.

422. TEALL, GARDNER CALLAHAN. "Mother and Child: The Theme as Developed in the Art of Mary Cassatt." *Good Housekeeping* 50:2(Feb. 1910):141-6. 9 illus.

423. THORNE, ANNA LOUISE. "My Afternoon with Mary Cassatt." *School Arts* 59:9(May 1960):10-2.

The painter recounts conversations with Cassatt, at the end of her days in France.

424. TINTEROW, GARY and LOUISINE WALDRON ELDER HAVEMEYER. "Les Audaces de Mr. And Mrs. Havemeyer." *L'Oeil* 490(Nov. 1997):43-59.

Discusses Cassatt's influence on the acquisition of the Havemeyers' art collection, in light of an exhibition at the Musée d'Orsay, Paris, Fall 1997.

425. VENTURI, LIONELLO. "L'Impressionismo." *Arte* 6(March 1935):118-49.

426. VERMEULEN, M. "The Case of the Curious Cassatt ... or Elementary My Dear Watson." *New Art Examiner* 4:8(May 1977):1,8. 1 illus.

Details the story of the purchase of a drawing by Cassatt at an auction in Chicago. It was later determined not to be an original by Cassatt, because of major differences in pencil pressure, age of paper, and unknown identity stamp.

427. VINCENT, STEVEN. "Home Grown Impressionists." *Antique Collector* 66:8(Sept.-Oct. 1995):40-5.

Examines the new interest in American Impressionism among art collectors. Vincent notes that American Impressionism is not as unified as French Impressionism, and describes the work of the ten artists, including Mary Cassatt.

428. WADE, JENNIFER. "The Chosen Few: Women Painters of the 19th Century." *Art and Antiques* 4:1(1981):26-8, 108-9. 1 illus.

Describes current prices for works by professional female painters of the 19th century, including Mary Cassatt and Berthe Morisot among others.

429. WALTON, WILLIAM. "Miss Mary Cassatt." *Scribner's Monthly Magazine* 19:3(March 1896):353-61.

430. WARNER, TONY. "In Conversation: Mary Newcomb." *Artist* 108:6(June 1993):10-2.

Examines the work of Mary Newcomb, who credits artists such as Ben Nicholson, Mary Cassatt, and Milton Avery among the artists who have influenced her landscapes.

431. WEBSTER, SALLY. "Mary Cassatt's Allegory of Modern Women." *Helicon Nine* 1(Fall/Winter 1979):38-47.

Discusses Cassatt's mural painting for the Woman's Building at the World's Columbian Exposition in Chicago, 1893. Includes bibliography and reproductions of details of several scenes in the mural.

432. WEBSTER, SALLY. *The 'Ultra' Feminism of Mary Cassatt: Murals for the 1893 Woman's Building.* Paper presented at the College Art Association conference, Chicago, February 1992.

433. WEITENKAMPF, FRANK. "The Drypoints of Mary Cassatt. *Print Collector's Quarterly* 6:2(Dec. 1916):396-409.

Discusses Cassatt's prints in terms of technique, unique expression of subject matter, and composition.

434. WEITENKAMPF, FRANK. "Some Women Etchers." *Scribner's Monthly Magazine* 46:6(Dec. 1909):731-39.

435. WEITZENHOFFER, FRANCES. "Louisine Havemeyer and Electra Havemeyer Webb." *Antiques* 133:2 (Feb. 1988):430-37.

Accounts of the American art collectors Louisine Havemeyer and her daughter Electra Havemeyer Webb. Louisine was the first American collector of works by Degas and Cassatt, among other Impressionists.

436. WELCH, M. L. "Mary Cassatt." *American Society of the Legion of Honor Magazine* 25 (Summer 1954):155-65.

437. WELLS, WILLIAM. "Who was Degas' Lyda?" *Apollo* 95:120(Feb. 1972):129-34. 14 illus.

Discusses Degas' *Femme à la lorgnette* (1874) and the inscription "Lyda" above his signature. Proposes the possibility of it being Lydia, Mary Cassatt's sister.

438. WHITFORD, FRANK. "Behind Closed Doors." *Royal Academy Magazine* 47:(Summer 1995):32-9. 8 illus.

Discusses the exhibition *Impressionist and Post-Impressionist Paintings, from Manet to Gauguin: Masterpieces from Swiss Private Collections*, held at the Royal Academy's Sackler Galleries, London (30 June-8 Oct. 1995). It included works by Mary Cassatt among other artists.

439. WILMERDING, JOHN. "Harvard and American Art." *Apollo* 107:196(June 1978):490-5. 8 illus.

Describes Harvard College's collection of American art, including the works in the Fogg Museum and the University Portrait Collection. Discusses stylistic changes in painting during the second half of the 19th century, as seen in the works by artists including Cassatt.

440. WITHERS, JOSEPHINE. "Artistic Women and Women Artists." *Art Journal* 35:4(Summer 1976):330-6. 8 illus.

Provides a biographical overview of four 19th century women artists, and describes how they dealt with the traditional feminine role at the time. Artists discussed include Sophia Peabody Hawthorne, Lily Martin Spencer, Harriet Hosmer, and Mary Cassatt.

441. "Women in Pittsburgh." *Carnegie Magazine* 49:1(Jan. 1975):13-21.

Photographs of women active in various aspects of Pittsburgh life, from the collection of the Carnegie Library. Includes a photograph of Mary Cassatt.

442. "Women of Yesteryear." *Wall Street Journal* (Feb 4, 1993):A1.

Contends that the letters and writings by famous women such as Marie Antoinette, Virginia Wolf, Mary Cassatt, and Louisa May Alcott are gaining more attention from collectors.

443. "Women's Work in the Fine Arts. The Woman's Building." *Art Amateur* 29:1(1893):10.

Description of the Woman's Building at the Chicago's World Fair, designed by Sophia Hayden, with decorations by Mary Cassatt.

444. "The Work of Mary Cassatt." *Arts and Decoration* 17:5(Sept. 1922):377.

445. "Work of Miss Mary Cassatt, the American Painter Living in France, who is a Chevalier of the Legion of Honor." *New York Times Magazine* (Nov. 27, 1910):15.

446. "World's Fair Notes." *Studio* (new ser.) 7:29 (1892):263-5.

Discusses the fact that Cassatt and MacMonnies are to decorate the Woman's Building in the Chicago World's Fair, 1893.

447. YEH, SUSAN FILLIN. "Mary Cassatt's Images of Women." *Art Journal* 35:4(Summer 1976):359-63.

Discusses Cassatt's view of women as independents with individual interests. Works such as *At the Opera* (1880) and *Two Women; One Sketching* (1869) clearly depict female cultural independence and friendship between women. Also contrasts Renoir's *Madame Charpentier and her Daughters* (1878) with Cassatt's *Madame Meerson and her Daughters* (1899).

448. YOUNG, MAHONRI SHARP. "Gilbert Stuart to Stuart Davis." *Apollo* 204:109(Feb. 1979):145-9. 12 illus.

Discusses the collection of American paintings housed in the Honolulu Academy of the Arts. Briefly mentions Cassatt among various artists.

VI. Reproduction of Paintings

449. *Afternoon Tea Party* (1890-1). Art and Auction 21:12(Mar. 1-14, 1999):5.

450. *Agnes— age six. Antiques* 130(Dec. 1986):1111.

451. *Alexander J. Cassatt* (1888). *Art in America* 76(Sept. 1988):87; *Antiques* 134(Sept. 1988):353.

452. *Alexander J. Cassatt* (ca. 1880). *Bulletin of the Detroit Institute of Arts* 63:1/2(1987):cov.

453. *Antoinette at her Dressing Table* (ca.1909). *Antiques* 128(Nov. 1985):1004.

454. *Arrangement in Black, no. 8: Portrait of Mrs. Cassatt* (1993-86). *Antiques* 134(Nov. 1988):893.

455. *At the Opera* (1879). *Antiques* 126(Oct. 1984):669.

456. *Baby ... Held by Nurse* (ca. 1891). *Art and Antiques* (Nov. 1986):116.

457. *Baby in a High Bonnet* (ca. 1880). *Antiques* 152(July 1997):11.

458. *Baby John Asleep, Sucking his Thumb* (ca. 1910). *Antiques* 128(Oct. 1985):681; 130(Aug. 1986):237.

459. *Baby with Left Hand Touching Tub, Held by her Nurse* (ca. 1891). *ARTnews* 85(Summer 1986):35.

460. *Le Baiser maternal* (ca. 1896). *Antiques* 148(Sept. 1995):218.

461. *The Banjo Lesson* (ca. 1893). *Antiques* 126(Nov. 1984):964.

462. *The Bare Back* (ca. 1906). *Antiques* 126 (Nov. 1984):1102.

463. *The Bath* (1890-1). *Art and Auction* 21:7(Nov. 30-Dec. 13, 1998):5.

464. *The Bath* (1891-92). *ARTnews* 91(Nov. 1992):114.

465. *Bébé souriant à sa mère. Antiques* 150(Dec. 1996):747.

466. *Boy Wearing Beret and Spectacles* (ca. 1883). *Antiques* 128(Dec. 1985):1082.

467. *Breakfast in Bed* (1897). *Antiques* 130 (Aug. 1986):277.

468. *Buste de fillette* (ca. 1909). *Antiques* 128(July 1985):56.

469. *Children Playing with a Cat* (1908). *Art and Auction* 21:5(Nov. 2-15, 1998):17.

470. *Clarissa, Turned Left, with her Hand to her Ear* (1895). *Antiques* 132(Oct. 1987):682.

471. *Contemplation* (1890). *Art and Auction* 21:4(Oct. 19-Nov. 1, 1998):9.

472. *The Conversation. ARTnews* 83(Sept. 1984):107.

473. *The Crocheting Lesson* (ca. 1902). *Antiques* 137(May 1990):1031.

474. *The Cup of Tea* (1879). *Apollo* 123(June 1986):409.

475. *Ellen Seated Holding an Apple* (1899). *Antiques* 142(Sept. 1992):267.

476. *The Fitting* (1890-1). *Antiques* 152(Aug. 1997):137.

477. *Françoise Wearing a Big White Hat* (ca. 1908). *Antiques* 138(Nov. 1990):937.

478. *In the Omnibus* (1890-1). *Art on Paper* 3:5(May/June 1999):3.

479. *In the Opera Box* (ca. 1880). *Antiques* 137(Mar. 1990):599; *Apollo* 144(Sept. 1996):61.

480. *Jenny and her Sleepy Child* (ca. 1891). *Antiques* 131(Jan. 1987):6.

481. *Jeune mère cousant. L'Oeil* 490(Nov. 1997):59.

482. *The Lamp* (ca. 1891). *Art in America* 72(Sept. 1984):28.

483. *The Letter* (1890-1). *American Artist* 61(Mar. 1997):13.

484. *Little Girl in a Blue Armchair* (1878). *National Gallery of Art Annual Report* (1983):45.

485. *Little Girl in a Red Hat* (1898). *Antiques* 127(June 1985):1211.

486. *Little Girl with White Ruffled Yoke to her Dress* (ca. 1875). *ARTnews* 84(Oct. 1985):28; *Antiques* 128(Oct. 1985):581.

487. *Lydia Reclining on a Divan* (ca. 1881). *Art and Antiques* (Nov. 1987):5.

488. *The Mandolin Player* (ca. 1889). *Antiques* 133(April 1988):840.

489. *The Map: The Lesson* (1890). *Antiques* 134(Nov. 1988):1069.

490. *Maternal Caress. Art and Auction* 21:9(Jan. 1999):5.

491. *Mme Fontveille* (1902). *Antiques* 135 (Jan. 1989):116.

492. *Mother About to Wash her Sleepy Child* (1880). *Art in America* 73(Aug. 1985):35.

493. *Mother and Child* (ca. 1898). *Antiques* 133(Mar. 1988):541.

494. *Mother and Child* (1898). *ARTnews* 97:7(Summer 1998):46.

495. *Mother and Sara Admiring the Baby. Connoisseur* 214(Dec. 1984):70.

496. *Mother holding her Baby. Antiques* 146(Nov. 1994):623.

497.*Mother in Profile with Baby Cheek to Cheek: Number 2* (ca.1909). *Antiques* 140(Nov. 1991):744.

498. *Mother Jeanne Nursing her Baby* (1908). *Antiques* 131(Jan. 1987):187; *ARTnews* 85(Dec. 1986):64.

499. *Mother Looking Down, Embracing both her Children* (ca. 1908). *Antiques* 137(April 1990):768.

500. *Peasant Mother and Child. Bulletin, Los Angeles County Museum of Art* 28 (1984):38.

501. *Portrait of a French Woman (Countess Morel d'Arleux). Antiques* 154:4(Oct. 1998):452.

502. *Portrait of a Woman in a Dark Dress* (ca. 1879). *Antiques* 129(Jan. 1986):119; 133(April 1988):792; 141(Jan. 1992):8; *Art and Antiques* (April 1988):19.

503. *Portrait of Agnes—Age Six. Antiques* 128(Nov. 1985):863.

504. *Portrait of an Italian Lady (Madame Marie del Sarte). Antiques* 154:5(Nov. 1998):616.

505. *Portrait of Mrs. Currey; Sketch of Mr. Cassatt* (ca. 1871). *Antiques* 136(Nov. 1989):1036.

506. *Sara and her Mother with the Baby* (ca. 1901). *Antiques* 151(Jan. 1997):29; 143(Feb. 1993):231.

507. *Sarah in a Large Flowered Hat, Looking Right, Holding her Dog* (ca. 1901). *Art in America* 75(June 1987):7; *Antiques* 131(June 1987):1132.

508. *Sarah in a Bonnet With a Plum Hanging Down at Left (No. 1)* (ca. 1901). *Antiques* 155:2(Feb. 1999):251.

509. *Sarah Holding Cat. Antiques* 142(Nov. 1992):629.

510. *Sarah tenant son chien. Connaissance des arts* 433(March 1988):124.

511. *Self-Portrait. Studio International* 197:1005(1984):7.

512. *Self-Portrait* (ca. 1865). *Antiques* 155:1 (Jan. 1999):63.

513. *Self-Portrait* (ca. 1880). *American Artist* 61(Sept. 1997):45.

514. *Sewing in the Conservatory* (ca. 1895). *Burlington Magazine* 139(Nov. 1997):xxi; *ARTnews* 96(Nov. 1997):14.

515. *Simone assise, coiffée d'un chapeau à plume, tenant un chien griffon* (ca. 1903). *Connaissance des arts* 453(Nov. 1989):182.

516. *Simone in a White Bonnet* (ca. 1901-3). *Antiques* 133(Jan. 1988):29.

517. *Simone in an Armchair* (ca. 1903). *Antiques* 135(Mar. 1989):578; 147(Jan. 1995):58; *Art and Antiques* 18(June 1995):31; *Architectural Digest* 45(Nov. 1988):212.

518. *Sketch of Mrs. Currey; Sketch of Mr. Cassatt* (1871). *Antiques* 131(June 1987):1133.

519. *Sketch of Reine and Child* (ca. 1902). *Antiques* 147(Jan. 1995):72.

520. *Sleeping Baby* (1880). *Antiques* 146(Nov. 1994):599.

521. *Sleepy Baby* (ca. 1910). *Apollo* 139(Mar. 1994):73.

522. *The Stocking* (1890). *Antiques* 135(April 1989):907.

523. *Summertime: Woman and Child in a Rowboat* (1894). *Antiques* 128(Nov. 1985):816;
Burlington Magazine 128(Jan. 1986):62.

524. *Tea* (ca. 1890). *Antiques* 128(Nov. 1985):882.

525. *Tendresse maternelle* (ca. 1908). *Antiques* 135(Feb. 1989):373.

526. *Under the Horse Chestnut Tree* (ca. 1895). *Antiques* 136(Oct. 1989):711.

527. *Untitled: Electra Havemeyer Webb with her Mother Louisine Havemeyer* (1895). *Art
and Antiques* 20(Oct. 1997):86.

528. *Woman in Green Sewing* (1909). *Antiques* 129(June 1986):1137.

529. *Woman Reading, Lydia Cassatt* (1878). *Southwest Art* 15(Apr. 1986):81.

530. *Woman Sewing* (1913-14). *Antiques* 153:6(June 1998):789.

531. *Women Admiring a Child* (ca. 1897). *Apollo*:124(Dec. 1986):531.

532. *Young Girl Arranging her Hair* (1886). *Apollo* 144(Sept. 1996):10.

533. *Young Mother, Daughter, and Son* (1913). *Antiques* 134(Nov. 1988):1155.

534. *A Young Woman* (ca. 1898). *Antiques* 141(Jan. 1992):33.

VII. Films

535. *American Art at the Huntington.* Directed by Pamela Glintenkamp and Rik van
Glintenkamp. Chicago: Facets Multimedia, 1993. Videocassette. 15 min.

536. *American Art from the National Gallery.* Irvington, NY: The Voyager Company, 1993.
Videodisc.

Presents more than 3,000 works of American art from the National Gallery collection, in
Washington, D.C.
Review: *LaserDisc News* 110 (Oct. 1993):14.

537. *Art as an Emissary: The Armand Hammer Collection.* Directed by Geoffrey Drummond. NY: Saga Productions, 1977. Videocassette. 29 min., col. 16mm.

538. *The Artist was a Woman.* Directed by Suzanne Bauman. Columbus, OH: Coronet/MTI Film & Video, 1980. Videocassette. 58 min., col. 16mm.

Surveys the history of women artists in light of the exhibition *Women Artists, 1550-1950* held at the Los Angeles County Museum of Art in 1980. Shows works by several women artists, including Mary Cassatt, and includes stills of places where the artists worked. Narrated by Jane Alexander, includes interviews with art historians Linda Nochlin and Ann Sutherland Harris.
a. German language version (45 min.) also available.
Reviews: *National Catholic Newsletter; Los Angeles Times.*
Awards: American Film Festival Red Ribbon, 1981; CINE Golden Eagle, 1981; Columbus Intl. Film Festival Chris Statuette, 1981; American Women in Radio and Television Award, 1981.

539. *ARTV.* Directed by Bob Barnett and Brad Powell. Lincoln, NE: Great Plains National Instructional Television, 1989. Videocassette. 20 min., col. video.

540. *Carleton Watkins.* Directed by William Howze. Fort Worth: Amon Carter Museum, 1983. 5 min., col. video.

541. *Carlotta Corpron: Design with Light.* Fort Worth: Amon Carter Museum, 1980. 10 min., col. video.

542. *Cassatt.* (Awareness Films). Washington, D.C.: National Gallery of Art, Dept. of Education Resources, 1976. 5 min., col. 16mm.

543. *Charles M. Russell.* Directed by Joan Black and Mary Lampe. Fort Worth: Amon Carter Museum, 1984. Videocassette. 8 min., col. video.

Reviews: *Arts & Acts* 96:4(Dec. 1984):14; *Booklist* 81:1(1 Sept. 1984):76; *Choice* 22:2 (Oct. 1984):351; *EFLA* (Spring 1984):35; *Landers* 29:2 (Winter 1984):56.

544. *From Reliable Sources.* Directed by Robert Pierce. Washington, D.C.: Smithsonian Institution Office of Telecommunications, 1987. 26 min., col. video; 16mm.

Discusses the importance of the Archives of American Art as a national collection of original documentation of American artists and art. Shows correspondence housed in the archive by several artists including Mary Cassatt.
Review: *Library Journal* (1 March 1989)
Award: American Film & Video Festival Red Ribbon, 1988.

545. *The Graphic Techniques of Mary Cassatt.* Fort Worth: Amon Carter Museum, 1980. Videocassette. 8 min., col. video.

546. *Hunter Museum of Art.* Directed by Talley Rhodes. Chattanooga, TN: Hunter Museum

of Art, 1990. Videocassette. 8 min., col. video.

547. *Impressionism.* (Art History: A Century of Modern Art; No. 1) Directed by Carol Cornsilk. Bloomington, IN: Agency for Instructional Technology, 1988. Videocassette.15 min., col. video.

548. *In Open Air: A Portrait of the American Impressionists.* Directed by Roger Snodgrass. St. Louis: Phoenix Learning Group, 1982. Videocassette. 29 min., col. 16mm.

In English, with Bulgarian, French, German, and Romanian language versions also released. Discusses the development of Impressionist painting in the United States through such artists as Mary Cassatt, William Merritt Chase, Childe Hassam, and John Twachtman among others. Includes stills of their works, French Impressionist artists who inspired them, and interviews with art historians.
Reviews: *A Newsletter Called FRED* ...(Nov.-Dec. 1986); *Sightlines* (Winter 1985-86; *New York Times* (2 July 1986); *Landers Film Reviews* (Fall 1985); *EFLA Evaluations* (May-June 1983).
Awards: CINE Golden Eagle, 1982; Information Film Producers of America Cindy Bronze Award, 1982; Columbus International Film Festival Chris Bronze Plaque, 1982.

549. *The Legacy of Impressionism.* (Impressionist Art; Vol. 1) Directed by Karen Weintraub and Doris Hirsch. New York: Merit Audio Visual, 1991. Videocassette. 24 min., col. video.

550. *Lost Wax Bronze Casting.* Fort Worth: Amon Carter Museum, 1987. Videocassette. 7 min., col. video.

551. *Mary Cassatt: American Impressionist.* (The Artists' Specials). Produced and directed by Richard Mozer. HBO Television Productions, 1999.

Part of the occasional HBO television series, stars Amy Brenneman and contains references to Cassatt's work.
Review: C. James, *New York Times* (May 11, 1999); *Los Angeles Times* (May 11, 1999); *The Boston Herald* (May 11, 1999).

552. *Mary Cassatt: Learning to Draw Figures.* Glenview, IL: Crystal Productions. Videocassette. 53 min.

Part of a six-volume teaching aid for art education, and a teacher's guide. Introduces students grades 4-8 to Mary Cassatt and her work. Each videotape includes three art lessons.

553. *Mary Cassatt: Impressionist from Philadelphia.* Directed by Perry Miller Adato. Chicago: Home Vision, 1978. Videodisc. 30 min., col. 16mm; video; videodisc. (The Originals: Women in Art Series)

Portrays Cassatt through photographs, newspaper clippings, excerpts from letters, memoirs from her contemporaries and interviews with her niece, Mrs. Percy Madeira. Shows examples of her paintings, drawings, aquatints, and drypoints.
Reviews: *Los Angeles Times* (1 April 1987); *Video Insider* (15 Sept. 1986); *Chicago Sun*

Times (1 Aug. 1986); *Billboard* (19 July 1986).
Award: Women in Communication Clarion Award.

554. *Masterworks*. (Masterworks from Great Museums) Directed by Reiner Moritz. London: RM Associates/US, 1988. Videocassette. 10 min., col. 35mm; 16mm; video 1988. Produced in France, Germany, and Austria. In English, with French and German language versions also available.

555. *Memories of Monet*. Directed by Meredith Martindale and Toby Molenaar. Greenwich, CT: artsAmerica, 1984. Videocassette. 28 min., col. 16mm; video 1984.

Portrays the friendship between Monet and the American artist Lilla Cabot Perry (1848-1933), who spent many summers in Giverny, France. Discusses the effects of light on various subjects such as haystacks, Rouen cathedral, the Japanese bridge, waterlillies, and mornings on the Seine. Includes works by Mary Cassatt and Berthe Morisot. Based on an article in the *American Magazine of Art*, 1927.
Reviews: *EFLA evaluations* (Summer-Fall 1985); *Library Journal* (Dec. 1985); *Booklist* (1 Nov. 1985); *Media & Methods* (Sept.-Oct. 1985); *Sightlines* (Summer-Fall 1985); *A Newsletter Called FRED* ... 13:6; *New York Times* (19 July 1984); *East Hampton Star* (9 Aug. 1984).
Awards: American Film Festival Blue Ribbon, 1985; Paris Festival International du Film d'art Historique Documentary Prize, 1985; *Booklist* Editor's Choice, 1985; CINE Golden Eagle, 1984.

556. *The Wet Plate Photography Process*. Directed by William Howze. Fort Worth: Amon Carter Museum, 1983. Videocassette. 4 min., col. vide.

557. *Woman as Painter*. Jackson: Mississippi ETV, 1983. Videocassette. 29 min., col. video.

VII. Individual Exhibitions

1891, April Paris, Galerie Durand-Ruel. *Exposition de tableaux, pastels, et gravures par Mlle Mary Cassatt*. 10 color prints, 2 oils, 2 pastels.

1893, 27 Paris, Galerie Durand-Ruel. *Exposition de tableaux, pastels, et*
November-16 *gravures par Mlle Mary Cassatt*. Preface by André Mellerio. 40
December p., illus. 16 oils, 14 pastels, 14 color prints, 50 drypoints, 1 lithograph.

 a. U.S. ed.: *Mary Cassatt*. NY: Garland, 1981.
 Review: A. Mellerio, *Modern Art* 3:1(1895):4-5.

1895, 16-30 April	New York, Durand-Ruel Gallery. *Exposition of Paintings, Pastels, and Etchings by Miss Mary Cassatt.* 4 p., illus. 26 paintings, 9 pastels, 18 prints, 1 gouache.
	Reviews: *Collector* 6:12(1895):198-202; *Art Amateur* 32:6(1895):158.
1898, February-March	New York, Durand-Ruel Gallery. *Exhibition of Paintings, Pastels, and Drypoints by Mary Cassatt.*
1898, 21 March-8 April	Boston, St. Botolph Club. *An Exhibition of Paintings, Pastels, and Etchings by Miss Mary Cassatt.*
1903, November	New York, Durand-Ruel Gallery. *Mary Cassatt.* 15 paintings, 10 pastels.
1906, 12-31 December	New York, Durand-Ruel Gallery. *Paintings, Pastels, and Etchings by Mary Cassatt.*
1907	New York, Durand-Ruel Gallery.
1907	Paris, Galerie Ambroise Vollard. *Exposition des tableaux et pastels par Mary Cassatt.*
1907-08, December-January	Manchester, England, City of Manchester Art Gallery. *Exposition des impressionnistes.*
1908, 3-28 November	Paris, Galerie Durand-Ruel. *Tableaux et pastels par Mary Cassatt.* 23 paintings, 22 pastels.
1909, 8-20 February	Boston, St. Botolph Club. *Pictures by Mary Cassatt.*
1910, March	Paris, Galerie Durand-Ruel. *Exposition de peintures de Mary Cassatt.*
1914, 8-27 June	Paris, Galerie Durand-Ruel. *Tableaux, pastels, dessins et pointes-sèches par Mary Cassatt.* 109 works.
1915, 5-20 April	New York, Durand-Ruel Gallery. *Exhibition of Water Colors and Drypoints by Mary Cassatt.* 81 works.
1917, 21 April-5 May	New York, Durand-Ruel Gallery. *Exhibition of Paintings by Mary Cassatt.* 20 paintings.
1920, 15 November-4 December	New York, Durand-Ruel Gallery. *Exhibition of Paintings and Pastels by Mary Cassatt.* 25 works.
1921, 28 January-26 February	New York, Grolier Club. *Etchings by Mary Cassatt.* Also shown Chicago, The Art Institute (Sept. 1922).
1922, January-February	New York, The Metropolitan Museum of Art. *Five Paintings, Four Pastels, and Etchings by Mary Cassatt.*

1923, 28 April	New York, Durand-Ruel Gallery. *Exhibition of Paintings, Pastels, Drypoints, and Watercolors by Mary Cassatt.* 72 works.
1923, 31 October- 9 December	Cleveland, Cleveland Museum of Art. *Etchings, Drypoints, and Drawings by Mary Cassatt.*
1924, March	Paris, Galerie Durand-Ruel. *Exposition de tableaux et pastels par Mary Cassatt.*
1924, 1 May	New York, Durand-Ruel Gallery. *Exhibition of Paintings and Pastels by Mary Cassatt.*
1926, 23 October- 12 November	New York, Durand-Ruel Gallery. *Exhibition of Paintings and Pastels by Mary Cassatt.* 1 vol., unpaged.
1926-27, 21 December-24 January	Chicago, The Art Institute. *Memorial Collection of the Works of Mary Cassatt* . 13 p., 5 illus.
1927, 30 April-30 May	Philadelphia, Philadelphia Museum of Art. *The Cassatt Exhibition.* Review: L. Havemeyer, *The Pennsylvania Museum Bulletin* 22:113(May 1927):373-82; F. Watson, *The Arts* 11(June 1927):288-97.
1928, 15 March- 15 April	Pittsburgh, Carnegie Institute, Department of Fine Arts. *A Memorial Exhibition of the Work of Mary Cassatt.* 16 p.
1931, 19 May-30 June	Paris, Galerie A. M. Reitlinger. *Dessins, pastels, peintures, études par Mary Cassatt.* 1 vol., unpaged, illus.
1933-34, 30 December-28 January	St. Louis, City Art Museum. *Exhibition of Oils and Pastels by Mary Cassatt.* 4 p. 20 works.
1935, 11 February-2 March	New York, Durand-Ruel Gallery. *Exhibition of Paintings and Pastels by Mary Cassatt.* 6 p., illus., port.
1936, 7 January- 10 February	Baltimore, Museum of Art. *An Exhibition of Pastels, Watercolors, Pencil Drawings, Soft-etchings, Aquatints, Color Prints, Drypoints, Etc. by Mary Cassatt.* Catalogue by Adelyn D. Breeskin. 24 p., illus.
1939, 13 May-10 June	Haverford, Haverford College, The Union. *The Mary Cassatt Exhibition Presented by the Haverford College Art Committee.* Foreword by J. Stogdell Stokes. Note of acknowledgment by Alexander J. Williamson, a "Glance in Retrospect" by Christian Brinton.
1941-42, 28 November-11 January	Baltimore, Museum of Art. *Mary Cassatt: The Catalogue of a Comprehensive Exhibition of her Work.* Catalogue by Adelyn Dohme Breeskin. 36 p., illus.

1947, 29 October- New York, Wildenstein Gallery. *A Loan Exhibition of Mary*
6 December *Cassatt for the Benefit of the Goddard Neighborhood Center.* 51
 p., illus. Exhibition and catalogue organized and prepared by
 Vladimir Visson and Daniel Wildenstein, assisted by Miss Ima N.
 Elbin.

1953, June-July London, England, Marlborough Fine Arts Ltd. *Mary Cassatt.*

1959-60, 25 Paris, Centre culturel américain. *Mary Cassatt, peintre et graveur,*
November-10 *1844-1926.* 24 p., illus., 9 col. pl. Paris: Les Presses Artistiques,
January 1959. Preface by Frederick A. Sweet.

1960, 22 April-29 Philadelphia, Philadelphia Museum of Art. *Checklist of Mary*
May *Cassatt Exhibition.* 6 p.

1965, 20 Chicago, International Galleries. *Mary Cassatt, 1844-1926:*
November-21 *Retrospective Exhibition.* Catalogue by Frederick A. Sweet and
December S. E. Johnson. 64 p., illus., some col.

1965, June-July Beauvais, France. Musée départemental de l'Oise, Palais
 épiscopal. *Hommage à Mary Cassatt.* Catalogue by Simone
 Cammas and Monique Quesnot. 25 p., col. illus.

1966, 1-26 Washington, D.C., Smithsonian Institution. *The Paintings of*
February *Mary Cassatt.* A benefit exhibition for the development of the
 National Collection of Fine Arts, Smithsonian Institution,
 Washington D.C. Catalogue by Adelyn Dohme Breeskin. NY:
 Knoedler Galleries, 1966. 56 p., illus. Also shown New York,
 Knoedler Galleries.

1967, 30 July-20 Southampton, New York, Parrish Art Museum. *Miss Mary*
August *Cassatt: Paintings and the Graphic Arts.* 8 p., 8 plates, 2 col.

1967-68 New York, Museum of Graphic Art. *The Graphic Art of Mary*
 Cassatt. Catalogue and introduction by Adelyn Dohme Breeskin,
 foreword by Donald H. Karshan. NY: Museum of Graphic Art,
 1967. 112 p., illus.

 Exhibition organized by the Museum of Graphic Art, New York.
 Included seven participating museums. Contains glossy black-
 and-white reproductions of 82 of Cassatt's prints.

1970, 27 Washington, D.C., National Gallery of Art. *Mary Cassatt, 1844-*
September- 8 *1926.* Exhibition catalogue by Adelyn Dohme Breeskin. 119 p.,
November chiefly illus., some col.

 Review: R. Drexler, *Life* 69(30 Oct. 1970):10.

1974, 10 May-2 Grand Rapids, MI, Grand Rapids Art Museum. 6 p.
June

| 1974, 26 October-1 December | Staten Island Institute of Arts and Sciences, NY. *Mary Cassatt: Selected Works from the Metropolitan Museum of Art.* 1 leaf, illus. |

1974, 26 October-
1 December

Staten Island Institute of Arts and Sciences, NY. *Mary Cassatt: Selected Works from the Metropolitan Museum of Art.* 1 leaf, illus.

1975

West Somerville, MA, Gropper Art Gallery. *25 Etchings by Mary Cassatt.* 26 p., illus.

1978, 24
February-30 April

Washington, D.C., National Collection of Fine Arts, Smithsonian Institution. *Mary Cassatt, Pastels and Color Prints.* Published by the Smithsonian Institution Press for sale by the Supt. of Documents, U.S. Government Printing Office, 1978. 38 p., 52 illus., some col.

1978, 5 August-24
September

Boston, Museum of Fine Arts. *Mary Cassatt at Home.* Catalogue by Barbara Stern Shapiro. 16 p., illus., some col.

Review: J. Russell, *Art in America* 66:6(Nov.-Dec. 1978):97-9.

1981,11 June-7
July

Tokyo, Isetan Museum of Art. *The Art of Mary Cassatt (1844-1926).* Also shown Nara, Nara Prefectural Museum of Art (18 July- 23 August, 1981). Organized by the American Federation of Arts, New York. Catalogue edited by the Cultural Project Department, the Asahi Shimbun. Tokyo: Asahi Shimbun, 1981. 125 p., 65 illus., 60 col. Text in Japanese and English.

a. U.S. ed.: *Art of Mary Cassatt (1844-1926).* New York: American Federation of Arts, 1981. 100 p., illus., some col. Review: I. Takahasi, *Mizue* 916 (July 1981):70-83.

1981-82

Mary Cassatt: Graphic Art. Catalogue by Adelyn Dohme Breeskin. Washington, D.C.: Published for the Smithsonian Institution Traveling Exhibition Service, by Smithsonian Institution Press, 1981. 62 p., 49 illus., 9 col.

Catalogue of a traveling exhibition shown in six U.S. museums.

1983, 4 June-3
September

Charleston, WV, Sunrise Museums. *Mary Cassatt, Impressionist from Philadelphia.* A guide to the exhibition. 12 p., illus., 1 col.

1984, 3-27
October

New York, Coe Kerr Gallery. *Mary Cassatt: An American Observer.* A Loan Exhibition for the Benefit of the American Wing of the Metropolitan Museum of Art. Exhibition catalogue by Warren Adelson and Donna Seldin. 48 p., col. illus.

1985, 17
February-14 April

Philadelphia, Philadelphia Museum of Art. *Mary Cassatt and Philadelphia.* Exhibition catalogue by Suzanne G. Lindsay. 96 p., illus., some col.

Illustrates the importance of Cassatt's work in Philadelphia. Contains previously unpublished materials located in archives and family records. Includes a chronology, genealogy table, and references to entries in Breeskin's catalogue raisonné.

1988,7 March-5 June

Paris, Musée d'Orsay. *Mary Cassatt*. Catalogue by Martine Mauvieux. Paris: Réunion des Musées Nationaux, 1988. 64 p., illus, 11 col. (Les Dossiers du Musée d'Orsay, 21)

1989-90, 18 June-21 January

Washington, DC., National Gallery of Art. *Mary Cassatt, the Color Prints*. Also shown Boston, Museum of Fine Arts (9 Sept.-5 Nov. 1989); Williamstown, MA, Williams College Museum of Art (24 Nov. 1989-21 Jan. 1990). Catalogue by Nancy Mowll Mathews and Barbara Stern Shapiro. NY: H. N. Abrams in association with Williams College Museum of Art. 207 p., illus., some col.

Examines in detail the 1890-91 series of prints. Reproductions have description of each print state, location of signatures, watermarks, and notes on design.
Reviews: C. Lloyd, *Print Quarterly* 7:2(June 1990):196-7; N. M. Mathews, *Antiques* 136:4(Oct. 1989):860-71; N. M. Mathews, *The Chronicle of Higher Education* 36:13(Nov. 1989):64; D. Johnson, *Burlington Magazine* 132:1042(Jan. 1990):72-3.

1993, 19 February-9 May

Ottawa, National Gallery of Canada. *Mary Cassatt: Colour Prints: the Drummond Bequest*. Organized by the National Gallery of Canada.

1997-98, Winter

Chicago, R. S. Johnson Fine Art. *Mary Cassatt: Retrospective Exhibition*. Chicago: R. S. Johnson Fine Art, 1997. 120 p., illus., some col.

1998-99, 10 October-6 September

Chicago, Art Institute. *Mary Cassatt, Modern Woman*. NY: Art Institute of Chicago, in association with Abrams, 1998. 378 p., illus. Also shown Boston, Museum of Fine Arts (Feb.14-May 9, 1999), Washington, D.C., National Gallery of Art (June 6-Sept.6, 1999). Catalogue by Judith A. Barter, with contributions by Erica E. Hirshler, George T. M. Shackelford, Kevin Sharp, Harriet K. Stratis, and Andrew J. Walker.

First major retrospective of Cassatt's works in 30 years. Included six essays and reproduces 300 works, 124 in color. Catalogue contains chronology, list of exhibitions, and maps showing locations of where Cassatt lived in Paris and France. Bibliography, pp. 363-73.
Reviews: Greenberg, *Art Newspaper* 10:85(Oct. 98):31; Holg, *ARTnews* 97:2(Feb. 98):127; *Library Journal* (Jan. 1999):90; E. L. Moss, *American Artist* 63:683(June 1999):80; C. Little, *Art New England* 20:3(Apr./May 1999):20-1.

1998-99, 20 October-24 January	New York, Metropolitan Museum of Art. *Mary Cassatt: Drawings and Prints in the Metropolitan Museum of Art.*

Reviews: C. Bindman, *Art On Paper* 3:4(Mar./Apr. 1999):60-1.

IX. Selected Group Exhibitions

1868	Paris, Palais des Champs-Elysées, *Salon.*
1870	Paris, Palais des Champs-Elysées, *Salon.*
1872	Paris, Palais des Champs-Elysées, *Salon.*
1872, 26 August	Milan, Esposizione di belle arti di Milano.
1873	Paris, Palais des Champs-Elysées, *Salon.*
1873	Vienna, Weltausstellung, American Dept., Gallery of Fine Arts.
1873, June-July	Philadelphia, Bailey & Co.
1873, 3 September-4 October	Cincinnati, Cincinnati Industrial Exposition. *Exhibition of Paintings, Engravings, Drawings, and Works of Household Art.*
1874	Paris, Palais des Champs-Elysées, *Salon.*
1874, May	New York, National Academy of Design. *Forty-ninth Annual Exhibition of the National Academy of Design.*
1876	Paris, Palais des Champs-Elysées, *Salon.*
1875	Paris, Palais des Champs-Elysées, *Salon.*
1876, 24 April-end May 1876.	Philadelphia, Pennsylvania Academy of the Fine Arts. *Forty-seventh Annual Exhibition.*
	Review: *Art Journal* 2:7(1876):222-3.
1877, January	Philadelphia, Pennsylvania Academy of the Fine Arts. *Exhibition of Choice Paintings Loaned from Private Galleries of Philadelphia and Hans Makart's Great Picture of "Venice Paying Homage to Caterina Cornaro."*
1878	Philadelphia, Earle's Gallery.
	Boston, Massachusetts Charitable Mechanics Association. *Thirteenth Exhibition. M.F.A.*
1878, March	New York, National Academy of Design. *Fifty-third Annual Exhibition of the National Academy of Design.*

1878, 1 May-November	Paris, Palais du Champ de Mars, Galerie de beaux-arts. *Exposition universelle.*
1878, 22 April-2 June	Philadelphia, Pennsylvania Academy of the Fine Arts. *Forty-ninth Annual Exhibition.*
1879, 10-29 March	New York, Kurtz Gallery. *Society of American Artists' Second Exhibition.*
	Review: S. N. Carter, *Art Journal* 5:5(1879):156-8.
1879, 10 April-11 May	Paris, *Fourth Impressionist Exhibition.* Catalogue par M. Bracquemond, Mlle Cassatt, MM. Degas, Forain, Lebourg, Monet, Pissarro. Paris: Morris père et fils, 1879. 18 p.
1879, 28 April-end May	Philadelphia, Pennsylvania Academy of the Fine Arts. *Fiftieth Annual Exhibition.*
1880, February-March	New York, National Academy of Design. *Thirteenth Annual Exhibition of the American Water Color Society.*
1880, 1-30 April	Paris, *Fifth Impressionist Exhibition.*
1881, 2 April-1 May	Paris, *Sixth Impressionist Exhibition.* Catalogue par Mlle Mary Cassatt, MM. Degas, Forain ... Gauguin, Guillaumin, Mme. Berthe Morisot, MM. Pissarro, Raffaëlli, Rouart ... Paris: Morris père et fils, 1881. 15 p.
1882	London, White Gallery. *The Impressionists.*
1883, November	Berlin, Galerie Fritz Gurlitt. *Kunstausstellung: Die Pariser Impressionisten.*
1883, May-August	London, Dowdeswell and Dowdeswell. *Paintings, Drawings, and Pastels by Members of "La Société des Impressionistes."*
1884, January	Paris, *Exposition du Cercle artistique de la Seine.*
1885, 29 October-10 December	Philadelphia, Pennsylvania Academy of the Fine Arts. *Fifth-sixth Annual Exhibition.*
	Review: *Art Union* 2:5 (1885):104.
1886, 10-28 April	New York, National Academy of Design. *Works in Oil and Pastel by the Impressionists in Paris.*
1886, 15 May-15 June	Paris, *Eighth Impressionist Exhibition.* Catalogue par Mlle Marie Bracquemond, Mlle Mary Cassatt, MM. Degas, Forain, Gauguin, Guillaumin, Mme. Berthe Morisot ... Paris: Morris père et fils, 1886. 20 p.
1887-88	*The Work of the Women Etchers of America.* Also shown New York, Union League (April 1888).

1889, 23 January- 14 February	Paris, Galerie Durand-Ruel. *Exposition des peintres-graveurs.*
1889, 30 October- 11 November	Copenhagen, Société Artistique. *Impressionnistes scandinaves et français.*
1890, 6-26 March	Paris, Galerie Durand-Ruel. *Deuxième exposition de peintres-graveurs.*
1891, October- November	New York, Frederick Keppel and Co.
1891	New York, Woman's Art Club of New York. *2ⁿᵈ Exhibition.*
	Review: *Collector* 2:9(1891):107.
1892, 1-10 February	Brussels, *Les XX, Bruxelles neuvième exposition annuelle.*
1892, 5-25 December	New York, Galleries of the American Fine Arts Society. *Retrospective Exhibition of the Society of American Artists.*
	Review: *Studio (New Series)* 7:13(1892):117.
1893, May- November	Chicago, World's Columbian Exposition, Woman's Building.
	Included Cassatt's mural *Modern Woman.*
1894	Saint Louis, Saint Louis Exposition. *11ᵗʰ Annual Fine Arts Exhibition of the St. Louis Exposition and Music Hall Association.*
	Cassatt listed as exhibiting drypoints. Review: H.R.H., *Arts for America* 3:4 (1894):123-4.
1894, 13 February	New York, Klackner's Gallery, Woman's Art Club of New York. *Fifth Annual Exhibition.*
	Review: *Art Amateur* 30:4(1894):102.
1894, 1 November-1 December	New York, National Academy of Design. *Portraits of Women.* Loan Exhibition for the Benefit of St. John's Guild and the Orthopaedic Hospital.
1895, 17 February	New York, Klackner's Gallery, Woman's Art Club Show.
	Review: *Art Amateur* 32:4 (1895):106.
1896	New York, Woman's Art Club.
	Review: *Monthly Illustrator and Home and Country* 12:2(1896):vi, viii, x.

1897-98, 4
November-1
January

Pittsburgh, Carnegie Institute. *Second Annual Exhibition.*

1898, 10 January-
22 February

Philadelphia, Pennsylvania Academy of the Fine Arts. *Sixty-seventh Annual Exhibition.*

1898

New York. *New York Water-Color Club Annual Exhibition.*

Included works by M. Louise Stowell, Charles H. Pepper, Mary Cassatt, W. Shirlaw, and Sarah C. Sears.
Review: *Art Amateur* 40:1(1898):10-11.

1898, 21 May-5
July

Cincinnati, Cincinnati Museum Association, Art Museum. *Fifth Annual Exhibition of Works by American Artists.*

1898-99, 3
November-1
January

Pittsburgh, Carnegie Institute. *Third Annual Exhibition.*

Review: F.B. Sheafer, *Brush and Pencil* 5:3(1899):125-37.

1899, 16 January-
25 February

Philadelphia, Pennsylvania Academy of the Arts. *Sixty-eighth Annual Exhibition.*

1899-90, 2
November-1
January

Pittsburgh, Carnegie Institute. *Fourth Annual Exhibition.*

1900, 15 January-
24 February

Philadelphia, Pennsylvania Academy of the Fine Arts. *Sixty-ninth Annual Exhibition.*

1900, 19 May-9
July

Cincinnati, Cincinnati Art Museum. *Seventh Annual Exhibition of American Art in the Museum.*

Review: *Brush and Pencil* 6:4 (1900):180-90.

1900-01, 1
November-1
January

Pittsburgh, Carnegie Institute. *Fifth Annual Exhibition.*

Review: A. E. Howland, *Brush and Pencil* 7:3(1900):129-46. 22 illus.

1901, 24 January-
23 February

Philadelphia, Pennsylvania Academy of the Fine Arts. *Seventieth Annual Exhibition.*

Review: M.E. Wright, *Brush and Pencil* 7:5(1901):257-76. 21 illus.

1901, 18 May-8
July

Cincinnati, Cincinnati Museum. *Eighth Annual Exhibition of American Art.*

1901, 3 June-14
October

Worcester, Worcester Art Museum. *Third Annual Exhibition of Oil Paintings.*

1901-02, 7 November-1 January	Pittsburgh, Carnegie Institute. *Sixth Annual International Exhibition.*
1902, 20 January-1 March	Philadelphia, Pennsylvania Academy of the Fine Arts. *Seventy-first Annual Exhibition.*
1902, 29 May-15 September	Worcester, Worcester Art Museum. *Fourth Annual Exhibition of Oil Paintings.*
1903, 19 January-28 February	Philadelphia, Pennsylvania Academy of the Fine Arts. *Seventy-second Annual Exhibition.*
1903, 2-25 April	Paris, Galerie Bernheim-Jeune et fils. *Exposition d'œuvres de l'Ecole impressionniste.*
1903, 1-14 December	New York, National Art's Club. *Thirteenth Annual Exhibition of the Woman's Art Club.*
	Review: *Brush and Pencil* 13:4(1904):313-22. 5 illus.
1904, 25 January-5 March	Philadelphia, Pennsylvania Academy of the Fine Arts. *Seventy-third Annual Exhibition.*
	Review: A. Z. Bateman, *Brush and Pencil* 13:5 (1904):386-404.
1904, 21 May-11 July	Cincinnati, Cincinnati Museum. *Eleventh Annual Exhibition of American Art.*
1904, 29 May-26 September	Worcester, Worcester Art Museum. *Seventh Annual Exhibition of Oil Paintings.*
1904, 20 October-27 November	Chicago, The Art Institute. *Seventeenth Annual Exhibition of Oil Paintings and Sculpture by American Artists.*
1905, Jauary-February	London, New Gallery. *Pictures, Drawings, Prints, and Sculpture at the Fifth Exhibition of the International Society of Sculptors, Painters, and Gravers.*
1905, 23 January-4 March	Philadelphia, Pennsylvania Academy of the Fine Arts. *Centenary Exhibition.*
	Review: H. W. Henderson, *Brush and Pencil* 15:3 (1905):145-55. 21 illus.
1905, 20 March-16 April	Philadelphia, Pennsylvania Academy of the Fine Arts and the Philadelphia Water Color Club. *Second Annual Philadelphia Water Color Exhibition.*
1905, 11 May-11 June	Chicago, The Art Institute. *Seventeenth Annual Exhibition of Water Colors, Pastels, and Miniatures by American Artists.*

1905, 2 June-24
September

Worcester, Worcester Art Museum. *Eighth Annual Exhibition of Oil Paintings.*

1905, 20
November-17
December

Philadelphia, Art Club of Philadelphia. *Seventeenth Annual Exhibition of Oil Paintings and Sculpture.*

1906, 19 March-
15 April

Philadelphia, Art Club of Philadelphia. *Fifteenth Annual Exhibition of Water Colors and Pastels.*

1906, April 17

New York, National Arts Club. *Woman's Art Club Annual Exhibition.*

1906, 19 May-16
July

Cincinnati, Cincinnati Art Museum. *Thirteenth Annual Exhibition of American Art.*

1906, 19
November-16
December

Philadelphia, Art Club of Philadelphia. *Eighteenth Annual Exhibition of Oil Paintings and Sculpture.*

1907, 21 January-
24 February

Philadelphia, Pennsylvania Academy of the Fine Arts. *One-hundred-second Annual Exhibition.*

1907, 7 February-
9 March

Washington, D.C., Corcoran Gallery of Art. *First Annual Exhibition.*

Review: F.M.S., *Brush and Pencil* 19:3(1907):84-94. 25 illus.

1907, 4-31 March

Philadelphia, Art Club of Philadelphia. *Sixteenth Annual Exhibition of Water Colors and Pastels.*

1907, 1-27 April

Philadelphia, Pennsylvania Academy of the Fine Arts and the Philadelphia Water Color Club. *Fourth Annual Philadelphia Water Color Exhibition.*

1907, 11 April-13
June

Pittsburgh, Carnegie Institute. *Eleventh Annual Exhibition.*

1907, 31 October-
8 December

Buffalo, Buffalo Fine Arts Academy. *Exhibitions of Paintings by the French Impressionists.*

1907-08,
December-January

Manchester, England, City of Manchester Art Gallery. *Exhibition of Modern French Paintings.*

1908, 24 March-
15 April

Paris, Galerie Ambroise Vollard.

1908, 13 April-30
June

Pittsburgh, Carnegie Institute. *Twelfth Annual Exhibition.*

1908, 16
November-20
December

Philadelphia, Art Club of Philadelphia. *Nineteenth Annual Exhibition.*

1908-09, 6 December-4 January	Indianapolis, John Herron Art Institute. *Twenty-fourth Annual Exhibition of Paintings.*
1908-09, 8 December-17 January	Washington, D.C., Corcoran Gallery of Art. *Second Exhibition: Oil Paintings by Contemporary American Artists.*
1909, 13 March-17 April	New York, National Academy of Design. *Eighty-fourth Annual Exhibition.*
1909, 29 April-30 June	Pittsburgh, Carnegie Institute. *Thirteenth Annual Exhibition.*
1909, 10 May-30 August	Buffalo, Buffalo Fine Arts Academy. *Fourth Annual Exhibition of Selected Paintings by American Artists.*
1909, 28 May-19 September	Worcester, Worcester Art Museum. *Twelfth Annual Exhibition of Oil Paintings.*
1909, 19 October-28 November	Chicago, The Art Institute. *Twenty-second Annual Exhibition of Paintings and Sculpture by American Artists.*
1909, 8 November-19 December	Philadelphia, Pennsylvania Academy of the Fine Arts and the Philadelphia Water Color Club. *Seventh Annual Philadelphia Water Color Exhibition.*
1910, 23 January-20 March	Philadelphia, Pennsylvania Academy of the Fine Arts. *One-hundred-fifth Annual Exhibition.*
1910, March-April	Berlin, Königliche Akademie der Künste zu Berlin. *Ausstellung Amerikanischer Kunst.* Also shown, Munich (May 1910).
1910, 2 May-30 June	Pittsburgh, Carnegie Institute. *Fourteenth Annual Exhibition.*
1910, 11 May-1 September	Buffalo, Buffalo Fine Arts Academy. *Fifth Annual Exhibition of Selected Paintings by American Artists.*
1910, 15 September-15 November	St. Louis, City Art Museum. *Fifth Annual Exhibition of Selected Paintings by American Artists.*
1910, 18 October-27 November	Chicago, The Art Institute. *Twenty-third Annual Exhibition of Oil Paintings and Sculpture by American Artists.*
1910, 17 November-18 December	Philadelphia, Pennsylvania Academy of the Fine Arts and the Philadelphia Water Color Club. *Eighth Annual Philadelphia Water Color Exhibition.*
1910-11, 13 December-22 January	Washington, D.C., Corcoran Art Gallery. *Third Exhibition: Oil Paintings by Contemporary American Artists.*

1911, 3-21 January	New York, Durand-Ruel Gallery.
1911, 5 February- 26 March	Philadelphia, Pennsylvania Academy of the Fine Arts. *One-hundred-sixth Annual Exhibition.*
1911, 11 February-5 March	Washington, D.C., Corcoran Art Gallery. *Special Exhibition of Paintings by the Masters of the Modern French School.*
1911, 27 April-21 May	New York, American Watercolor Society, American Fine Arts Galleries. *Forty-fourth Annual Exhibition.*
1911, 27 April-30 June	Pittsburgh, Carnegie Institute. *Fifteenth Annual Exhibition.*
1911, 12 May-28 August	Buffalo, Buffalo Fine Arts Academy. *Sixth Annual Exhibition of Selected Paintings by American Artists.*
1911, 20 May-22 July	Cincinnati, Cincinnati Art Museum. *Eighteenth Annual Exhibition of American Art.*
1911, 28 May-18 September	Worcester, Worcester Art Museum. *Fourteenth Annual Exhibition of Oil Paintings by American Painters.*
1911, 17 September-17 November	St. Louis, City Art Museum. *Sixth Annual Exhibition of Selected Paintings by American Artists.*
1911, 14 November-27 December	Chicago, The Art Institute. *Twenty-fourth Annual Exhibition of Oil Paintings and Sculpture.*
1912, 4 February- 24 March	Philadelphia, Pennsylvania Academy of the Fine Arts. *One-hundred-seventh Annual Exhibition.*
1912, 25 April-30 June	Pittsburgh, Carnegie Institute. *Sixteenth Annual Exhibition.*
1912, 21 May-2 September	Buffalo, Buffalo Fine Arts Academy. *Seventh Annual Exhibition of Selected Paintings by American Artists.*
1912, 25 May-27 July	Cincinnati, Cincinnati Art Museum. *Nineteenth Annual Exhibition of American Art.*
1912, 7 June-15 September	Worcester, Worcester Art Museum. *Fifteenth Annual Exhibition of Oil Paintings.*
1912, 15 September	St. Louis, City Art Museum. *Seventh Annual Exhibition of Selected Paintings by American Artists.*
1912, 5 November-8 December	Chicago, The Art Institute. *Twenty-fifth Annual Exhibition of Oil Paintings and Sculpture.*

1912, 1 June Paris, Hôtel des Modes. *Exposition d'art moderne.*

1912-13, 17
December-26
January Washington, D.C., Corcoran Art Gallery. *Fourth Exhibition: Oil Paintings by Contemporary American Artists.*

1913, 15
February-18 May New York, 69th Street Armory. *International Exhibition of Modern Art (Armory Show).* Also shown Chicago, The Art Institute of Chicago (24 Mar.-16 Apr.); Boston, Copley Hall (28 April-18 May).

1913, 24 April-30
June Pittsburgh, Carnegie Institute. *Seventeenth Annual Exhibition.*

1913, 24 May-26
July Cincinnati, Cincinnati Art Museum. *Twentieth Annual Exhibition of American Art.*

1913, 14
September St. Louis, City Art Museum. *Eighth Annual Exhibition of Selected Paintings by American Artists.*

1913, 14
November-25
December Chicago, The Art Institute. *Twenty-sixth Annual Exhibition of American Oil Paintings and Sculpture.*

1914, 30 April-13
June Pittsburgh, Carnegie Institute. *Eighteenth Annual Exhibition.*

1914, 23 May-31
July Cincinnati, Cincinnati Art Museum. *Twenty-first Annual Exhibition of American Art.*

1914, 6 September St. Louis, City Art Museum. *Ninth Annual Exhibition of Selected Paintings by American Artists*

1914-15, 15
December-24
January Washington, D.C., Corcoran Art Gallery. *Fifth Exhibition: Oil Paintings by Contemporary American Artists.*

1915, 7 February-
28 March Philadelphia, Pennsylvania Academy of the Fine Arts. *One-hundred-tenth Annual Exhibition.*

1915, 6-24 April New York, M. Knoedler and Co. *Loan Exhibition of Masterpieces by Old and Modern Painters for the Benefit of Woman Suffrage.* 18 works by Cassatt.

1915, 22 May-31
July Cincinnati, Cincinnati Art Museum. *Twenty-second Annual Exhibition of American Art.*

1915, 22 May-30
August Buffalo, Buffalo Fine Arts Academy. *Tenth Annual Exhibition of Selected Paintings by American Artists.*

1915, 12
September St. Louis, City Art Museum. *Tenth Annual Exhibition of Selected Paintings by American Artists.*

1915, 7
November-12
December

Philadelphia, Pennsylvania Academy of the Fine Arts, Philadelphia Water Color Club, and the Pennsylvania Society of Miniature Painters. *Thirteenth Annual Philadelphia Water Color Exhibition and the Fourteenth Annual Exhibition of Miniatures.*

1915-16, 16
November-2
January

Chicago, The Art Institute. *Twenty-eighth Annual Exhibition of American Oil Paintings and Sculpture.*

1916, 6 February-
26 March

Philadelphia, Pennsylvania Academy of the Fine Arts. *One-hundred-eleventh Annual Exhibition.*

1916, 27 May-31
July

Cincinnati, Cincinnati Art Museum. *Twenty-third Annual Exhibition of American Art.*

1916, 3 September

St. Louis, City Art Museum. *Eleventh Annual Exhibition of Selected Paintings by American Artists.*

1916, 2
November-7
December

Chicago, The Art Institute. *Twenty-ninth Annual Exhibition of American Oil Paintings and Sculpture.*

1916-17, 17
December-21
January

Washington, D.C., Corcoran Art Gallery. *Sixth Exhibition: Oil Paintings by Contemporary American Artists.*

1917, 4 February-
25 March

Philadelphia, Pennsylvania Academy of the Fine Arts. *One-hundred-twelfth Annual Exhibition.*

1917, 12 May-17
September

Buffalo, Buffalo Fine Arts Academy. *Eleventh Annual Exhibition of Selected Paintings by American Artists.*

1917, 4
November-9
December

Philadelphia, Pennsylvania Academy of the Fine Arts, Philadelphia Water Color Club, and the Pennsylvania Society of Miniature Painters. *Fifteenth Annual Philadelphia Water Color Exhibition and the Sixteenth Annual Exhibition of Miniatures.*

1919, 16 April-31
May

Detroit, Detroit Museum of Art. *Fifth Annual Exhibition of Paintings by American Artists.*

1919, 24 May-8
September

Buffalo, Buffalo Fine Arts Academy. *Thirteenth Annual Exhibition of Selected Paintings by American Artists and a group of Small Selected Bronzes by American Sculptors.*

1919, October-
November

Paris, Musée National du Luxembourg. *Exposition d'artistes de l'école américaine.*

1919, 9
November-14
December

Philadelphia, Pennsylvania Academy of the Fine Arts, Philadelphia Water Color Club, and the Pennsylvania Society of Miniature Painters. *Seventeenth Annual Philadelphia Water Color Exhibition and the Eighteenth Annual Exhibition of Miniatures.*

1919-20, 21 December-25 January	Washington, D.C., Corcoran Art Gallery. *Seventh Exhibition: Oil Paintings by Contemporary American Artists.*
1920, February	New York, Durand-Ruel Gallery. *Etchings and Drawings.*
1920, 17 April-9 May	Philadelphia, Pennsylvania Academy of the Fine Arts. *Exhibition of Paintings and Drawings by Representative Modern Masters.*
1920, 29 April-30 June	Pittsburgh, Carnegie Institute. *Nineteenth Annual Exhibition of Paintings.*
1920, 20 May-31 July	Cincinnati, Cincinnati Art Museum. *Twenty-seventh Annual Exhibition of American Art.*
1921, 28 April-30 June	Pittsburgh, Carnegie Institute. *Twentieth Annual International Exhibition of Paintings.*
1921, 7-21 April	Dallas, Dallas Art Association, Adolphus Hotel. *Second Annual Exhibition of American and European Art.*
1921-22, 18 December-22 January	Washington, D.C., Corcoran Art Gallery. *Eighth Exhibition of Oil Paintings by Contemporary American Artists.*
1922, 3 February-4 March	New York, Frederick Keppel and Co. *Modern Prints by Daumier, Delacroix, Degas, Forain, Manet, Corot, Millet, Pissarro, Cézanne, Steinlen, John, Cassatt, Davies.* 13 works.
1922, 27 April-15 June	Pittsburgh, Carnegie Institute. *Twenty-first Annual International Exhibition of Paintings.*
1922, 9 April-12 June	Buffalo, Buffalo Fine Arts Academy. *Sixteenth Annual Exhibition of Selected Paintings by American Artists and a group of Small Selected Bronzes by American Sculptors.*
1922, 3 May-3 June	Paris, Galerie Paul Rosenberg. *Exposition d'œuvres de grands maîtres du dix-neuvième siècle.*
1922, 18 June-31 July	Pittsburgh, Carnegie Institute. *Exhibition of Art and Science in Gardens.*
1923, 26 June-21 July	London, M. Knoedler and Co. *Nineteenth-Century French Painters.*
1923-24, 16 December-20 January	Washington, D.C., Corcoran Art Gallery. *Ninth Exhibition of Contemporary American Oil Paintings.*
1925, 23 May-31 July	Cincinnati, Cincinnati Art Museum. *Thirty-second Annual Exhibition of American Art.*
1925, 29 October-13 December	Chicago, The Art Institute. *Twenty-eighth Annual Exhibition of American Paintings and Sculpture.*

1926, 4 April-16 May Washington, D.C., Corcoran Art Gallery. *Tenth Exhibition of Contemporary American Oil Paintings.*

1926, 25 April-21 June Buffalo, Buffalo Fine Arts Academy. *Twentieth Exhibition of Selected Paintings by American Artists.*

1930, 20 October-10 November New York, Durand-Ruel Galleries. *Exhibition of Paintings by Mary Cassatt and Berthe Morisot.* 8 p., illus., some col.

1933, 1 June-1 November Chicago, The Art Institute. *Catalogue of a Century of Progress: Exhibition of Paintings and Sculpture, Lent from American Collections.* 120 p., illus.

1936, April-May London, Ernest Brown & Phillips, The Leicester Galleries. *Catalogue of an Exhibition of Paintings by Sisley, Renoir, Pissarro, Monet, Boudin, Cassatt.* 11 p.

1937 New York, Brooklyn Museum. *Leaders of American Impressionism: Mary Cassatt, Childe Hassam, John H. Twachtman, J. Alden Weir.* 43 p., illus.
Another ed.: 1974.

1951, October Pasadena, Calif., Pasadena Art Institute. *Mary Cassatt and Her Parisian Friends.* Catalogue by John Palmer Leeper, in *The Bulletin of the Pasadena Art Institute* 2(Oct. 1951):1-9. Lists 48 works by Cassatt.

1953, 4-25 January Utica, NY, Munson Williams Proctor Institute. *Expatriates: Whistler, Cassatt, Sargent.* 8 p., illus., some col.

1954, 14 January-25 February Chicago, Art Institute. *Sargent, Whistler and Mary Cassatt.* Also shown NY, Metropolitan Museum of Art (25 March-23 May). Exhibition catalog by Frederick A. Sweet. 104 p., illus., some col.

Review: *ARTnews* 53:2(April 1954):21-3, 61-2.

1959, 7 March-5 April Palm Beach, FL, Society of the Four Arts. *Loan Exhibition of Works by John Singer Sargent and Mary Cassatt.* 22 p., illus.

1961, 7-25 November New York, Hirschl & Adler Galleries. *The American Painting Collection of the Montclair Art Museum.* 68 p., illus., some col.

1962, 18 April-3 June Baltimore, Baltimore Museum of Art. *Paintings, Drawings, and Graphic Works by Manet, Degas, Morisot, and Cassatt.* 62 p., 143 illus., some col. Foreword by Adelyn Dohme Breeskin.

1962, 10-30 April South Hadley, MA, Dwight Art Memorial, Mount Holyoke College. *Women Artists in America Today: A Loan Exhibition.* Introduction by Jean C. Harris. 30 p., illus.

Sponsored by the Mount Holyoke Friends of Art and the 125th Anniversary Special Events Committee.

1963

New York. *Armory Show: 50ᵗʰ Anniversary Exhibition.* Organized by Munson-Williams-Proctor Institute, sponsored by the Henry Street Settlement. NY: Henry Street Settlement; Utica: Munson-Williams-Proctor Institute, 1963. 212 p., illus., some col.

1969, 10 April-1 June

Omaha, Joslyn Art Museum. *Mary Cassatt Among the Impressionists.* 80 p., illus., some col. Catalogue and short essay by Adelyn Dohme Breeskin and William A. McGonagle.

1970-71, 30 November-10 January

Washington, D.C., National Gallery of Art. *Great American Paintings from the Boston and Metropolitan Museums National Gallery of Art.* Also shown City Art Museum, St. Louis (28 Jan.-7 Mar., 1971); Seattle Art Museum (25 Mar.-9 May, 1971). Catalogue by Thomas N. Maytham. 163 p., illus., some col.

1972, 17 November-10 December

Paris, Société des Peintres-graveurs français. *53e Exposition.* Précédé de hommage à Mary Cassatt. Bibliothèque Nationale, Galerie Mansart. Paris: Presses Artistiques, 1972. 69 p., illus.

1973, 1 July-26 August

Washington, D.C., National Gallery of Art. *American Impressionist Painting.* Also shown NY, Whitney Museum (18 Sept.-2 Nov., 1973), Cincinnati (15 Dec. 1973-31 Jan. 1974), Raleigh, North Carolina Museum of Art. Catalogue by Moussa M. Domit. Washington, D.C.: Smithsonian Institution, National Gallery of Art, 1973. 156 p., 81 illus.

Reviews: M. S. Young, *Apollo* 140:98(Oct. 1973):308-10; B. Forgey, *ARTnews* 72:7(Sept. 1973):24-7.

1976, 4 July-8 August

Memphis, Dixon Gallery and Gardens. *Mary Cassatt and the American Impressionists, a Loan Exhibition Commemorating the 50ᵗʰ Anniversary of Mary Cassatt's Death and the American Bicentennial Celebration.* Catalogue by Michael Milkovich. 33 p., 33 illus., 2 col.

1981, 9 February-8 February

Andover, MA, Addison Gallery of American Art. *Mary Cassatt, James A. McNeill Whistler, John Singer Sargent.* Essay by Christopher C. Cook. 6 p., illus.

1981, 15 October-15 December

San Jose, San Jose Museum of Art. *Mary Cassatt and Edgar Degas.* Essays by Nancy Mowll Mathews. 36 p., illus., some col.

1984, 17 June-21 October

Lausanne, Foundation de l'Hermitage. *L'Impressionnisme dans les collections romandes.* 199 p., illus.

1986

New York, Berry Hill Galleries. *American Paintings IV.* 107 p., col. illus.

1986, 17 January- Washington, D.C., National Gallery of Art. *The New Painting:*
6 July *Impressionism, 1874-1886.* Also shown San Francisco, Fine Arts
 Museums of San Francisco, M. H. DeYoung Memorial Museum
 (19 Apr.-6 July). Catalogue by Charles Moffett. San Francisco:
 The Museums, 1986. 507 p., illus., some col.

1988, 7 March-5 Paris, Musée d'Orsay. *Mary Cassatt.* Organized in association
June with Bibliothèque Nationale, Paris. Catalogue by Martine
 Mauvieux. Paris: Réunion des Musées Nationaux, 1988. 64 p.,
 56 col. illus. (Les Dossiers du Musée d'Orsay: 21)

1988, 25 October- *American Masterworks on Paper, 1800-1960.* NY: Susan
23 December Sheehan, 1988. 96 p., chiefly illus.

1989 Beverly Hills, Louis Newman Galleries. *In Black and White:*
 Selected American Drawings and Prints. Part I, Whistler, Homer,
 Cassatt, Glackens, Sloan, Lewis, Bellows, Hopper, Marsh,
 Bishop, Cadmus. 1 vol., illus.

1989-90, 7 New York, Metropolitan Museum of Art. *Revivals and*
October-14 *Revitalizations: American Pastels in the Metropolitan Museum of*
January *Art.* Catalogue by Doreen Bolger. 250 illus, 35 col.

 Includes two essays discussing the increased use of pastel and
 technique in late 19th century American art, as in the works of
 Cassatt, Whistler, and O'Keeffe among others.

1990, Spring Lugano, Switzerland, Villa Favorita. *Masterworks of American*
 Impressionism. Catalogue by William H. Gerdts. Lugano,
 Switzerland: Thyssen-Bornemisza Foundation; distributed by
 Harry N. Abrams, New York, 1990. 163 p., 79 illus., 66 col.

 Presents the work of 25 Impressionists from the Thyssen-
 Bornemisza collection, one of the most significant collections of
 American art in Europe. Includes 3 color reproductions by
 Cassatt, with brief criticism.

1993, 27 March- New York, The Metropolitan Museum of Art. *Splendid Legacy:*
20 June *The Havemeyer Collection.* Exhibition catalogue by Alice Cooney
 Frelinghuysen, et al. 432 p., 392 illus., 176 col.

 Review: A. C. Frelinghuysen, *Connaissance des arts* 494(Apr.
 1993):27-34. 6 illus.

1993-94, 13
October-15
January

Paris, Musée Marmottan. *Les Femmes impressionistes: Mary Cassatt, Eva Gonzalès, Berthe Morisot*. Also shown Tokyo, Isetan Bijutsukan (2 Mar-11 Apr 1995); Hiroshima, Hiroshima Bijutsukan (16 Apr-21 May, 1995); Osaka, Takashimaya 7-kai Gurando Horu (31 May- 13 June, 1995); Hakodate, Hokkaidoritsu Hakodate Bijutsukan (1 July-20 Aug, 1995). Catalogue preface by Arnaud d'Hauterives. Paris: Bibliothèque des Arts, 1993. 174 p., illus. 90 works exhibited.

a. Another ed.: Japan: Art Life, 1995. 157 p., col. illus.
Reviews: M. T. Lewisry, *Art Journal* 53:3 (Fall 1994):90-2; A. Riding, *New York Times* (28 October 1993):C15+; P. Piguet, *L'Oeil* 457(Dec. 1993):91.

1995, 30 June-8
October

London, Royal Academy's Sackler Galleries. *Impressionist and Post-Impressionist Paintings, from Manet to Gauguin: Masterpieces from Swiss Private Collections.*

Discusses how the exhibition included works rarely seen in public, and how the works which came from various private Swiss collections were relatively inexpensive to acquire at the time. Brief mention of Cassatt as part of the exhibition.
Review: F. Whitford, *Royal Academy Magazine* 47:(Summer 1995):32-9; illus.

1998, 24 January-
5 April

Philadelphia. Museum of Art. *Paris in the 1890s: Painters' Prints in the Age of Bonnard, Vuillard, and Toulouse-Lautrec.* Catalogue by John Ittman. Philadelphia: Museum of Art, 80 p., illus, some col.

Includes criticism and reproduces four of Cassatt's prints.

Berthe Morisot

Biography

You can hardly conceive how surprised we all were and how moved, too, by the disappearance of this distinguished woman, who had such a splendid feminine talent and who brought honor to our Impressionist group which is vanishing– like all things. Poor Mme Morisot, the public hardly knows her!

> – Camille Pissarro to his son Lucien,
> shortly after Berthe Morisot's death
> in 1895.

Berthe Morisot was at the heart of the circle of artists who initiated Impressionism and was considered the quintessential Impressionist by contemporary critics such as Paul Mantz and Théodore Duret. Morisot exhibited in seven of their eight exhibitions, missing only the 1879 show due to an illness following the birth of her daughter Julie. She was directly involved in the organization of these shows and promoted the group's aesthetic and political agenda. Her work was handled by the Impressionist dealer Paul Durand-Ruel and her home was a gathering place for intellectuals and artists such as Stéphane Mallarmé, Manet, Monet Degas, Renoir, Fantin-Latour, Puvis de Chavannes, and fellow woman Impressionist Mary Cassatt. Only she and Monet adhered to Impressionism throughout their careers.

Morisot had an impeccable artistic pedigree and credentials. She studied with Corot, Oudinot, Daubigny, Daumier, and Aimée Millet; married Edouard Manet's brother Eugène; and was purportedly a granddaughter of Fragonard. The third daughter of a high-ranking civil servant whose career took the family throughout France (Valenciennes, Bourges– where Berthe was born in 1841, Limoges, Caen, Rennes, and finally to Paris in 1851), Morisot and her older sister received drawing lessons as a birthday present from their father in 1857. The following year she and her sister Edma studied under Joseph-Benoit Guichard, a pupil of Ingres and Delacroix, and registered as copyists at the Louvre. Although the official art schools were closed to women then, through private tuition Berthe and Edma received an unusually serious art education. The Morisot sisters met Corot in 1861 and began to paint *en plein air* at Pontoise and in Normandy and Brittany. Morisot exhibited at the official Salon from 1864 to 1868 and received favorable reviews.

In early 1868, Henri Fantin-Latour introduced her to Edouard Manet. She posed for

his painting *On the Balcony* and became a close friend for life. He critiqued her art and so admired her early masterpiece, *The Harbour at Lorient* (1869), that she gave it to him. In 1870, Manet produced a full-length portrait of Berthe (*Repose*); a later portrait, *Berthe Morisot with a Black Hat and Violets* (1872), was ranked by Paul Valéry as among Manet's finest work. The same year she produced perhaps her best-known painting, *The Cradle*. Considerable conjecture surrounds their relationship. The two families were close and there is evidence of intellectual teasing and shared confidences. Edouard was married at the time and apparently sought a compromise of sorts by urging her to marry his lackluster brother Eugène, an amateur painter and writer, which she did after much indecision in 1874. To his credit, Eugène recognized and supported his wife's talent and respected her standing as an established artist.

That same year she turned her back on the Salons and aligned herself decisively with the Impressionist avant-garde. In March 1874, she was rejected by the Salon and six weeks later she submitted nine works to the first Impressionist exhibition, which garnered mixed reviews from the mostly hostile press. For the next decade Morisot was firmly entrenched in Impressionism's inner circle, organizing exhibitions and promoting its aesthetics and artists. In 1875, she met Stéphane Mallarmé, an impoverished English teacher and nascent Symbolist poet. Mallarmé called almost daily at Manet's studio and became friendly with and supportive of Morisot. In March 1875, Morisot participated with Renoir, Monet, and Sisley in an auction at Hôtel Drouot of 70 works (Berthe sent a dozen). Spurred on by negative critics, a bellicose crowd gathered to jeer. According to one account, Berthe was called a "harlot." In response, Camille Pissarro slugged the perpetrator and the auctioneer, Charles Pillet, had to call in the police. The sale was a financial and critical disaster, although Berthe's works averaged 250 francs and marginally topped the others.

The publicity surrounding the first three Impressionist exhibitions (1874, 1876, and 1877) and the quartet's auction at Drouot's catapulted Berthe Morisot in the eyes of critics, collectors, and the public. In 1878, Manet's friend Théodore Duret published his *Les Peintres impressionnistes* (Paris: Librairie Parisienne), the first articulate defense of the group. In it, he classes Morisot with Monet, Renoir, Sisley, and Pissarro as a "true painter of light." Her daughter Julie was born in late 1878. During her confinement and prolonged recovery, she met Mary Cassatt, Degas' protégée. The two women Impressionists were never intimate and for some time rivalry and jealousy were said to prevail. Her relationship with her brother-in-law became even closer until Edouard's death at age 51 in 1883. The two artists shared models and inspiration for compositions.

In 1881, the Eugène Manets moved to Bougival, a fashionable riverside town close to Paris; later that year she painted in Nice. Morisot was a devoted mother who frequently sketched and painted her daughter. As the art world changed and Impressionism began to unravel in the mid-1880s, Morisot established strong ties to her colleagues, especially Renoir, Monet, Degas, and Mallarmé, and presided over regular Thursday dinners at her home in the rue de Villejust. In 1891, the couple purchased a country home, the Château du Mesnil near Mézy. Eugène died shortly after; Berthe succumbed to typhoid fever three years later at age 54.

In addition to nearly 1,000 oils, watercolors, and pastels (a new *catalogue raisonné* is in preparation by Alain Clairet, Yves Rouart, and Delphine Montalant), Morisot executed lithographs and drypoint etchings from 1888 to 1890. Her reputation, always strong in France, was left in competent hands. Her daughter Julie's journal (*Growing Up With the Impressionists: The Diary of Julie Manet*. London: Sotheby's, 1987) and her grandson Denis Rouart's writings and editions of her letters provide vivid accounts of Morisot's life.

Poets such as Mallarmé and Paul Valéry left detailed memories of her personality and work. Her reputation in the English-speaking art world was launched by the publication of *The Correspondence of Berthe Morisot* (London: Camden Books, 1986); Kathleen Adler and Tamar Garb's *Berthe Morisot* (Ithaca, NY: Cornell University Press, 1987); and the 1987 *Berthe Morisot, Impressionist* exhibition at the National Gallery of Art in Washington, D.C.

Berthe Morisot

Chronology, 1841–1895

Information for this chronology was gathered from Marianne Delafond and Marie-Caroline Sainsaulieu, *Les Femmes impressionnistes* (Paris: La Bibliothèque des Arts, 1993):164-8; Tamar Garb, "Berthe Morisot" in *The Dictionary of Art* (NY: Grove, 1996)22:119-20; Kathleen Adler and Tamar Garb, *Berthe Morisot* (Oxford: Phaidon, 1987); Kathleen Adler and Tamar Garb, "Berthe Morisot" in *Dictionary of Women Artists*, ed. by Delia Gaze (London: Fitzroy Dearborn, 1997)1:976-80; Margaret Shennan, *Berthe Morisot: The First Lady of Impressionism* (Stroud, England: Sutton, 1996); Jean Dominique Rey, *Berthe Morisot* (NY: Crown, 1982):92; Marie-Louise Bataille and Georges Wildenstein, *Berthe Morisot* (Paris: Les Beaux-Arts, 1961):13-21; and Edward Lucie-Smith, *Impressionist Women* (London: Weidenfeld & Nicolson, 1989):148-9, among other sources.

1841

14 January
Birth of Berthe-Marie-Pauline Morisot at Bourges (Cher), third daughter of Marie-Joséphine Cornélie Thomas and Edme Tiburce Morisot. Her mother's family is from Toulouse; her father, son of an architect, is prefect of Cher. The Morisot family is related to the Fragonard family of painters. Berthe's elder sisters are named Yves and Edma; her brother Tiburce is born in 1848. Through her English governess Louisa, Berthe develops a love of English literature, especially Shakespeare.

1848

Her father becomes prefect of Haute Vienne, but soon resigns his commission in the wake of the Revolution.

1849

Her father becomes prefect of Calvados.

1852-55

Her father is named prefect of l'Ille-et-Vilaine. The family moves permanently to Paris and lives in rue des Moulins (now rue Scheffer) in Passy, a western suburb of Paris. The Morisot

sisters take drawing lessons and Berthe studies the piano with Camille Stamaty, an eminent teacher whose family owns a drawing by Ingres.

1857-60

At their mother's insistence, Berthe and her sisters study drawing with Geoffrey-Alphonse Chocarne, but quickly become disillusioned. Yves quits drawing entirely but Berthe and Edma continue lessons with Joseph-Benoit Guichard, a pupil of Ingres and Delacroix, who lives on the same street. In 1858 they register as copyists in the Louvre, copying Titian, Veronese, and Rubens under Guichard's direction, and they begin painting landscapes. Through her activities in the Louvre, she meets Félix Bracquemond (1833-1914), the engraver and husband of Marie Bracquemond, and the painter Henri Fantin-Latour.

1861-62

Acting upon Guichard's advice, Berthe and Edma join the studio of Jean-Baptiste-Camille Corot (1796-1875), who dines with the Morisots on Tuesdays. They are also instructed by Corot's pupil Achille-François Oudinot (1820-91) and become familiar with contemporary artistic styles.

1863

The Morisots lease a small house at Chou, a village on the banks of the Oise River between Pontoise and Auvers, where Oudinot paints. The sisters create landscapes and meet the artists Charles Daubigny, Honoré Daumier, and Antoine Guillemet.

1864

Berthe and Edma participate in the official Salon with landscapes. In Paris, the Morisots move to rue Franklin. During spring and summer the family rents a cottage in Beuzeval from the artist Léon Riesener (1808-78), establishing a long friendship. Riesener's daughter Rosalie later models for Berthe. The Morisot sisters paint landscapes from nature, portraits, and still-lifes.

1865

Their father builds a garden studio at the rue Franklin home. Berthe and Edma show again at the Salon, where they receive positive reviews for the next three years.

1866

In the summer the Morisot sisters paint in Brittany, around Pont-Aven, Quimperlé, and Ros-Bras. Family guests include Carolus-Duran, Henri Fantin-Latour, and the Ferry brothers.

1867

The sisters return to Brittany, staying with their sister Yves who has married a tax official in Quimperlé named Théodore Gobillard. The Morisot family vacations at Petites Dalles.

1868

In late 1867 or early 1868, Fantin-Latour introduces Berthe to Edouard Manet. They establish a close relationship. Berthe models for Manet (*Le Balcon*), he advises her on her work, and she later marries his brother Eugène. The Morisots attend Thursday night gatherings hosted by Madame Auguste Manet where they meet Charles Baudelaire, Emile Zola, Edgar Degas, and Alfred Stevens, who introduces Berthe to Pierre Puvis de Chavannes.

1869

Edma marries Adolphe Pontillon, a naval officer who had served with Edouard Manet as a cadet in 1848, and abandons painting. This separation produces a frequent and close correspondence between the sisters. Berthe visits the newlyweds at Lorient and paints portraits of her sister and mother. Eva Gonzalès poses for Manet, which irritates Morisot.

1870

Berthe stays in Paris with her parents during the Franco-Prussian War, whose privations affect her health. Paints watercolors.

1871

Following Puvis de Chavannes's advice, she paints for two months in Saint-Germain-en-Laye and for three months in Cherbourg, where she creates watercolors. Upon her return to Paris, she joins the studio of Aimé Millet (1819-91).

1872

Poses for Manet's *Portrait au bouquet de violettes*. Visits Saint-Jean-de-Luz and Madrid, accompanied by her sister Yves.

1873

Shows for the final time at the official Salon. Paints at Petites Dalles and at Fécamp, where she shows several canvasses.

1874

24 January
Death of her father in Paris. Berthe visits the Pontillon family and the Morisot women move from rue Franklin to an apartment in rue Guichard.

15 April
Morisot participates in the First Impressionist exhibition with four oil paintings (*Le Berceau, Cache-cache, La Lecture,* and *Marine de Fécamp*), two pastels (*Portrait de Mlle Thomas* and *Village de Maurecourt*), and three watercolors. She shows in all but one of the eight Impressionist shows (1874-86), missing only the 1879 exhibition due to health problems following the birth of her daughter Julie in late 1878. She is a staunch Impressionist leader,

organizing shows and helping to develop its aesthetic principles.

Summer
Visits Fécamp, where she becomes engaged to Eugène Manet, the painter's brother.

22 December
Marries Eugène Manet in the Catholic Church in Passy, rue de l'Annonciation. Eugène is an amateur painter and writer (one novel, *Victimes!* Clamecy: Imprimerie A. Staub, 1889).

1875

24 March
Auction of art works at l'Hôtel Drouot, Paris with Monet, Sisley, and Renoir. Most paintings sell for around 10 francs, although Morisot's are highly valued and her *Intérieur* fetches a record 480 francs.

Spring-Summer
Paints in Gennevilliers and visits England and the Isle of Wight. Visits her sister Yves in Cambrai.

1876

Spring
Second Impressionist exhibition. Morisot shows *Au Bal, Jeune femme au miroir, Le Déjeuner sur l'herbe, Plage de Fécamp, Bateaux en construction, Percher de blanchisseuse, La Toilette, Le Bateau à vapeur,* and paintings from the Isle of Wight.

October
Death of her mother. Berthe and Eugène move to a new apartment at 9, avenue d'Eylau.

1877

April
Third Impressionist exhibition, rue le Peletier. Morisot shows *Tête de jeune fille, La Psyché, Sur la terrasse,* and *Femme à sa toilette.*

1878

14 November
Birth of Julie Manet, Berthe's only child.

1879

Occupied with her daughter and recovery from health problems, Morisot misses the Fourth Impressionist exhibition. Summer visit to Beuzeval.

1880

April
Fifth Impressionist exhibition, 10, rue des Pyramides. Morisot participates with *Jour d'été, Hiver, Femme à sa toilette, Le Lac du Bois de Boulogne, Avenue du Bois par la neige, Au jardin, Portrait, Tête de jeune fille, Paysage,* and five watercolors, including one painted on a fan.

1881

April
Sixth Impressionist exhibition. Morisot shows *Etude en plein air, Nourrice et bébé, Jeune femme en rose, Portrait d'enfant, Paysage,* and pastel sketches.

Summer
The Manets lease a cottage in Bougival, where Berthe paints several canvasses. They purchase property in Paris intended for a future house.

Winter
Visits Nice and Italy, where Julie falls ill. They return to Nice, where Berthe continues to paint.

1882

March
Seventh Impressionist exhibition, where Morisot shows *Marie dans la véranda, Marie à l'ombrelle, M. Manet et sa fille dans le jardin de Bougival, Blanchisseuse, Petite fille dans le jardin de Bougival, Jeune femme cousant, Villa Arnulphi,* and *Le Port de Nice.*

Summer visit to Bougival. Edouard Manet resides nearby in Rueil.

1883

30 April
Death of Edouard Manet. Berthe, Eugène, and Julie move into their new home in rue de Villejust (now rue Paul Valéry), whose salon is transformed into a studio.

Fall
Sends three paintings to the Impressionist exhibition organized by Durand-Ruel in London: *Le Jardin, Femme étendant du linge,* and *Sur la plage.* Edouard Manet's widow moves in with the Manets in rue de Villejust. Berthe decorates her apartment with *Vénus demandant des armes à Vulcain,* a copy of Boucher's painting in the Louvre.

1884

Berthe prepares a retrospective of Manet's works with Edouard's widow and two brothers (Gustave and husband Eugène), assembling a collection of masterpieces and family portraits by Manet. Visits Bougival for the last time.

1885

Year of intense painting in the Bois de Boulogne and in her garden in the rue de Villejust. Hosts Thursday dinners that include Degas, Mallarmé, Renoir, Madame Gobillard, de Jouy, Caillebotte, Monet, Puvis de Chavannes, Whistler, Théodore Duret, and other artsits and writers. Death of her mother-in-law. Berthe paints at Vieux-Moulin in the Forest of Compiègne and travels to Belgium and Holland. Paints watercolors and admires Rubens.

1886

15 May-15 June
Eighth and final Impressionist show. Berthe participates with *Jeune fille sur l'herbe, Le Bain, La Petite servante,* and pastel portraits, many of which feature the model Isabelle Lambert.

June-August
Works on the Island of Jersey, staying in Montorgueil. Visits Renoir and studies his painting technique and process.

1887

Shows *Femme étendant du linge, Portrait de Mme X, Port de Nice, Plage de Nice, Marine,* and *Jeune fille à l'ombrelle* in New York. Also shows oil paintings and pastels in an international exhibition at Galerie Georges Petit, Paris, in May, and at Les XX in Brussels. Stéphane Mallarmé asks Morisot to help illustrate his book of poetry, *Le Tiroir de laque.*

1888

Morisot stays in Paris, paints in the Bois de Boulogne, and shows with other Impressionists in May. Experiments with lithographs and drypoints until 1890.

Fall
Berthe, Eugène, and Julie lease a villa in Cimiez.

1889

May
Returns from Cimiez and spends the summer in Paris. Visits the Château de Vassé.

1890

Because of her husband's health, the family leases a home overlooking the Seine in Mézy.

1891

Completes *Le Cerisier* in Mézy, a painting that features Julie Manet and Jeannie Gobillard. The family purchases property in Le Mesnil, between Meulan and Mantes.

1892

Eugène Manet falls seriously ill; Berthe paints from their home in rue de Villejust.

13 April
Eugène dies. Berthe and Julie retreat to Le Mesnil.

25 May-18 June
First individual exhibition, Galerie Boussod et Valadon, catalogue preface by Gustave Geffroy. Works sell for as much as 3,000 francs. Monet buys *La Jatte de lait* for 1,500 francs.

1893

Death of Yves Gobillard, Berthe's elder sister. Berthe moves to a small apartment at 10, rue Weber, reluctantly leaving her home in rue de Villejust. Julie, Jeanne Fourmanoir, and Lucie Léon sit for her as models. Stays at Fontainebleau and paints Mallarmé in his boat. Entertains friends, including Degas, Renoir, and Mallarmé.

1894

March
Shows at Les XX in Brussels and purchases Manet's *Portrait au bouquet de violettes* for 5,100 francs at Duret's in Paris. Mallarmé purchases her *Jeune femme en toilette de bal,* shown at the 1880 Impressionist exhibition, for the State. Morisot often visits Galerie Durand-Ruel to study works by Manet and models for Renoir. Journeys to Brittany with Julie.

1895

2 March
Morisot dies after a short illness. She is interred in the cemetery in Passy, in the crypt of Edouard Manet.

1896

21 March
Retrospective exhibition of 300 oil paintings, pastels, watercolors, and drawings held at Galerie Durand-Ruel, rue Laffitte. Stéphane Mallarmé writes the catalogue preface.

Berthe Morisot

Bibliography

I. Primary Works

558. MORISOT, BERTHE. *Croquis de ma mère*. Facsimile sketchbook, July 1886. 1 vol., 15 p. Located at The Getty Research Institute for the History of Art and the Humanities, Special Collections, Los Angeles.

Facsimile sketchbook, printed in Paris in 1956, that contains illustrations of women, children, and landscapes, with some annotations.

559. MORISOT, BERTHE. *Letter to Léon Riesener*. Holograph, signed. ca. 1892. 4 p. Located at The Getty Research Institute for the History of Art and the Humanities, Special Collections, Los Angeles.

Personal letter to a friend, Louis Antoine Léon Riesener, regarding the refurnishing and renting of a house following the death of her husband, Eugène Manet, on April 13, 1892.

560. MORISOT, BERTHE. *Seize aquarelles*. Préfaces de Stéphane Mallarmé et de Paul Valéry. Paris: Editart, Editions des Quatre Chemins, 1946. 16 p., 16 col. pl.

561. MORISOT, BERTHE. *Correspondance de Berthe Morisot: avec sa famille et ses amis Manet, Puvis de Chavannes, Degas, Monet, Renoir et Mallarmé*. Documents réunis et présentés par Denis Rouart. Paris: Quatre Chemins, 1950. 184 p., illus., some col.

Includes letters by Berthe Morisot's mother and sisters.
a. U.S. eds.: *The Correspondance of Berthe Morisot, with her Family and her Friends*. Trans. by Betty W. Hubbard. NY: G. Wittenborn, 1957. 187 p., illus., some col.; NY: Weyhe, 1959; with a new introduction and notes by Kathleen Adler and Tamar Garb. Mt.

Kisco, NY: Moyer Bell, 1987.
b. English eds.: London: Lund, Humphries, 1957. 187 p., illus., some col.; London: Camden Press, 1986. 246 p., illus.
Reviews: *Burlington Magazine* 93(May 1951):173; C. Brightman, *New York Times Book Review* (March 1989):39; J. McKenzie, *Studio International* 201(April 1988):64-7; N. Mathews, *Woman's Art Journal* 10:1(Spring-Summer 1989):46-9.

562. MORISOT, BERTHE. *Croquis de ma mère.* Paris, 1956. 1 p., 14 pl., some col.

Facsimile platebook of Morisot's *Croquis de ma mère* sketchbook.

563. BROWN, JOHN LEWIS. *Letters Received,* 1862-88. Holographs, signed. 11 items. Located at The Getty Research Institute for the History of Art and the Humanities, Special Collections, Los Angeles.

Collection includes letters dealing with group art exhibitions, from Mario Carl-Rose (1855-1913), Ernest-Ange Duez (1843-96), Etienne Moreau-Nélaton, and others, and a letter of 1888 from Eugène Manet commenting on his wife Berthe Morisot's painting activity at Nice and on a revival of an 18th century decorative aesthetic.

564. MALLARME, STEPHANE and BERTHE MORISOT. *Correspondance de Stéphane Mallarmé et Berthe Morisot, 1876-1895.* Lettres réunies et annotées par Olivier Daulte et Manuel Dupertuis. Lausanne; Paris: Bibliothèque des Arts, 1995. 147 p., illus. (Collection Pergamine)

Exchange of about 125 letters that cover appointments, news, and career details.

II. Illustrated Book

565. MALLARME, STEPHANE. *Poésies.* Préface par Paul Valéry. Avec six dessins originaux de Berthe Morisot. Paris: Les Cent Une, 1931. 37, 167 p., illus., 1 col.

III. Books

566. ADLER, KATHLEEN and TAMAR GARB. *Berthe Morisot.* Ithaca, NY: Cornell University Press, 1987. 128 p., 98 illus., 48 col.

Biography in five chapters that covers Morisot's upper middle-class background and education, early contacts with other artists, relationships with Impressionists and her contributions to the movement, paintings of everyday bourgeois life, and depictions of specific contemporary places.
a. English eds.: Oxford: Phaidon, 1987. 128 p., 98 illus., some col.; 1995. 128 p., illus.
Reviews: G. Hughes, *Arts Review* 39:13(3 July 1987):469; M. Vaizey, *Country Life* 181:38(17 Sept. 1987): 190; B. Scott, *Apollo* 126:308(1987): 302; N. Bryson, *Times Literary Supplement* 4436(8-14 April 1988):386; N. Mathews, *Woman's Art Journal* 10:1(Spring-Summer 1989):46-9.

567. AMORNPICHETKUL, CHITTIMA. *"The Mother and Sister of the Artist"* by *Berthe Morisot*. M.A. thesis, Brown University, 1989. 32 p., illus.

568. AMORNPICHETKUL, CHITTIMA. *Berthe Morisot: A Study of her Development from 1864-1886*. Ph.D. Diss., Brown University 1989. 466 p., illus.

Examination of Morisot's stylistic evolution from the Salon debut in 1864 to her final Impressionist show in 1886 that focuses on early education, influences, relationships with other Impressionists and women artists, and critical reactions to her work.

569. ANGOULVENT, MONIQUE. *Berthe Morisot*. Préface de Robert Rey. Paris: A. Morancé, 1933. 161 p. 40 pl.

Early biography that reproduces important letters and personal documents (see "Pièces justificatives"). Lists 655 works in private and public collections. Bibliography, pp. 159-61. Review: *L'Amour de l'art* 15(Feb. 1934):12.

570. BATAILLE, GEORGES. *Manet.* Biographical and critical study by Georges Bataille. Trans. by Austryn Wainhouse and James Emmons. Geneva; Paris; NY: Skira, 1955. 136 p., col. illus. (Taste of Our Time, no. 14)

a. Other eds.: 1983, 1994, 1995.

571. BATAILLE, MARIE-LOUISE and GEORGES WILDENSTEIN. *Berthe Morisot: catalogue des peintures, pastels et aquarelles*. Paris: Les Beaux-Arts, 1961. 306 p., illus. (L'Art français)

Catalogue raisonné of 847 works by Morisot, including 416 paintings (1859-95), 192 pastels (1864-95), and 239 watercolors (1864-94). Includes black-and-white reproductions, chronology (pp. 13-22), bibliography (pp. 287-90), index, and portraits of Morisot by Edouard Manet and Edma Pontillon. The catalogue was initiated by the art dealer Ambroise Vollard during World War I.
Review: A. Scharf, *Burlington Magazine* 104(May 1962):217-8.

572. BAUDOT, JEANNE. *Renoir, ses amis, ses modèles*. Paris: Editions Littéraires de France, 1949. 137 p., illus., pl.

573. BAZIN, GERMAIN. *Edouard Manet*. Milan: Fabbri, 1972. 95 p., illus., some col. (Gli impressionisti)

Biography of Manet's life and career that discusses his relationship with Morisot.
a. French ed.: Paris: Diffusion Princesse, 1974.
b. English eds.: NY: Exeter Books, 1987; London: Cassell, 1988. 94 p., 167 illus., 56 col.

574. BAZIN, GERMAIN. *Les Impressionnistes au Musée d'Orsay.* Paris: Somogy, 1990. 280 p., 222 illus., 212 col.

Introductory survey of 24 Impressionists held in the collection of the Musée d'Orsay, Paris, that includes Morisot and Cassatt.

575. BRETTELL, RICHARD R. *An Impressionist Legacy: The Collection of Sara Lee Corporation.* Introduction by David Finn. NY: Abbeville; dist. in the U.K. and Europe by Pandemic, London, 1986. 127 p., 80 col. illus.

Catalogue raisonné of the collection of paintings and sculpture on permanent display at the Chicago headquarters of the Sara Lee Corporation, acquired from the company's founder, Nathan Cummings. Includes works by Morisot.

576. BROUDE, NORMA F. and MARY D. GARRARD, eds. *The Expanding Discourse: Feminism and Art History.* NY: Icon Editions, 1992. 518 p., illus.

Includes Linda Nochlin's essay, "Morisot's *Wet Nurse*: The Construction of Work and Leisure in Impressionist Painting" (pp. 230-43), which originally appeared in *Perspectives on Morisot*, ed. by Teri J. Edelstein (NY: Hudson Hills Press in association with the Mount Holyoke College Art Museum, 1990):91-102; and Griselda Pollock's "Modernity and the Spaces of Femininity" (pp. 244-67), which focuses on subtle differences in subject matter between women Impressionists such as Cassatt and Morisot in contrast to their male counterparts.

577. CACHIN, FRANÇOISE and CHARLES S. MOFFETT. *Manet, 1832-1883.* Avec la participation de Michel Melot. Paris: Ministère de la Culture; Musées Nationaux; NY: Metropolitan Museum of Art, 1983. 544 p., illus.

Exhibition catalogue with references to women Impressionists, held at Paris, Grand Palais (22 April-1 Aug. 1983) and NY, Metropolitan Museum of Art (10 Sept.-27 Nov. 1983).

578. CALLEN, ANTHEA. *Techniques of the Impressionists.* London: Orbis, 1982. 192 p., 30 illus.

Introduction and examination of Impressionism that analyzes individual artists' techniques employed from 1860 to 1905, including sections on Morisot and Cassatt.

579. CLARK, TIMOTHY J. *The Painting of Modern Life: Paris in the Art of Manet and his Followers.* NY: Knopf; London: Thames Hudson, 1985. 338 p., illus., 31 pl.

580. COURTHION, PIERRE. *Edouard Manet.* London: Thames & Hudson, 1962. 152 p., illus., some col.

a. U.S. eds.: NY: Abrams, 1962. 152 p., illus., some col.; concise ed. 1984.

581. COURTHION, PIERRE. *Autour de l'impressionnisme: Bazille, Boudin, Mary Cassatt, Fantin-Latour, Guigou, Lebourg, Guillaumin, Jongkind, Lépine, Berthe Morisot, Prins, Sisley.* Paris: Nouvelles Editions Françaises, 1964. 53 p., illus., 48 col. pl.

582. CRESPELLE, JEAN-PIERRE. *La Vie quotidienne des impressionnistes: du Salon des*

Refusés (1863) à la mort de Manet (1883). Paris: Hachette, 1981. 286 p., illus.
Survey of Impressionism in its cultural and historic context, focusing on everyday life of artists including Morisot. Includes a chronology of principal events.

583. DAIX, PIERRE. *La Vie de peintre d'Edouard Manet.* Paris: Fayard, 1983. 336 p., illus., 16 pl.

a. Spanish ed.: *La Vida de pintor de Edouard Manet.* Barcelona: Argos Vergara, 1983. 217 p.

584. DARRAGON, ERIC. *Manet.* Paris: Fayard, 1989. 473 p., illus., 14 pl.

Biography of Manet that includes many references to Morisot. Bibliography, pp. 462-64.

585. DARRAGON, ERIC. *Manet.* Paris: Editions Citadelles, 1991. 444 p., illus. (Collection les Phares)

586. DURET, THEODORE. *Les Peintres impressionnistes: Claude Monet, Sisley, C. Pisarro* [sic.] *, Renoir, Berthe Morisot.* Avec un dessin de Renoir. Paris: Librairie Parisienne, 1878. 35 p., 1 illus.

Early critical survey of Impressionism that treats Morisot very favorably.

587. DURET, THEODORE. *Critique d'avant-garde, les peintres impressionnistes, Berthe Morisot.* Paris: G. Charpentier, 1885.

See pp. 82-3 for criticism on Morisot.

588. DURET, THEODORE. *Histoire des peintres impressionnistes: Claude Monet, Sisley, Renoir, Berthe Morisot, Cézanne, Guillaumin.* Paris: H. Floury, 1906. 214 p., illus., 40 pl.

Expanded version of Duret's *Les Peintres impressionnistes* (Paris: Librairie Parisienne, 1878).
a. Other eds.: 1919, 1922.
b. German eds.: *Die Impressionisten.* Berlin: Cassirer, 1909. 226 p., illus., 12 pl.; 1918, 1920, 1923.
c. English eds. *Manet and the French Impressionists.* Trans. by J. E. Crawford, *London:* G. Richards; Philadelphia: J.B. Lippincott, 1910; 1912; Freeport, NY: Books for Libraries, 1971. 256 p., 38 pl.

589. EDELSTEIN, TERI J., ed. *Perspectives on Morisot.* NY: Hudson Hills Press in association with the Mount Holyoke College Art Museum; dist. by Rizzoli International Publications, 1990. 120 p., illus., some col.

Compilation of seven essays originally presented as lectures at a symposium held 9 April 1988 at Mount Holyoke College (South Hadley, Massachusetts) as a complement to the exhibition *Berthe Morisot–Impressionist*. Includes: Kathleen Adler, "The Spaces of Everyday Life: Berthe Morisot and Passy"; Beatrice Farwell, "Manet, Morisot, and

Propriety"; Tamar Garb, "Berthe Morisot and the Feminizing of Impressionism"; Anne Higonnet, "The Other Side of the Mirror"; Suzanne Glover Lindsay, "Berthe Morisot, Nineteenth-Century Woman as Professional"; Linda Nochlin, "Morisot's *Wet Nurse*: The Construction of Work and Leisure in Impressionist Painting"; and Anne Schirrmeister, "La Dernière mode: Berthe Morisot and Costume."
Reviews: T. Dolan, *Woman's Art Journal* 15:2(Fall 1994-Winter 1995):40-3; M. Tompkins, *Art Journal* 50(Fall 1990):92-5; B. Thomson, *Burlington Magazine* 134:1074(Sept. 1992):604-5.

590. FARR, MARGARET FITZGERALD. *Impressionist Portraiture: A Study in Context and Meaning.* Ph.D. diss., University of North Carolina at Chapel Hill, 1992. 416 p.

Examination of Impressionist portraiture that includes examples and analysis of works by Morisot and Cassatt.

591. FENEON, FELIX. *Les Impressionistes* [sic.] *en 1886.* Paris: Publications de la Vogue, 1886. 42 p.

592. FOURREAU, ARMAND. *Berthe Morisot.* 40 planches hors-texte en héliogravure. Paris: F. Rieder, 1925. 63 p., 40 pl. (Maîtres de l'art moderne)

Includes biographical information and plates of representative works.

593. FRASCINA, FRANCIS, et al. *Modernity and Modernism: French Painting in the Nineteenth Century.* New Haven, CT; London: Yale University Press; Open University, 1993. 304 p., 250 illus., 50 col.

Examination of various 19th century French movements with a particular focus on Manet, Monet, Cézanne, Pissarro, and Morisot.

594. FRIED, MICHAEL. *Manet's Modernism, or The Face of Painting in the 1860s.* Chicago and London: University of Chicago Press, 1996. 647p., 200 illus.

Full-scale biography and cultural history of Manet and his generation of painters in the 1860s which mentions his relationship with Morisot.

595. FRIEDRICH, OTTO. *Olympia, Paris in the Age of Manet.* NY: HarperCollins, 1992. 329 p., 22 illus., 8 col., 12 pl.

Focuses on the cultural and artistic milieu of late 19th century Paris seen through the lives of Manet and his circle, including Berthe Morisot. See especially Chapter 3, pp. 78-105.

596. GEFFROY, GUSTAVE. *La Vie artistique.* Préface de l'auteur, pointe sèche d'Auguste Renoir. Troisième série. Paris: E. Dentu, 1894. 395 p.

Morisot is discussed on pp. 261-7. For more criticism of Morisot, see also the 6th series (Paris: E. Dentu, 1900):193-9.

597. HERBERT, ROBERT L. *Impressionismus: Paris—Gesellschaft und Kunst.* Stuttgart; Zurich: Besler, 1989. 344 p., 311 illus., 249 col.

Presents Impressionism as a mirror of Parisian society and examines sociological methods used to analyze its cultural milieu and influences. Includes references to Morisot.

598. HIGONNET, ANNE. *Berthe Morisot.* NY: Harper and Row, 1990. 240 p., illus., 16 pl.

Biography that argues that Morisot's struggle to become a recognized and respected Impressionist ran counter to 19th century French sexist attitudes.
a. Another ed.: Berkeley: University of California Press, 1995. 240 p., illus., 16 pl.
b. English ed.: London: Collins, 1990. 240 p., illus.
c. French ed.: Traduit par Isabelle Chapman. Paris: Adam Biro, 1990. 236 p., illus., 16 pl.
Reviews: A Truitt, *New York Times Book Review* (June 1990):20-1; P. Conisbee, *Times Literary Supplement* 4556 (10-16 Aug. 1990):850; R. Snell, *Apollo* 132:345(Nov. 1990):380-1; A. Wooster, *Arts Magazine* 65:5(Jan. 1991):111-2; J. Haville, *Modern Painters* 4:1(1991):105-6; M. Lewis, *Art Journal* 50:3(Fall 1991):92-5; T. Dolan, *Woman's Art Journal* 15:2(Fall 1994-Winter1995):40-3.

599. HIGONNET, ANNE. *Berthe Morisot's Images of Women.* Cambridge; London: Harvard University Press, 1992. 311 p., 123 illus., 12 col., 12 pl.

Scholarly treatment of Morisot's career and role as a woman artist in the Impressionist circle that focuses on her depictions of women, based on access to private family papers.
Reviews: C. Bower, *Antioch Review* 51:2(Spring 1993):307-8; G. Collins, *Journal of Aesthetic Education* 28:2(Summer1994):109-11; T. Dolan, *Woman's Art Journal* 15:2(Fall 1994-Winter 1995):40-3; M. Jacobus, *Art History* 16:3(Sept. 1993):470-4; C. Schwartz, *New York Times Book Review* (17 Jan. 1993):24; E. Weber, *Times Literary Supplement* 4696(2 April 1993):11; C. Zemd, *American Historical Review* 99:1(Feb. 1994):246-7.

600. HOUSSIN, MONIQUE. *Lettres de peintres.* Préface par François Nourissier. Paris: Messillor, 1991. 221 p., 60 illus., 33 col.

Anthology of letters by painters that includes examples by Morisot.

601. HUISMAN, PHILIPPE. *Berthe Morisot.* Lausanne; Paris: La Bibliothèque des Arts, 1962. 91 p., illus., some col. (Polychrome)

Biography and critical appreciation.
a. Another ed.: 1995.

602. HUISMAN, PHILIPPE. *Morisot, charmes.* Lausanne: IAB, 1962. 65 p., col., illus. (Rhythmes et couleurs, no. 9)

Matches poems by Stéphane Mallarmé to reproductions of paintings by Morisot.
a. U.S. ed.: *Morisot, Enchantment.* Trans. by Diane Imber. NY: French European Publications, 1963. 65 p., col., illus. (Rhythm and Colour)

603. HUYSMANS, JORIS-KARL. *L'Art moderne. L'Exposition des Indépendants de 1880. L'Exposition des Indépendants de 1881.* Paris: Plon-Nourrit, 1883. 301 p.

"Des articles . . . ont paru, pour la plupart, dans *Le Voltaire*, dans *La Réforme*, dans *La Revue littéraire et artistique*".
a. Other eds.: 1902, 1908, 1911, 1923.

604. KAPOS, MARTHA, ed. *The Impressionists: A Retrospective.* London: Hugh Lauter Levin, 1991. 380 p., illus.

Elucidates the Impressionist movement and major artists, including Morisot, by concentrating on the letters, comments and debates between the artists themselves.

605. LANGDON, HELEN. *Impressionist Seasons.* Oxford: Phaidon, 1986. 80 p., 40 illus., 32 col.

Analyzes 32 examples of Impressionist works, including examples by Morisot, that capture various seasons of the year.

606. LECOMTE, GEORGES. *L'Art impressionniste, d'après la collection privée Durand-Ruel.* 36 eaux-fortes, pointe-sèches et illustrations dans le texte de A.-M. Lauzet. Paris: Chamerot et Renouard, 1892. 270 p., illus.

607. LIPTON, EUNICE. *Alias Olympia: A Woman's Search for Manet's Notorious Model and her Own Desire.* NY: C. Scribner's Sons, 1992.

Informal journal of the author's search for details of the life and personality of Victoria Meurent, Manet's infamous model for *Olympia* and *Déjeuner sur l'herbe*.
a. Other eds.: 1992, 1994, 1999. 1994, 1999.
b. English ed.: London: Thames & Hudson, 1993. 181p.
c. Chinese ed.: 1996.

608. LOCKE, NANCY. *Manet and the Family Romance.* Ph.D. diss., Harvard University, 1992. 312 p.

Applies Freudian analysis to Manet's paintings of his family and discusses his portraits of Morisot.

609. MALLARME, STEPHANE. *Divagations.* Paris: E. Fasquelle, 1897. 377 p.

Includes Mallarmé's preface to the 1896 Morisot retrospective exhibition catalogue (Paris, Galerie Durand-Ruel).
a. Other eds.: 1912, 1922, 1932, 1935, 1943, 1949, 1961.

610. MALLARME, STEPHANE. *Oeuvres complètes.* Editées par Henri Mondor et G.-Jean-Aubry. Paris: Gallimard; Bibliothèque de la Pléiade, 1945. 1659 p. (Bibliothèque de la Pléiade, no. 65)

Reprints Mallarmé's preface to the 1896 Morisot exhibition catalogue (Paris, Galerie Durand-Ruel).
a. Other eds.: 1956, 1961, 1970, 1983, 1989.

611. MALLARME, STEPHANE. *Correspondance.* Editée par Henri Mondor et Lloyd James Austin. Paris: Gallimard, 1969-85. 11 vols.

See indexes for references to and correspondence with Morisot.

612. MANET, EDOUARD. *Manet raconté par lui-même.* Edité par Etienne Moreau-Nélaton. Paris: Henri Laurens, 1926. 2 vols.

Combines official biography with an anthology of contemporary statements on Manet. Moreau-Nélaton was a major collector of Manet's works, which he donated to the Louvre.

613. MANET EDOUARD. *Manet raconté par lui-même et par ses amis.* Edité par Pierre Courthion et Pierre Cailler. Geneva: Pierre Cailler, 1953. 2 vols., illus.

a. English eds.: *Portrait of Manet by Himself and his Contemporaries.* London: Cassell, 1953; London: Cassell; 1960.
b. U.S. ed.: NY: Ross, 1960. 238 p.

614. MANET, EUGENE. *Victimes!* Clamecy: Imprimerie A. Staub, 1889. 347 p.

Novel by Berthe Morisot's husband, the brother of Edouard Manet.

615. MANET, JULIE. *Julie Manet: journal (1893-1899)—sa jeunesse parmi les peintres impressionnistes et les hommes de lettres.* Préface par J. Griot. Paris: Klincksieck, 1979. 242 p., 8 illus.

Diary of Julie Manet, daughter of Berthe Morisot and Eugène Manet and niece of Edouard Manet, which spans the period 1893, when she was 14 years old, to 1899, four years after her mother's death.

616. MANET, JULIE. *Growing up with the Impressionists: The Diary of Julie Manet.* Edited by Rosalind de Boland Roberts and Jane Roberts. London: Sotheby's, 1987. 200 p., 104 illus., 23 col.

Excerpts from the diary (1893-99) of the daughter of Eugène Manet and Berthe Morisot that contain information about them and their Impressionist circle, especially Renoir, who encouraged Julie to paint.
Review: M. Kessler, *Woman's Art Journal* 11:1(Spring-Summer 1990):41-2.

617. MAUCLAIR, CAMILLE. *L'Impressionnisme, son histoire, son esthétique, ses maîtres.* Paris: Librairie de l'art ancien et moderne, 1904. 238 p., illus.

Includes a section on Morisot.

618. MCQUILLAN, MELISSA. *Impressionist Portraits.* London: Thames and Hudson, 1986. 200 p., 138 illus., 83 col.

Exploration of Impressionist portraits and self-portraits, 1864-86, that includes works by Morisot.

619. MELLERIO, ANDRE. *L'Exposition de 1900 et l'art impressionniste.* Paris: H. Floury, 1900. 46 p.

Impressionist art shown at l'Exposition universelle internationale de 1900 in Paris; includes bibliographical references.

620. *Mistresses Covers of the Graphic Arts: Famous Forgotten Women Printmakers, c.1550-c.1950.* North Aston, England: Elizabeth Harvey-Lee Gallery, 1995. 126 p., 359 illus.

Guide to works by women printmakers in the collection of the Elizabeth Harvey-Lee Gallery, North Aston, England that notes prints by Morisot and Cassatt.

621. MELOT, MICHEL. *The Impressionist Print.* New Haven, CT; London: Yale University Press, 1996. 296 p., 300 illus., 60 col.

History of Impressionist printmaking that includes works by Morisot and Cassatt.

622. *Mo-li-so, 1841-1895; Ká-sa-té*, 1844-1926. Shang-hai: Shang-hai jen min mei shu chu pan she; Hsin hua shu tien Shang-hai fa hsing so fa hsing, 1981. 64 p., illlus.

Heavily illustrated biographies and appreciations of Morisot and Cassatt.

623. MONDOR, HENRI. *Vie de Mallarmé.* Edition complète en un volume. Paris: Gallimard, 1941. 827 p.

a. Other eds.: 1943, 1944, 1946, 1950.

624. MOORE, GEORGE. *Confessions of a Young Man.* London: S. Somenschein, Lowrey, 1888. 357 p.

Describes a painting of young girls by Morisot at an Impressionist exhibition, probably one in the 1880s. Moore (1852-1933) was an Irish poet and novelist.
a. Other eds.: 1889, 1904, 1907, 1915, 1917, 1918, 1920, 1923, 1925, 1928, 1933, 1939, 1952, 1959, 1961, 1972.
b. French eds.: *Confessions d'un jeune anglais.* Paris: A. Savine, 1889. 286 p.; Paris: Stock, 1925.

625. MOORE, GEORGES. *Memoirs of my Dead Life.* London: W. Heinemann, 1906. 335 p.

a. Other eds.: 1908, 1911, 1915, 1920, 1921, 1928, 1936, 1960.
b. French ed,: *Mémoires de ma vie morte.* Traduit de l'anglais par Jean-Aubry. Paris: B.

Grasset, 1922, 246 p. (Les Cahiers verts, 13)

626. MOORE, GEORGES. *Hail and Farewell*. London: W. Heinemann, 1911-14. 3 vols.

a. Other eds.: 1915, 1923, 1925, 1947, 1976.

627. MRÀZ, BOHUMÌR. *Zeichnungen der französischen Impressionisten: Manet, Degas, Morisot, Monet, Renoir, Sisley, Pissarro, Cézanne*. Prague: Odeon, 1985. 206 p., illus., some col.

Picture-book and catalogue of Impressionist drawings. Bibliography, pp. 203-5.
a. Spanish ed.: *Dibujos de impresionistas franceses*. Versión castellana, Ramón Ibero. Barcelona: Polígrata, 1985. 209 p., illus., some col.
b. German ed.: *Zeichnungen der französischen Impressionisten*. Ubersetzt von Robert Bartos. Hanau: W. Dausien, 1985. 209 p., illus., some col.
c. French ed.: *Aquarelles et dessins impressionnistes*. Traduction du tchèque, Raphaël Rodriguez. Gennevilliers: Ars Mundi, 1987. 206 p., illus., some col.

628. NEAR, PINKNEY L. *French Paintings: The Collection of Mr. and Mrs. Paul Mellon in the Virginia Museum of Fine Arts*. Introduction by John Rewald. Richmond: Virginia Museum of Fine Arts; Seattle: dist. by the University of Washington Press, 1985. 145 p. 69 col. illus.

Includes examples by Morisot and other Impressionists.

629. ORWICZ, MICHAEL R., ed. *Art Criticism and its Institution in Nineteenth-Century France*. Manchester, England: Manchester University Press; dist. in the USA and Canada by St. Martin's Press, 1994. 200 p.

Collection of essays by Orwicz, Anne Higonnet, Martha Ward, and Dario Gamboni on the development and manifestation of 19th century French art criticism. Of particular interest is Orwicz's examination (pp. 122-45) of the post-death criticism of Manet's paintings and Higonnet's discussion (pp. 146-61) of gender-specific characteristics identified by French critics in works by Morisot and Camille Claudel.

630. PARKER, ROZSIKA and GRISELDA POLLOCK. *Old Mistresses: Women, Art and Ideology*. London: Routledge Kegan Paul, 1981. 184 p., illus.

For information on Morisot, see pages 38, 41-4, and 146. Reproduces her *Psyche* and *Self-Portrait*.
a. Another ed.: London: Pandora Press, 1987.
b. U.S. ed.: NY: Pantheon Books, 1981.

631. PERRUCHOT, HENRI. *La Vie de Manet*. Paris: Librairie Hachette, 1959. 344 p., illus., 20 pl., some col. (Art et destin)

Standard biography of Manet that includes numerous references to his relationship with Morisot and Gonzalès.

a. English ed.: *Manet*. Trans. by Humphrey Hare, ed. by Jean Ellsmore. London: Perpetua Books, 1962. 296 p., illus., 40 pl.
b. U.S. ed.: Manet. Trans. by Humphrey Hare. Cleveland: World, 1962. 296 p., illus., 40 pl.

632. PETTIT, MARTHA. *Mary Cassatt and Berthe Morisot: Women Impressionist Painters*. Master's essay, 1976. 70 p. illus.

633. PREUTU, MARINA. *Berthe Morisot*. Bucharest: Meridiane, 1977. 80 p., illus., some col. In Hungarian. (Maéstrii Artei Universale)

634. REGNIER, HENRI DE. *Mallarmé et les peintres: nos rencontres.* Paris: Mercure de France, 1981.

Morisot is discussed on pp. 199-201, 203, 205.

635. REY, JEAN DOMINIQUE. *Berthe Morisot*. Trans. by Shirley Jennings. Naefels, Switzerland: Bonfini, 1982. 95 p., 70 illus., 50 col. Text in French and English.

Heavily illustrated introduction to Morisot's life and career. Bibliography, p. 93; Principal Exhibitions, p. 94.
a. U.S. ed.: NY: Crown, 1982. 95 p., 70 illus., 50 col.
b. French ed.: Trans. by Shirley Jennings. Paris: Flammarion, 1982. 95 p., illus.
Review: C. Lloyd, *Art International* 26:5(Nov.-Dec. 1983):76.

636. RIVIERE, GEORGES. *Renoir et ses amis.* Paris: H. Floury, 1921.

637. ROGER-MARX, CLAUDE. *Maîtres d'hier et d'aujourd'hui.* Paris: Calmann-Lévy, 1914.

638. ROOS, JANE MAYO. *Early Impressionism and the French State* (1866-1874). Cambridge; NY; Melbourne: Cambridge University Press, 1996. 300 p., 158 illus.

History of cultural and political events that flowered in the first Impressionist exhibition in 1874 that notes in particular Salon attitudes toward women artists such as Morisot.

639. ROUART, DENIS. *Berthe Morisot, 1841-1895*. Paris: Braun; agent pour U.S.A.: E.S. Herrmann, New York, 1941. 15 p., illus., 48 pl. (Collection des maîtres)

Mostly illustrated biographical account.
a. Another ed.: Paris: Braun, 1954. 15 p., illus., 48 pl.

640. ROUART, DENIS. *Manet.* Paris: Aimery Somogy, 1957. 87 p., illus.

a. English ed.: Trans. by Marion Shapiro. London: Oldbourne Press, 1960.

641. ROUART, LOUIS. *Berthe Morisot.* Paris: Plon, 1941. 46 p., illus. (Editions d'histoire et d'art)

Illustrated biography.

642. SENIOR, DIANA M. *Berthe Morisot: A Reappraisal.* 1992. 97 p., col. illus.

643. SHENNAN, MARGARET. *Berthe Morisot: The First Lady of Impressionism.* Foreword by Griselda Pollock. Stroud, England: Sutton Publishing; dist. by Littlehampton Book Services, 1996. 342 p., 33 illus., 10 col.

Biography divided into four parts: Morisot's background; childhood, education, and early artistic contacts; personal and professional relationships with Edouard Manet and marriage to his brother Eugène; and her career and friendships with Degas and Renoir after Manet's death in 1883. Appendix One: Locations and Public Collections with Examples of Berthe Morisot's Work, pp. 281-5. Bibliography, pp. 319-29.

644. STUCKEY, CHARLES F. and WILLIAM P. SCOTT. *Berthe Morisot, Impressionist.* With the assistance of Suzanne G. Lindsay. NY: Hudson Hills Press; dist. in the U.S. by Rizzoli International Publications, 1987.

a. English ed.: London: Sotheby's Publications, 1987. 228 p., illus.
b. French ed.: Traduit par Marie-Odile Probst, 1987.
c. Italian ed.: Milan: A. Mondadori, 1987. 227 p.,
Reviews: C. Brightman, *New York Times Book Review* (March 1988):39; C. Movalli, *American Artist* 52(March 1988):18[+]; P. Piguet, *L'Oeil* 398(1988):75; N. Mathews, *Woman's Art Journal* 10:1(Spring-Summer 1989):46-9.

645. TABARANT, ADOLPHE. *Manet et ses œuvres.* Paris: Gallimard, 1947. 622 p., illus.

Detailed biography of Manet's life and career. Includes interviews with contemporaries and associates, describes each painting, and provides measurements and sales history.

646. TONO, YOSHIAKI. *Morisot.* Textes de Yoshiaki Tono, Takeshi Kashiwa. Tokyo: Japan Art Center, 1978. 87 p., col. illus. In French and Japanese. (Les Peintres impressionnistes, no. 6)

647. VALERY, PAUL. *Triomphe de Manet, suivi de Tante Berthe.* Paris: Edition des Musées Nationaux, 1932.

Reprints Valéry's exhibition catalogue preface, "Tante Berthe" (Paris, L. Dru, 1926).

648. VALERY, PAUL. *Pièces sur l'art.* Paris: Gallimard, 1934.

Reprints Valéry's exhibition catalogue preface, "Tante Berthe" (Paris, L. Dru, 1926).

649. VALERY, PAUL. *Vues.* Paris: La Table Ronde, 1948.

Reprints Valéry's exhibition catalogue preface, "Au sujet de Berthe Morisot" (Paris, Musée de l'Orangerie, 1941).

650. VALERY, PAUL. *Oeuvres*. Editées par Jean Hytier. Paris: Gallimard, 1960. 4 vols.

Includes Valéry's catalogue prefaces "Tante Berthe" (Paris, L. Dru, 1926) and "Au sujet de Berthe Morisot" (Paris, Musée de l'Orangerie, 1941).
a. English ed.: *Degas, Manet, Morisot*. Trans. by David Paul; with an introduction by Douglas Cooper. London: Routledge Kegan Paul, 1960
b. U.S. eds.: NY: Pantheon Books, 1960. 261 p.; Princeton, NJ: Yale University Press, 1989. 261 p. (Bollingen series, 45; Collected Works of Paul Valéry, no. 12)

651. VIALLEFOND, GENEVIEVE. *Le Peintre Léon Riesener (1808-1878): sa vie, son œuvre, avec des extraits d'un manuscrit inédit de l'artiste, De David à Berthe Morisot*. Paris: Editions A. Morancé, 1955. 113 p., illus.

Treatise on the painter Léon Riesener, a friend of the Morisot family, that extracts an unpublished manuscript, *De David à Berthe Morisot*.

652. WELTON, JUDE. *Impressionist Gardens*. London: Studies Editions, 1993. 64 p., 28 col. illus.

Focuses on Impressionist works with gardens as their subject matter, including examples by Morisot.

653. WHITE, BARBARA EHRLICH. *Impressionists Side by Side: Their Friendships, Rivalries, and Artistic Exchanges*. NY: A. A. Knopf, 1996. 292 p., illus., some col., 1 col. map.

Examines personal and professional relationships and interactions between Manet and Morisot, Morisot and Renoir, and Cassatt and Morisot, among other pairs. See especially pp. 183-212, 259-65.

654. WITZLING, MARA ROSE, ed. *Voicing our Visions: Writings by Women Artists*. NY: Universe, 1991. 390 p., illus.

Presents a selection of writings by 20 women artists, including Morisot and Cassatt.

655. *Women Painters: Beaux, Cassatt, Knight, Morisot. Scrapbook of Reproductions of Paintings, etc.* NY: New York Public Library, 1931.

656. WYZEWA, TEODOR DE. *Peintres de jadis et d'aujourd'hui*. Paris: Perrin, 1903.

657. YELDHAM, CHARLOTTE. *Women Artists in Nineteenth Century France and England. Their Art Education, Exhibition Opportunities and Membership of Exhibiting Societies and Academies, with an Assessment of the Subject Matter of Their Work and Summary Biographies.* NY; London: Garland Publishing Co., 1984. 2 vols., illus. (Outstanding Theses from the Courtauld Institute of Art)

See vol. 1, pp. 351-6 for information on Morisot.

658. ZACZEK, IAIN. *Impressionist Interiors.* London: Studio Editions, 1993. 64 p., 28 col. illus.

Includes examples by Morisot and Cassatt.

IV. Articles

659. ADLER, KATHLEEN. "The Suburban, the Modern and 'Une dame de Passy.'" *Oxford Art Journal* 12:1(1989):3-13.

Examines the influence and relationship of the Parisian suburb of Passy, Morisot's home from 1852-95, on her work.

660. ADLER, KATHLEEN. "The Spaces of Everyday Life: Berthe Morisot and Passy" in *Perspectives on Morisot*, ed. by Teri J. Edelstein (NY: Hudson Hills Press in association with the Mount Holyoke College Art Museum, 1990):35-44. 1 col. illus.

Essay on Morisot's painting *View of Paris from the Trocadero* (ca. 1871-72) that focuses on the suburb of Passy, where it was painted. Morisot lived in Passy from 1852 until her death in 1895.

661. ARMSTRONG, CAROL. "Facturing Feminity: Manet's *Before the Mirror.*" *October* 74(Fall 1995):74-104. 12 illus.

Analyzes Manet's painting *Before the Mirror* (1875-6) and the influence of Morisot on his depictions of the female figure.

662. AURIER, GABRIEL-ALBERT. "Berthe Morisot." *Mercure de France* (July 1892).

663. AUSTIN, LLOYD JAMES. "Mallarmé, critique d'art" in *The Artist and the Writer in France: Essays in Honour of Jean Seznec*, ed. by Francis Haskell, Anthony Levi, and Robert Shackleton (Oxford: Clarendon Press, 1974):153-62. 8 illus., 4 pl.

Concerns Mallarmé's meager art criticism and close relationships with Whistler, Redon, Monet, Gauguin, Morisot, and other contemporary artists. Mallarmé wrote the catalogue preface to Morisot's 1896 retrospective exhibition, one article on Manet, and one on the Impressionists.

664. BABELON, JEAN. "La Candeur de Berthe Morisot." *Beaux-arts* 23(1941).

665. BAILLY-HERZBERG, JANINE. "Marcellin Desboutin and his World." *Apollo* 95(June 1972):496-500. 16 illus.

Overview of Desboutin's life (1823-1902) and career that mentions his association with and his portrait of Morisot (1876).

666. BAILLY-HERZBERG, JANINE. "Les Estampes de Berthe Morisot." *Gazette des*

Beaux-arts ser. 6, 93:1324-5(May-June 1979):215-27. 9 illus.

Describes nine prints made between 1888-90 and their five impressions. Mallarmé wanted a collection of poetry, *Tiroir de laque*, illustrated by artist friends; Morisot chose the poem "Nénuphar blanc" and began her efforts with drypoint etchings under the influence of Cassatt and possibly Degas. In 1888-9, she produced eight drypoint etchings and in 1890, a four-color lithograph. Mallarmé's poems were published in Brussels in 1891 as *Pages*, with one etching by Renoir.

667. BARAZZETTI, S. "Le 14 janvier 1841..." *Beaux-arts* (14 Jan. 1938):2.

Article on Morisot, beginning with the date of her birth.

668. BERNIER, ROSAMOND. "Dans la lumière impressionniste." *L'Oeil* 53(May 1959):38-47. 18 illus., 2 col. pl.

Showcases Berthe Morisot's house and art collection in rue Paul-Valéry, Paris, occupied at the time by her daughter Julie (Madame Ernest Rouart), then 80 years old.

669. BLANCHE, JACQUES-EMILE. "Les Dames de la grande rue, Berthe Morisot." *Les Ecrits nouveaux* (March 1920).

670. BLIN, SYLVIE. "Faire vrai et laisser dire Manet." *Connaissance des arts* 592(June 1996):54-61. 10 col. illus.

Overview of Manet's life and work that mentions his friendship with Morisot, published on the occasion of a retrospective exhibition at the Fondation Pierre Gianadda, Martigny.

671. BRAYER, YVES. "La Collection Wilhelm Hansen et le Musée d'Ordrupgaard." *L'Oeil* 316(Nov. 1981):26-33. 11 illus.

Discusses the collection and collecting activities of the Danish businessman Wilhelm Hansen, who purchased works by many Impressionists including portraits by Morisot.

672. BROUDE, NORMA F. "Degas's 'Misogyny.'" *Art Bulletin* 59(March 1977):95-107. 23 illus.

Analysis of Degas's relationships with women, including Berthe Morisot (see especially p. 103), and the controversy surrounding his alleged misogyny.

673. BUETTNER, STEWART. "Images of Modern Motherhood in the Art of Morisot, Cassatt, Modersohn-Becker, and Kollwitz." *Woman's Art Journal* 7:2(Fall 1986-Winter 1987):14-21.

Concerns the theme of mother-and-child in the work of these four women artists.

674. BUMPUS, JUDITH. "'What a Pity They Aren't Men,' Manet 1868." *Art and Artists* 201(June 1983):9-10. 2 illus.

Discussion of women Impressionists that focuses on Morisot, Gonzalès, and Cassatt.

675. BUTTERFIELD, JAN. "Re-placing Women Artists in History." *ARTnews* 76:3(March 1977):40-4.

Discusses four centuries of women artists, with reference to the exhibition *Women Artists: 1550-1950* (Los Angeles County Museum of Art and three other venues, 1977). Morisot and Cassatt are mentioned on p. 44.

676. CLAIRET, ALAIN. *"Le Cerisier de Mézy."* *L'Oeil* 358(May 1985):48-51. 6 illus.

Exploration of preliminary studies (drawings, pastels, water colors, and three versions of the oil painting) of Morisot's painting *Le Cerisier* (1891-3).

677. CLARETIE, JULES. "La Vie à Paris." *Le Temps* (6 April 1880); (5 April 1881).

Reviews of Morisot's contributions to the Fifth and Sixth Impressionist Exhibitions.

678. DAULTE, FRANÇOIS. "La Gloire de l'impressionnisme: ses précurseurs et ses maîtres à Lyon." *L'Oeil* 407(June 1989):56-61. 8 illus., 4 col.

Mentions Morisot and other Impressionists' reliance on *plein-air* painting to capture fleeting impressions of nature.

679. DAULTE, FRANCOIS. "Monet and his Friends." *L'Oeil* 452(June 1993):32-9. 11 illus., 9 col.

General overview of Impressionism with reference to an exhibition at the Fondation de l'Hermitage, Lausanne (May-Sept. 1993) that included works by Morisot.

680. DAVIDSON, BERNICE F. *"Le Repos*, a Portrait of Berthe Morisot by Manet." *Rhode Island School of Design Bulletin* 46(Dec. 1959):5-10[+].

681. DAVIS, R. S. "Berthe Morisot and her Clients." *Minneapolis Institute of Art Bulletin* 42(Nov. 1953):126-31.

Discusses Morisot's life, career and influence, with reference to the travelling exhibition, *Berthe Morisot and her Circle: Paintings from the Rouart Collection, Paris* (Toronto, Art Gallery of Toronto and other locations, 1952-54).

682. DAVIS, SHANE ADLER. *"Without Repose:* Manet's Portrait of Berthe Morisot." *Women's Studies* 18:4(1991):421-43.

683. DELOUCHE, DOMINIQUE. "La Bretagne et ses peintres autour de 1900: recherches à faire." *Arts de l'ouest* 1-2(1979):2-13. 26 illus.

Mentions Morisot as worthy of study in proposed research on the colorists of l'Ecole de Pont-Aven.

684. DENISOFF, DENNIS. "The Rare Space of the Female Artist: Impressionism in Audrey Thomas's *Latakia.*" *Mosaic* 26:4(Fall 1993):69-86.

Analyzes the Canadian novelist's *Latakia* (1979) as a depiction of society's alienation of women artists, evident in paintings by Morisot and Cassatt.

685. D'ESPAGNAT, GEORGES. "Berthe Morisot." *La Grande Revue* (Oct. 1907).

686. DOLAN, THERESE. "Perspectives on Morisot." *Woman's Art Journal* 1592(Fall 1994-Winter 1995):40-3.

Composite book reviews of Teri J. Edelstein, ed., *Perspectives on Morisot* (NY: Hudson Hills Press in association with the Mount Holyoke College Art Museum, 1990); Anne Higonnet, *Berthe Morisot* (NY: Harper Row, 1990); and Anne Higonnet's *Berthe Morisot's Images of Women* (Cambridge: Harvard University Press, 1992).

687. DORMOY, M. "Berthe Morisot." *Kunst and Kunstler* 29(Sept. 1931):469-70. 3 illus.

688. DORMOY, M. "Collection Ernest Rouart." *Formes* 24(April 1932):257-9.

689. DU COLOMBIER, PIERRE. "Berthe Morisot, bourgeoise de Passy." *Beaux-arts* 4(1941).

690. DUMAS, ANNE. "Degas and his Contemporaries." *Apollo* 144(Sept. 1996):39-41. 3 col. illus.

Illustrated with Manet's *Berthe Morisot in Mourning* (1874).

691. DURO, PAUL. "The Demoiselles à copier in the Second Empire." *Woman's Art Journal* 7(Spring-Summer 1986):1-7.

692. FARWELL, BEATRICE. "Manet, Morisot, and Propriety" in *Perspectives on Morisot*, ed. by Teri J. Edelstein (NY: Hudson Hills Press in association with the Mount Holyoke College Art Museum, 1990):45-56.

Analyzes Manet's 1870 portrait of Berthe Morisot known as *Repose*, relating the work to the 18th-19th century tradition of posing women on a sofa. Citing criticism from 1873 which labelled the portrait indecent, Farwell examines its mildly erotic overtones.

693. FELL, H. GRANVILLE. "Berthe Morisot, 1841-95." *Apollo* 11(April 1930): 293-5. 3 illus.

Overview of Morisot's life and career, with reference to an exhibition at The Leicester Galleries, London (March-April 1930).

694. FENEON, FELIX. "Souvenirs sur Manet." *Bulletin de la vie artistique* (15 Oct. 1920).

695. FIERENS, P. "Paris Letter: Louvre Receives *The Cradle*." *ARTnews* 29(15 Nov. 1930):28.

696. FINE-COLLINS, AMY M. "Portraits of Berthe Morisot: Manet's Modern Images of Melancholy." *Gazette des Beaux-arts* ser. 6, 110:1422-3(July-Aug. 1987):17-20. 1 illus.

Examines various portraits of Morisot by Manet, concluding that he transformed her into a melancholic Baudelairian heroine.

697. "Fine Impressionist Painting: *In the Garden*." *Toledo Museum of Art News* 61(Sept. 1931):4-5.

698. FONTBONA, FRANCESE. "Los Impresionstas franceses en Barcelona 1907." *Archivo Español de Arte* 63:250 (April-June 1990):312-22. 6 illus.

Examines French Impressionist paintings, including works by Morisot, at the 5th International Exhibition of Fine Arts and Artistic Industries held in 1907 in Barcelona, which featured 2,013 paintings by 93 artists.

699. FRANCIS, H. S. "*Sur la falaise aux petites dalles* (Mme Pontillon, Sister of the Artist) by Berthe Morisot." *Cleveland Museum of Art Bulletin* 37(Dec. 1950):205-11.

700. GALLIGAN, GREGORY. "Berthe Morisot: Impressionism Rediscovered." *Arts Magazine* 62:4(Dec. 1987):78-81. 6 illus., 4 col.

Reevaluation of Morisot in light of the exhibition *Berthe Morisot: Impressionist*, National Gallery of Art, Washington, D.C. (6 Sept.-29 Nov. 1987), which the author found highly successful.

701. GARB, TAMAR. "Berthe Morisot and the Feminizing of Impressionism" in *Perspectives on Morisot*, ed. by Teri J. Edelstein (NY: Hudson Hills Press in association with the Mount Holyoke College Art Museum, 1990):57-66.

Relates Morisot's role as a woman Impressionist to 1890s French art criticism regarding the "feminine" characteristics of Impressionism.

702. GEFFROY, GUSTAVE. "Notre temps. Berthe Morisot." *La Justice* (6 March 1895).

Obituary and tribute.

703. GENNE, BETH. "Two Self-Portraits by Berthe Morisot." *Psychoanalytic Perspectives on Art* 2(1987):133-70. 10 illus.

Analyzes Morisot's self-portraits of 1885 in light of her relationship with Manet. One self-portrait in oil, depicts the artist as a professional painter. The other, in pastel, is more a personal portrait of psychological pain, set against the death in 1883 of her colleague, friend and brother-in-law Edouard Manet.

704. GIBSON, ERIC. "Berthe Morisot: Reflections of Mood." *Studio International* 201(April 1988):24-7. illus.

Analyzes Morisot's life and career, claiming that she produced her best Impressionist work between the mid-1860s and mid-1880s under the influence of Corot.

705. "A Gifted Woman Impressionist, Aspects of Berthe Morisot's Art." *Illustrated London News* 1(1950):875.

706. GORDON, MARY. "Some Things I Saw; I. The Case of Berthe Morisot." *Salmagundi* 88-9(Fall 1990-Winter 1991):109-12.

Reflections on an exhibition of Morisot's works held at the National Gallery, Washington, D.C. in 1987.

707. GRAYSON, MARION L. "Berthe Morisot, 'A Woman Among the Lunatics.'" *Pharos* 18:1(Oct. 1981):4-13.

Details Morisot's role as a French Impressionist and her relationships with Edouard Manet and the symbolist poet Stéphane Mallarmé. Analyzes Morisot's *Reading* (1888), purchased in 1981 by the Museum of Fine Arts, St. Petersburg, Florida.

708. HARVEY-LEE, ELIZABETH. "His or Hers? *Antique Collecting* 30:7(Dec. 1995-Jan. 1996):11. 2 illus.

Overview of the history of printmaking that cites Morisot's and Cassatt's graphic works.

709. HAVICE, CHRISTINE. "The Artist in her Own Words" *Woman's Art Journal* 2:2(Fall 1981-Winter 1982):1-7.

Discusses the published writings of Morisot, Cassatt, Beaux, Elisabeth Vigée-Lebrun, Rosa Bonheur, Barbara Leigh Smith, Marie Bashkirtseff, and Käthe Kollwitz.

710. HAVILLE, JANE. "Berthe Morisot, a Demure Defiance." *Modern Painters* 4:1(Spring 1991):105-6.

Biographical overview and review of Anne Higonnet's *Berthe Morisot* (NY: Harper Row, 1990).

711. HIGONNET, ANNE. "Writing the Gender of the Image: Art Criticism in Late Nineteenth-Century France." *Genders* 6(1989):60-73.

Study of late 19th century French art criticism on femininity that compares critic Frederic Masson's evaluation of Jean-Léon Gérôme to Thadée Natanson's comments on Morisot.

712. HIGONNET, ANNE. "The Other Side of the Mirror" in *Perspectives on Morisot*, ed. by Teri J. Edelstein (NY: Hudson Hills Press in association with the Mount Holyoke College Art Museum, 1990):67-78. 15 illus., 3 col.

Compares Morisot's self-portraits to portraits of her made by her sister Edma and Edouard Manet, and discusses her use of pictures-within-pictures.

713. HYSLOP, FRANCIS E., JR. "Berthe Morisot and Mary Cassatt." *College Art Journal* 13:3(Spring 1954):178-84. 4 illus.

Compares the two artists' lives, relationship, mutual friends, and exhibitions on the occasion of the exhibition of the Rouart Collection in North America (1952-54).

714. IVES, COLTA FELLER. "French Prints in the Era of Impressionism and Symbolism." *Metropolitan Museum of Art Bulletin* 46(Summer 1988): 4-57. Illus.

715. JACOBUS, MARY. "The Woman who Mistook her Art for a Hat." *Art History* 16:3(Sept. 1993):470-4.

Extensive review of Anne Higonnet, *Berthe Morisot's Images of Women* (Cambridge: Harvard University Press, 1992).

716. JAMOT, PAUL. "Etudes sur Manet: Manet et Berthe Morisot." *Gazette des Beaux-arts* (Jan.-June 1927).

717. JAMOT, PAUL. *"Le 'Berceau'* de B. Morisot." *Bulletin des Musées* (1930):157-61.

Study of Morisot's *Le Berceau*, acquired in 1930 by the Louvre.

718. *"Jour d'été* Removed from the Tate Gallery." *Illustrated London News* 228(21 April 1956):344, 342.

719. KEARNS, JAMES. "Mallarmé and Morisot in 1896." *Australian Journal of French Studies* 31:1(1994):71-82.

Describes and analyzes, Mallarmé's preface to the posthumous anniversary exhibition of the work of Berthe Morisot held at Galerie Paul Durand-Ruel in March, 1896.

720. KEARNS, JAMES. "Recherches poétiques et modernisme pictural chez Mallarmé pendant les années 1890" in *The Turn of the Century: Modernism and Modernity in Literature and the Arts*, ed. by Christian Berg, Frank Durieux, and Geert Lernout; introduction by Walter Gobbers (Berlin: de Gruyter, 1995):442-9. In English, French, and German. (European Cultures: Studies in Literature and the Arts, no. 3)

721. KESSLER, MARNIREVA. "Reconstructing Relationships: Berthe Morisot *Edma* Series." *Woman's Art Journal* 12:1(Spring-Summer 1991):24-8.

Examines Morisot's portraits of her sister, completed between Edma's marriage in 1869 and Berthe's marriage in 1874. Claims that Berthe saw in her sister her roles and identity as wife and mother.

722. KINNEY, LEILA W. "Morisot." *Art Journal* 47:3(Fall 1988):236-41. 4 illus.

Overview of Morisot's life and influence, on the occasion of the exhibition *Berthe Morisot* (1987-88).

723. LEE, DAVID. "The Art of Selling." *Art Review* 45(May 1993):36-9. 10 col. illus.

Reference to Morisot and problems of copyright in this discussion of the relationship between art and advertising.

724. LEWIS, MARY TOMPKINS. "Berthe Morisot." *Art Journal* 50:3(Fall 1991):92-5. 2 illus.

Composite book reviews of Anne Higonnet, *Berthe Morisot* (NY: Harper and Row, 1990) and *Perspectives on Morisot*, ed. by T. J. Edelstein (NY: Hudson Hills Press, 1990).

725. LINDSAY, SUZANNE GLOVER. "Berthe Morisot and the Poets: The Visual Language of Woman." *Helicon Nine* 19(1988):8-17.

726. LINDSAY, SUZANNE GLOVER. "Berthe Morisot, Nineteenth-Century Woman as Professional" in *Perspectives on Morisot*, ed. by Teri J. Edelstein (NY: Hudson Hills in association with the Mount Holyoke College Art Museum, 1990):79-90.

Deals with Morisot's commercial career as a woman Impressionist.

727. LOWE, JEANETTE. "The Women Impressionist Masters: Important Unfamiliar Works by Morisot and Cassatt." *ARTnews* 38(4 Nov. 1939):9, 17.

Discusses Morisot's and Cassatt's lack of fame and recognition, with reference to a joint exhibition held at Durand-Ruel, New York (1939).

728. MANTZ, PAUL. "Salon de 1865." *Gazette des Beaux-arts* (July 1865).

Favorably reviews paintings by Morisot and her sister Edma.

729. MATHEWS, NANCY MOWLL. "Documenting Berthe Morisot." *Woman's Art Journal* 10:1(Spring-Summer 1989):46-9.

Composite review of Charles F. Stuckey and William P. Scott, *Berthe Morisot: Impressionist* (exh. cat., Washington, D.C., National Gallery, 1987); Kathleen Adler and Tamar Garb, *Berthe Morisot* (Ithaca, NY: Cornell University Press, 1987); Berthe Morisot, *The Correspondence of Berthe Morisot*, ed. by Kathleen Adler and Tamar Garb (London: Camden Press, 1986); and Tamar Garb, *Women Impressionists* (NY: Rizzoli, 1986).

730. MAUCLAIR, CAMILLE. "Choses d'art." *Mercure de France* (April 1895).

Obituary and tribute.

731. MELLQUIST, JEROME. "Berthe Morisot." *Apollo* 70(Dec. 1959):158-60. 2 illus. Highlights the exhibition held at the Musée Toulouse-Lautrec, Albi (1958).

732. MELOT, MICHEL. "Une pointe-sèche inconnue de Renoir entre dans les collections nationales." *Nouvelles de l'estampe* 139(March 1995):17-20. 2 illus.

Description of an unknown drypoint engraving by Renoir, *Tête de jeune fille,* recently acquired by La Bibliothèque Nationale, Paris that notes Renoir's printmaking collaboration with Morisot in 1888.

733. MONOD, FRANÇOIS. L'Impressionnisme féminin, deux élèves de Manet: Berthe Morisot, Eva Gonzalès." *Arts et décoration* (May 1914):supp.

734. MONTALANT, DELPHINE. "Une longue amitié: Berthe Morisot et Pierre-Auguste Renoir." *L'Oeil* 358(May 1985):42-7. 8 illus.

Details the long friendship between Morisot and Renoir through references to their correspondence, noting its intensity after the death of Morisot's husband in 1892 and concluding with Renoir's relationship with her daughter Julie after Berthe's death in 1895.

735. MONTALANT, DELPHINE. "Julie Manet." *L'Oeil* 374(Sept. 1986):52-7. 12 illus.

736. MOORE, GEORGE. "Sex in Art" in *Modern Painting* (London: Walter Scott; NY: Scribners' Sons, 1898): 226-37.

Includes favorable comments on Berthe Morisot.
Biographical sketch of the painter Julie Manet, daughter of Berthe Morisot and Eugène Manet and niece of Edouard Manet, that references Julie's diary and paintings.

737. NEWTON, ERIC. "French Painters Part VIII: Berthe Morisot et Pierre-Auguste Renoir." *Apollo* 57(Jan. 1953):49-52

Illustrated with Morisot's *Port de Nice, Jeune fille au flageolet*, and *Petite fille et sa bonne.*

738. NOCHLIN, LINDA. "Morisot's *Wet Nurse*: The Construction of Work and Leisure in Impressionist Painting" in *Perspectives on Morisot*, ed. by Teri J. Edelstein (NY: Hudson Hills Press in association with the Mount Holyoke College Art Museum, 1990):91-102. 14 illus., 1 col.

Focuses on a painting by Morisot (1879) that depicts two working women facing each other across the body of a child. Notes wet-nursing as an occupation and identifies references to manual labor in Morisot's paintings.
a. Reprint: *The Expanding Discourse: Feminism and Art History,* ed. by Norma F. Broude and Mary D. Garrard (NY: HarperCollins, 1992):230-43.

739. NUNN, PAMELA GERRISH. "Frances Hodgkins: A Question of Identity." *Woman's Art Journal* 15:2(Fall 1994-Winter 1995) 9-13. 4 illus.

Biographical sketch of New Zealand painter Frances Hodgkins (1869-1947) that cites the influence of Morisot and Cassatt on her art beginning in 1908.

740. Obituaries: *Journal des arts* (6 March 1895); G. Geffroy, *La Justice* (6 March 1895); *Chronique des arts* (9 March 1895); H., N., *Journal des artistes* (10 March 1895); *Artiste* 2(1895):157; C. Mauclair, *Mercure de France* (April 1895).

741. PAOLETTI, JOHN T. "Comments on Rohn." *Berkshire Review* (Fall 1986):91-4.

Commentary on Matthew Rohn's article, "Berthe Morisot's *Two Sisters on a Couch*," which appeared in the same issue.

742. PFISTER PAUL. "Annaherung an die Gemaldeoberflache der modernen Malerei." *Restauro* 99:5(Sept.-Oct. 1993):338-41. 8 illus. Summary in English.

Delineates typical problems of restoration of 19th and 20th century paintings with reference to Edouard Manet's painting *Berthe Morisot en deuil* (1873).

743. PICA, VITTORIO. "Artisti contemporanei–Berthe Morisot e Mary Cassatt." *Emporium* 26: 151 (July 1907): 3-16.

744. POLLOCK, GRISELDA. "Underground Women." *Spare Rib* 21(March 1974):36-9. 7 illus.

Complains that only 13 paintings by nine women artists, including Morisot, are exhibited in the National Gallery, London, but none on the main floors. Provides biographical details and criticism of the paintings by female artists.

745. POLLOCK, GRISELDA. "Modernity and the Spaces of Femininity" in *The Expanding Discourse: Feminism and Art History*, ed. by Norma F. Broude and Mary D. Garrard (NY: HarperCollins, 1992):244-67. 15 illus.

Focuses on subtle differences in domestic subject matter—dining rooms, drawing rooms, bedrooms, balconies, and private gardens—prevalent in paintings by women Impressionists such as Cassatt and Morisot in contrast to works by their male counterparts.

746. "*Portrait* by E. Manet." *Kunst und Künstler* 31(July 1932):237; *Revue d'art* 62(July 1932):265; *ARTnews* 35(17 Oct. 1936):18; *Print Collectors Quarterly* 23(Oct. 1936):315; *Emporium* 86(Oct. 1937):533; *Philadelphia Museum of Art Bulletin* 37(March 1942):62; 39(Jan. 1944):60; *Yale Art Museum Associates Bulletin* 18(April 1950):13; *Toledo Museum of Art Bulletin* 144(April 1953):4; *Art Quarterly* 21:1(Spring 1958):104; *ARTnews* 57(March 1958):37.

747. "*Portrait* by M. Desboutin." *Print Collectors' Quarterly* 23(Jan. 1936):51.

Reproduces a portrait of Morisot by Marcellin Desboutin.

748. PRICE, AIMEE BROWN. "Puvis de Chavannes's Caricatures: Manifestoes, Commentary, Expressions." *Art Bulletin* 71(May 1991):119-40. illus.

749. RAMOND, MICHELE. "L'Insistance: reflexion sur la création des femmes (Louise

Moillon, Berthe Morisot, Marguerite Duras)" in *Lectures de la différence sexuelle*, Colloque Paris-VIII, CIPH, Paris (Octobre 1990), Actes I, édité par Negron Mara (Paris: Des Femmes, 1994):185-95.

750. REGNIER, HENRI DE. "Mallarmé et les peintres." *L'Art vivant* (1 April 1930).

751. REGNIER, HENRI DE. "Faces et profils: Berthe Morisot." *Nouvelles littéraires, artistiques et scientifiques* (13 July 1935).

752. REUTERSWARD, OSCAR. "Berthe Morisot." *Konstrevy* 25(1949):280-5.

753. REWALD, JOHN. "Paysages de Paris." *La Renaissance* (Jan.-Feb. 1937).

754. REY, ROBERT. "Berthe Morisot." *Gazette des Beaux-arts* (1926):222-3.

755. ROGER-MARX, CLAUDE. "Les Femmes peintres et l'impressionnisme: Berthe Morisot." *Gazette des Beaux-arts* ser. 3, 38(Dec. 1907).

756. ROHN, MATTHEW. "Berthe Morisot's *Two Sisters on a Couch*." *Berkshire Review* (Fall 1986):80-90. "Comments on Rohn" by John T. Paoletti, pp. 91-5.

Discusses Berthe's relationship with her sister Edma, with reference to her correspondence and the painting *Two Sisters on a Couch* (1869).

757. ROTHKOPF, KATHERINE. "From Argenteuil to Bougival: Life and Leisure on the Seine, 1868-1882" in *Impressionists on the Seine: A Celebration of Renoir's Luncheon of the Boating Party* (Washington, D.C.: Counterpoint in association with the Phillips Collection, 1996):56-85. 22 illus., 6 col., 1 map.

Elucidates the popularity of life and boating on the Seine as a subject for Impressionist painters, including Morisot.

758. ROUART, LOUIS. "Berthe Morisot (Mme Eugène Manet 1841-1895)." *Arts et décoration* (May 1908).

759. ROUART-VALERY, AGATHE. "De 'Madame Manet' à 'Tante Berthe.'" *Arts* (March 1961).

760. ROUART-VALERY, AGATHE. "Degas, ami de ma famille" in *Degas inédit: actes du colloque Degas, Musée d'Orsay, 18-21 avril 1988* (Paris: La Documentation Française, 1989):22-34. 5 illus.

Family memories of Degas, Henri Rouart, Berthe Morisot and Paul Valéry by a descendent of the collector Ernest Rouart.

761. RYAN, GURLEY E. "Renoir, Rosen und eine Marmorstatuette." *Die Kunst und das Schone Heim* 86:7(1974):397-402. 18 illus.

Analysis of Renoir's marble statuette, *Eurydice aux roses* (1907-08), inspired, the author contends, by two portraits of Morisot by Edouard Manet.

762. RYAN, GURLEY E. "Berthe Morisot: quatre portraits inédits par Marcello." *L'Estampille* 178(1985):14-21. 11 illus.

Presents four portraits of Morisot by the Duchess Castiglione Colonna (called Marcello) produced between 1872-75, held at the Fondation Marcello and the Musée d'Art et d'histoire de Fribourg. Includes biographical information on the Swiss-born painter and sculptress who lived 1836-79.

763. SAUVAGE, CLAUDE. "L'Impressionnisme." Magazine d'art 3:1(Sept. 1990):90-2. 2 col. illus.

764. SCHIRRMEISTER, ANNE. "La Dernière mode: Berthe Morisot and Costume" in *Perspectives on Morisot,* ed. by Teri J. Edelstein (NY: Hudson Hills Press in association with the Mount Holyoke College Art Museum, 1990):103-15. 15 illus., 6 col.

Compares bourgeois costumes depicted in Morisot's paintings to contemporary fashion illustration and industry.

765. SCHLAGHECK, IRMA. "Spater Ruhm fur eine Rebellin." *ART: das Kunstmagazin* 8(Aug. 1987):54-65. 11 col. illus.

Reassessment of the life and work of Morisot that describes early teachers, relationships with the Impressionist circle, and her friendship with Edouard Manet.

766. SCHUHL, PIERRE MAXIME. "L'Oeuvre de Berthe Morisot, un art de vivre." *Rivista di Estetica* (1961).

767. SCOTT, BARBARA. "Letter from Paris. The Particular Charm of Berthe Morisot." *Apollo* 126:306(Aug. 1987):121-3.

Comments on Morisot's appeal, with reference to a solo exhibition held at Galerie Hopkins-Thomas, Paris (1987-88).

768. SCOTT, WILLIAM P. "Berthe Morisot: Paintings from a Private Place." *American Artist* 41(Nov. 1977):66-71, 95-100, 107-8. 9 illus.

Examines Morisot's life, career, and relationships with other Impressionists. Explains why her work deserves wider appreciation.

769. SCOTT, WILLIAM P. "The Enchanting World of Berthe Morisot." *Art and Antiques* 4:1(Jan.-Feb. 1981):92-9. 10 col. illus.

Details Morisot's life and career, her studies with Corot, and the influence of Edouard Manet and other Impressionists. Favorite subjects changed during her career from early landscapes and seascapes to women and children. Alludes to positive critical responses to her work,

although Morisot was somewhat indifferent to her abilities.

770. SCOTT, WILLIAM P. "Berthe Morisot's Experimental Techniques and Impressionist Style." *American Artist* 51:545(Dec. 1987):42-7. 8 col. illus.

Elucidates Morisot's comparatively light brushstroke and the spontaneity of her paintings and comments on her individuality and isolation as a female Impressionist.

771. SENIOR, ELIZABETH. *"Portrait Sketch* by Edouard Manet." *British Museum Quarterly* 10(June 1936):10:1(1935):156. 1 pl.

Discusses the acquisition of a portrait sketch of Berthe Morisot by Manet, reproduced in the *London Mercury* (Feb. 1936).

772. SHENNAN, MARGARET. "The Woman Behind the Fan." *Country Life* 189:28(13 July 1995):60-3. 7 col. illus.

Introduces Morisot's life and career.

773. SPENCER, ELEANOR P. "Modern Look Through Impressionist Eyes." *ARTnews* 61:2(April 1962):29-31, 55-6. 5 illus.

Commentary on Morisot and Cassatt with reference to an exhibition of French Impressionism at the Baltimore Museum of Art.

774. STONGE, CARMEN. "Women and the Folkwang: Ida Gerhardi, Milly Stegner, and Maria Slavona." *Woman's Art Journal* 15:1(Spring-Summer 1994):3-10. 7 illus.

Treats the careers of three women—Ida Gerhardi, Milly Stegner, and Maria Slavona—who regularly exhibited at the Folkwang Museum in Hagen Germany from 1909-21, Germany's first museum of modern art. Notes that Slavona's paintings are often compared to works by Morisot.

775. TINTEROW, GARY. "Miracle au Met." *Connaissance des arts* 472(June 1991):32-41. 10 col. illus.

Description of the Walter Annenberg bequest of 53 Impressionist and Post-Impressionist paintings made to the Metropolitan Museum of Art, NY, that included works by Morisot, among other artists.

776. TINTEROW, GARY. *"Young Woman Seated on a Sofa."* *Metropolitan Museum of Art Bulletin* 50(Fall 1992):49.

777. "Two Artists' Families." *Country Life* 148(15 Oct. 1970):972. illus.

778. VENTURI, LIONELLO. "L'Impressionismo." *Arte* 6(March 1935):118-49.

779. WADE, JENNIFER. "The Chosen Few: Women Painters of the 19th Century." *Art and Antiques* 4:1(Jan.-Feb. 1981):26-8, 108-9. 1 illus.

Comments on the popularity of works in the art market by professional 19th century women artists such as Morisot and Cassatt.

780. WERNER, ALFRED. "Berthe Morisot: Major Impressionist." *Arts Magazine* 32(March 1958):40-5. illus.

781. WILLOCH, S. "Edouard Manets *Fra Verdensud-stillingen i Paris 1867.*" *Konsthistorisk Tidskrift* 45:3-4(1976):101-8. 4 illus. In Swedish; summary in French.

Analysis of Manet's painting *From the World Exhibition in Paris 1867*, the property of the National Gallery in Oslo since 1923, that rejects the notion that Manet was inspired by a painting by Berthe Morisot of the same subject.

782. WOLFE, JOHN. "Bill Scott." *Art and Antiques* 1(Jan. 1996):96.

Profiles William P. Scott, art historian and painter known for his writings on Morisot.

783. WYZEWA, TEODOR DE. "Berthe Morisot." *L'Art dans les deux mondes* (28 March 1891).

V. Individual Exhibitions

1892, 25 May-18 June	Paris, Boussod, Valadon et Cie. *Exposition de tableaux, pastels et dessins par Berthe Morisot.* Préface par Gustave Geffroy. 23 p.
	a. Reprint: *Exhibitons of Impressionist Art.* NY: Garland, 1981 (Modern Art in Paris, 1884-1900, no. 43) Review: R. Sertat, *Journal des artistes* (13 June 1892).
1896, 5-23 March	Paris, Galerie Durand-Ruel. *Berthe Morisot (Madame Eugène Manet): exposition de son œuvre.* Avec portrait photogravé d'après Edouard Manet. Préface par Stéphane Mallarmé. 47 p., 1 illus. 300 works shown.
	a. Reprints: Stéphane Mallarmé, *Divagations.* Paris: E. Fasquelle, 1897; *Exhibitions of Impressionist Art.* NY: Garland, 1981 (Modern Art in Paris, 1884-1900, no. 43). Reviews: A.D., *Journal des arts* (7 March 1896); R. Sertat, *Journal des artistes*; C. Mauclair, *Mercure de France* (April 1896); A. Mellerio, *La Revue artistique* (April 1896).

1902, 23 April-10 May	Paris: Galerie Durand-Ruel. *Exposition Berthe Morisot.* Review: J. de Saint-Hilaire, *Journal des arts* (7 May 1902).
1905, January-February	Paris, Galerie E. Druet. *Exposition Berthe Morisot.*
1912	Paris, Galerie Manzi-Joyant. *Exposition Berthe Morisot.*
1914, April	Paris, Galerie Manzi-Joyant. *Exposition Berthe Morisot.* Reviews: L. Hautecœur, *Chronique des arts et de la curiosité* (1914); L. Vauxcelles, *Gil Blas* (6 April 1914); A. Alexandre, *Le Figaro* (9 April 1914); E. Genet, *La République française* (9 April 1914); E. Sarradin, *Journal des débats* (9 April 1914); L. Dimier, *L'Action française* (14 April 1914).
1919, 7-22 November	Paris, Galerie Bernheim-Jeune. *Cent œuvres de Berthe Morisot (1841-1895).*
1922, 20 June-8 July	Paris, Galerie Marcel Bernheim. *Réunion d'œuvres, par Berthe Morisot.*
1925, 30 January-10 March	Chicago, Arts Club of Chicago. *Exposition of Paintings by Berthe Morisot.* 3 p.
1926, 31 May-25 June	Paris, L. Dru. *Exposition Berthe Morisot.* Avant-propos par Paul Valéry, "Tante Berthe." a. Reprints: Paul Valéry, *Pièces sur l'art.* Paris: Gallimard, 1934; Paul Valéry, *Degas, Manet, Morisot.* Trans. by David Paul; with an introduction by Douglas Cooper. London: Routledge & Kegan Paul, 1960; Princeton, NJ: Princeton University Press, 1989.
1928	Paris, Galerie Dru. *Quelques tableaux, études, pastels, aquarelles et dessins de Berthe Morisot.*
1929, 6-24 May	Paris, Galerie Bernheim-Jeune. *Exposition d'œuvres de Berthe Morisot, au profit des Amis du Luxembourg.* Reviews: *Beaux-arts* 7(June 1929):17; C. Roger-Marx, *Creative Arts* 5(July 1929):522.
1930, March-April	London, Ernest Brown & Phillips, The Leicester Galleries. *Berthe Morisot Exhibition*: 50 works shown. Reviews: *ARTnews* 28(22 March 1930):21; H. Fell, *Apollo* (April 1930); T. Earp, *Creative Arts* 6(April 1930):288-9; T. Earp, *Studio* 1(1930):288; L. Gordon-Stables, *ARTnews* 28(19 April 1930):291.

1936, May-June	London, Knoedler & Co. *Berthe Morisot (Madame Eugène Manet), 1841-1895.* 19 p., 7 pl.
1936, 24 November-12 December	New York, Wildenstein Galleries. *Berthe Morisot Exhibition.* Paintings, watercolors, drawings.
	Reviews: J. Lowe, *ARTnews* 35(28 Nov. 1936):14+; *Art Digest* 11(1 Dec. 1936):21; M. Breuning, *Parnassus* 9(Jan. 1937):37; *Arts & Decoration* 45 (Feb. 1937):18.
1941, Summer	Paris, Musée de l'Orangerie. *Berthe Morisot, 1841-1895.* Préface de Paul Valéry, "Au sujet de Berthe Morisot." 50 p., illus.
	a. Reprint: Paul Valéry, *Vues* (Paris: Gallimard, 1948).
1943, 24 March-7 April	Chicago, Arts Club of Chicago. *Berthe Morisot.* 1 folded sheet.
1947	Paris, Galerie Weil. *Berthe Morisot, rétrospective.*
1948, 9-30 April	Paris, Galerie Durand-Ruel. *Exposition, Berthe Morisot, 1841-1895: pastels, aquarelles, dessins.*
	Reviews: *Arts magazine* (9 April 1948):1; M. Bataille, *Arts* (16 April 1948): 8.
1949, 20 August-23 October	Copenhagen, NY Carlsberg Glyptotek. *Berthe Morisot, 1841-1895: Mälningar: Olja och Akvarellsamt Teckningar.* Also shown Stockholm, National Museum (23 Sept.-23 Oct. 1949). 25 p., illus., 6 pl.
1950	London, Arts Council of Great Britain, Matthiesen Galleries. *Berthe Morisot: An Exhibition of Paintings & Drawings.* 19 p., illus., 8 pl.
	Reviews: *London News* 216(3 June 1950):875; *Art News* 49(June 1950):62; *Architecture Review* 108(July 1950):71.
1951, 12-30 June	Geneva, Motte Gallery. *Exposition Berthe Morisot.*
	Review: *Werk* 38(Aug. 1951):supp. 106.
1957, 5 July-30 September	Dieppe, Musée de Dieppe. *Exposition Berthe Morisot.* Préface de Paul Valéry. 19 p., 5 pl.
1958, 1 July-15 September	Albi, Musée Toulouse-Lautrec. *Exposition Berthe Morisot (1841-1895): peintures. aquarelles, dessins.* 106 p., illus.

1960, 10 October-
10 December

Boston, Museum of Fine Arts, Boston. *Berthe Morisot: Drawings, Pastels, Watercolors.* Also shown NY, Charles E. Slatkin Galleries (12 Nov. - 10 Dec. 1960). Introduction by Elizabeth Mongan. Preface by Denis Rouart. Research and Chronology by Elaine Johnson. Catalog commentary by Regina Shoulman. General editor, Ira Moskowitz. NY: Shorewood; in collaboration with Charles E. Slatkin Galleries, 1960. 35 p., 11 illus., some col.

a. English ed.: London: Thames & Hudson, 1961.
b. German ed.: Hamburg: Rütten & Loening, 1961.
Review: *ARTnews* 59(Nov. 1960):40[+].

1960, 3
November-10
December

NY, Wildenstein & Co. *Berthe Morisot: Loan Exhibition of Paintings for the Benefit of the National Organization for Mentally Ill Children, Inc.* 77 p., illus., 70 pl.

Reviews: *ARTnews* 59(Nov. 1960):40[+]; *Arts Magazine* 35(Nov. 1960):24-5; S. Preston, *Burlington Magazine* 102(Dec. 1960):546.

1961

London, Wildenstein Galleries. *Berthe Morisot, 1841-1895.* Loan exhibition of paintings in aid of the French Hospital and Dispensary. 57 p., illus.

Reviews: S. Preston, *Burlington Magazine.* 102(Dec. 1960):546; H. Shipp, *Apollo* 73(Feb. 1961):31-2; R. Melville, *Architecture Review* 129(April 1961):280.

1961

Paris, Musée Jacquemart-André, Institut de France. *Berthe Morisot.* 29 p., 24 pl.

Reviews: K. Morland, *Burlington Magazine* 103(April 1961):158; A. Michelson, *Arts Magazine* 35(May 1961):17; *Domus* 378(May 1961):27; P. Schneider, *Art News* 60(May 1961):44; A. Watt, *Studio International* 161 (June 1961):224-6.

1961

Chicago, Fairweather-Hardin Gallery. *Berthe Morisot.* Included drawings, pastels, watercolors.

Review: F. Schulze, *ARTnews* 60(Summer 1961):50.

1961, 24 June-3
September

Vevey, Switzerland, Musée Jenisch. *Berthe Morisot.* Catalogue par M.-L. Bataille et Georges Wildenstein.

1963

Los Angeles, Hatfield Gallery. *Berthe Morisot.* Pastel and drawings.

Review: G. Nordland, *Arts* 37:7(April 1963):17.

1973, 16 March- 12 April	Birmingham, AL, Birmingham Museum of Art. *The Enchantress, Berthe Morisot*. In joint sponsorship with the 1973 Birmingham Festival of Arts honoring France. 16 p., 19 illus.
1987-88, April-9 May	Paris, Galerie Hopkins-Thomas. *Berthe Morisot*. 124 p., 52 pl., some col. Catalogue par Waring Hopkins et Alain Thomas. Expanded version, *Berthe Morisot: Impressionist*, shown Washington, D.C., National Gallery of Art (6 Sept.-29 Nov. 1987); Fort Worth, Kimbell Art Museum (14 Dec. 1987-22 Feb. 1988); South Hadley, MA, Mount Holyoke College Art Museum (14 March-9 May 1988). Catalogue by Charles F. Stuckey, William P. Scott, and Suzanne G. Lindsay. NY: Hudson Hills Press, 1987. 228 p., 240 illus. 123 col.

Reviews: B. Scott, *Apollo* 126:306(Aug. 1987):121-3; *Connaissance des arts* 423(1987):6-7; N. Mathews, *Woman's Art Journal* 10:1(Spring-Summer 1989):46-9, H. Kenner, *Art and Antiques* (Sept. 1987):112; K. Adler, *Burlington Magazine* 129:1016(Nov. 1987):765-6; K. Collmer, *Southwest Art* 17(Dec. 1987):76; G. Galligan, *Arts Magazine* 62:4(Dec. 1987):78-61; E. Gibson, *Studio International* 201:1019(April 1988):24-7.

1990-91, 7 November-18 January	London, JPL Fine Arts. *Berthe Morisot (1841-1895)*. In association with Galerie Hopkins-Thomas, Paris. Catalogue by Richard Shone. 94 p., 38 illus., 37 col. 37 paintings, drawings, and watercolors shown. Includes Shone's introduction, "Berthe Morisot: A Great Impressionist."

Reviews: M. Wykes-Joyce, *Arts Review* 42(16 Nov. 1990):622[+]; P. Kitchen, *The Artist* 106(Jan. 1991):40.

1993, 15 October- 30 November	Paris, Galerie Hopkins Thomas. *Berthe Morisot*. 20 oils, watercolors, and drawings shown.

Review: *Connaissance des arts* 499(Oct. 1993):24.

19_ _	Los Angeles, Dalzell Hatfield Galleries. *Berthe Morisot, 1841-1895*. 1 folded sheet.

VI. Selected Group Exhibitions

1874, 15 April-May	Paris, 35, blvd. des Capucines. Société Anonyme des artistes, peintres, sculpteurs, graveurs. *Première exposition*.

First Impressionist exhibition. Morisot showed *Le Berceau, Cache-cache, La Lecture, Marine de Fécamp,* a pastel *Portrait of Mademoiselle Thomas,* a pastel *Village de Maurecoult,* and three watercolors.
Reviews: J. Prouvaire, *Le Rappel* (20 April 1874); P. Burty, *La République française* (25 April 1874).

1876, April Paris, 11, rue Le Peletier. *Deuxième exposition de peinture.*

Second Impressionist exhibition. Morisot shows *Au bal, Jeune femme au miroir, Le Déjeuner sur l'herbe, Plage de Fécamp, Bateaux en construction, Percher de blanchisseuse, La Toilette, Le Bateau à vapeur,* and canvasses of the Isle of Wight.

1877, April Paris, 6, rue Le Peletier. *Troisième exposition de peinture.*

Third Impressionist exhibition. Morisot showed *Tête de jeune fille, La Psyché, Sur la terrasse,* and *Femme à sa toilette.*
Review: P. Mantz, *Le Temps* (22 April 1877).

1880, 1-30 April Paris, 10, rue des Pyramides. *Cinquième exposition de peinture.*

Fifth Impressionist exhibition. Morisot showed *Tour d'été, Hiver, Femme à sa toilette, Le Lac du Bois de Boulogne, Avenue du Bois par la neige, Au jardin, Portrait, Tête de jeune fille, Paysage,* and five watercolors, including one decorated fan.
Reviews: J. Claretie, *Le Temps* (6 April 1880); G. Goetschy, *Le Voltaire* (6 April 1880); P. Burty, *La République française* (10 April 1880).

1881, 2 April-1 May Paris, 35, blvd. des Capucines. *Sixième exposition de peinture.*

Sixth Impressionist show. Morisot exhibited *Etude en plein air, Nourrice et bébé, Jeune femme en rose, Portrait, Paysage,* and pastel sketches.
Reviews: J. Claretie, *Le Temps* (5 April 1881); C. Ephrussi, *Chronique des arts* (April 1881).

1882, March Paris, 251, rue St.-Honoré. Exposition des Artistes Indépendants.

Seventh Impressionist exhibition. Morisot showed *Marie dans la véranda, Marie à l'ombrelle, M. Manet et sa fille dans le jardin de Bougival, Blanchisseuse, Petite fille dans le jardin de Bougival, Jeune femme cousant, Villa Arnulphi,* and *Le Port de Nice.*

Review: A. Silvestre, *La Vie moderne* (11 May 1882).

1886, 15 May-15 June	Paris, 1, rue Laffitte. *Huitième exposition de peinture.*

Eighth and final Impressionist exhibition. Morisot showed *Jeune fille sur l'herbe, Le Bain, La Petite servante*, and pastel portraits.

1888, 25 May-25 June	Paris, Galerie Durand-Ruel. *Exposition: Brown, Boudin, Caillebotte, Lépine, Morisot, Pissarro, Renoir, Sisley, Whistler.* 4 p.
1893, May	Anvers, Association pour l'Art. *Seconde exposition annuelle.*
1894, 17 February-15 March	Brussels, La Libre Esthétique. *Première exposition.*
1905, January-February	London, Grafton Galleries. *Pictures by Boudin, Cézanne, Degas, Manet, Monet, Morisot, Pissarro, Renoir, Sisley.* Exhibited by Durand-Ruel & Sons from Paris at the Grafton Galleries, London. 29 p., 42 pl.
1907	Barcelona, *5ᵗʰ International Exhibition of Fine Arts and Artistic Industries.*

Included 2,013 paintings by 93 painters, including Morisot and other French Impressionists.
Review: F. Fontbona, *Archivo Español de Arte* 63:250(April-June 1990):312-22.

1914	Copenhagen, Royal Museum of Copenhagen.
1918, 6-7 November	Paris, Hôtel Drouot. *Catalogue des estampes anciennes et modernes: œuvres de Bracquemond, Mary Cassatt, Daumier, Eugène Delacroix, Gauguin, Gavarni, Ingres, Legros, Manet, Berthe Morisot, Pissarro, Whistler, etc.*; composant la collection Edgar Degas dont la vente aux enchère publiques après son décès, aura lieu à Paris à l'Hôtel Drouot.
1924, 15 October-1 December	Pittsburgh, Carnegie Institute. *Exhibition of Paintings: Edouard Manet, Pierre Renoir, Berthe Morisot.* 25 p., illus.
1930, May	Paris, Galerie d'Art Pleyel. *Exposition du Syndicat des artistes femmes, peintures et sculptures.* 12 p.
1930, 20 October-10 November	NY, Durand-Ruel Galleries. *Exhibition of Paintings by Mary Cassatt and Berthe Morisot.* 8 p., illus.

Reviews: *ARTnews* 29(25 Oct. 1930):10; L. Goodrich, *Arts* 17(Nov. 1930): 115; A. Sayre, *International Studio* 97(Dec. 1930):96.

1937, November-December	NY, Carroll Carstairs Gallery.
	Reviews: *Art Digest* 12(15 Nov. 1937):15; *ARTnews* 36(27 Nov. 1937):15[+].
1939, 30 October-18 November	NY, Durand-Ruel Galleries. *Exhibition of Paintings by Berthe Morisot and Mary Cassatt.* 2 p.
	Reviews: J. Lowe, *ARTnews* 38(4 Nov. 1939):9,17; M. Breuning, *Magazine of Art* 32(Dec. 1939):732.
1942	Paris, Hôtel Drouot. *Catalogue des dessins, aquarelles, gouaches, pastels ... composant la collection de M. Georges Viau.* 50 p., illus.
	Included paintings by Morisot, among other French painters.
1948	NY, Durand-Ruel Galleries. *Paintings of Ships: Monet, Pissarro, Renoir, Sisley, Redon, Morisot.* 4 p.
1950	Paris, Quatre Chemins-Editart. *Quelques œuvres de Berthe Morisot, Degas, Fantin-Latour, Manet, C. Monet. Puvis de Chavannes, Renoir.* 3 p.
1952, 19 July-10 October	Limoges, Musée Municipal. *Hommage à Berthe Morisot et à Pierre-Auguste Renoir.* Préface par Denis Rouart. 82 p., illus., 35 pl.
1952, September-October 1954	Toronto, Art Gallery of Toronto. *Berthe Morisot and her Circle: Paintings from the Rouart Collection, Paris.* Also shown Montréal, Montréal Museum of Art; NY, Metropolitan Museum of Art; Toledo, Museum of Art; Washington, D.C., Phillips Collection; San Francisco; Portland, Oregon, Portland Museum of Art. 10 p., 30 pl.
	Reviews: *Time* 60(13 Oct. 1952):74[+]; *Art Digest* 27(1 Feb. 1953):12; R. Davis, *Minneapolis Institute of Art Bulletin* 42(Nov. 1953):126-31.
1958, 19 November	NY, Parke-Bernet Galleries. *Major Works by Bonnard, Cézanne, Degas, Raoul Dufy, Manet, Matisse, Modigliani, Monet, Morisot ...* from the collection of Arnold Kirkeby. 91 p., illus., some col.
1959, 14 January	NY, Parke-Bernet Galleries. *Modern Paintings & Drawings.* Sale no. 1927. 81 p., illus., some col.
	Included works by Morisot.

1962, 18 April-3 June Baltimore, Baltimore Museum of Art. *Paintings, Drawings and Graphic Works by Manet, Degas, Berthe Morisot and Mary Cassatt.* 62 p., illus., pl.

Review: E. Spencer, *ARTnews* 61:2(April 1962):29-31, 55-6.

1965, 6-28 March Palm Beach, FL, Society of the Four Arts. *Auguste Rodin and Berthe Morisot: A Loan Exhibition.* 32 p., illus.

1970, October-November London, Gerald M. Norman Gallery. *18th, 19th, and 20th Century Watercolours and Drawings.*

Inaugural exhibition that included drawings by Morisot. Review: S. Flower, *Connoisseur* 175(Dec. 1970):301.

1972, 17 May-17 June Paris, Galerie Schmit. *Les Impressionnistes et leurs précurseurs.* Catalogue par François Daulte. 95 p., 71 illus.

Included works by Morisot and Cassatt. Review: *Apollo* 95(June 1972):506.

1972, 2 November-9 December NY, Wildenstein Galleries. *Faces from the World of Impressionism and Post-Impressionism.* Catalogue by A. Poulet. 80 p., 71 illus.

Included works by Morisot and Cassatt.

1973, 15 June-14 October Boston, Boston Museum of Fine Arts. *Impressionism, French and American.* 40 p., 35 col. illus.

Exhibition of 35 Impressionist works held in the Museum of Fine Arts, Boston, including examples by Morisot and Cassatt, that highlighted connections between Bostonian collectors and French artists.

1974, 21 September-24 November Paris, Grand Palais. *Centenaire de l'impressionnisme.* Préface par Jean Chatelain et Thomas Hoving. Avant-propos par Hélène Adhemar et Anthony M. Clark. Catalogue par Anne Dayez, Michel Hoog et Charles S. Moffett. Texte par René Huyghe. Paris: Musées Nationaux, 1974. 227 p., 153 illus., 51 col. 42 works shown.

Included works by Morisot and documents pertaining to the inaugural 1874 Impressionists' exhibition.

1975-77, 20 December-16 March	Los Angeles, Los Angeles County Museum of Art. *Women Artists, 1550-1950.* Also shown Austin, University of Texas, University Museum (12 April-12 June); Pittsburgh, Carnegie Institute (14 July-4 Sept.); Brooklyn, Brooklyn Museum of Art (Dec.); (1 Oct-27 Nov.); Philadelphia, Philadelphia Museum of Art; Detroit, Detroit Museum of Arts (18 Jan.-18 March 1977).

Review: J. Butterfield, *ARTnews* 76:3(March 1977):40-4.

1976-77, 10 December-28 February	Pontoise, Musée de Pontoise. *Camille Pissarro, sa famille, ses amis.* 18 p., 7 illus. 96 works shown.

Included works by Pissarro's friends and contemporary artists such as Morisot.

1977-78, 4 December-8 January	Memphis, Dixon Gallery and Gardens. *Impressionists in 1877.* Catalogue by Michael Milkovich. 81 p., 40 illus., 9 col. 30 works shown.

Included works by Morisot and 13 other French artists who participated in The Third Impressionist show in 1877.

1978	Washington, D.C., National Gallery of Art. *Small Paintings from the Bequest of Ailsa Mellon Bruce.* Catalogue by David E. Rust. 121 p., 67 illus., 7 col. 59 works shown.

Included two paintings by Morisot, both from 1869.

1980-81, 22 November-15 February	Pontoise, Musée de Pontoise. *Gravures du XIXe siècle.* Textes par Ursula Vanderbroucke, E. Murer, K. Dupont, Jean Leymarie. 46 p., illus.

Exhibition of engravings by 19th century artists, including Morisot, who lived and worked in the Pontoise area or were friends of Camille Pissarro.

1981-82, November-28 February	Mont-de-Marsan, Musée Despiau-Wlerick. *La Femme artiste d'Elisabeth Vigée-Lebrun à Rosa Bonheur.* Textes par Germaine Beaulieu, Ginette Bléry, Geneviève Lacambre, Isabelle Lemaistre, et al. 128 p., 69 illus., 1 col. 68 works shown.

Included works by Morisot and other women Impressionists. Review: *Connaissance des arts* 358(Dec. 1981):42.

1984-85, 28 June-22 April — Los Angeles, Los Angeles County Museum of Art. *A Day in the Country: Impressionism and the French Landscape.* Also shown Chicago, Chicago Art Institute (23 Oct. 1984-6 Jan. 1985); Paris, Grand Palais (8 Feb.-22 April 1985). Sponsored by the IBM Corporation, The National Endowment for the Arts, and the Federal Council on the Arts and Humanitites, Washington, D.C., Catalogue by Richard R. Brettell, et. al.; edited by A.P.A. Belloli. 375 p., 233 illus.

Exhibition of landscapes and urbanscapes by 16 Impressionist painters, including Morisot. Catalogue essays include significant information and research on Morisot.

1985, 16 March-5 May — St. Petersburg, FL, Museum of Fine Arts. *French Marine Paintings of the Nineteenth Century.* Catalogue by Michael Milkovich. 51 p., 34 illus.

Included seascapes by Morisot.

1986-87, December-May — Naples, Museo di Capodimonte. *Capilavori impressionisti dei musei americani.* Also shown Milan, Pinacoteca di Brera (March-May 1987). Catalogue by Gary Tinterow. Milan; Naples: Electa Napoli, 1986. 113 p., 47 col. illus.

Included works by Morisot and Cassatt lent by the National Gallery of Art, Washington, D.C. and the Metropolitan Museum of Art, New York.

1993, May-September — Lausanne, Fondation de l'Hermitage. *Claude Monet et ses amis.*

Retrospective of 24 paintings by Monet (1883-1926) that included works by Morisot and other Impressionists.
Review: F. Daulte, *L'Oeil* 452(June 1993):32-9.

1996-97, 21 September-9 February — Washington, D.C., Phillips Collection. *Impressionists on the Seine: A Celebration of Renoir's 'Luncheon of the Boating Party.'* Catalogue by Eliza E. Rathbone, et al. 264 p., illus.

Included works by Morisot.

1996-97, December-28 February — Paris, Musée Marmottan. *Fondation Denis et Annie Rouart.*

Includes works by Morisot, Corot, Manet, Degas, Renoir, and Monet from the collection of Denis and Annie Rouart. Denis Rouart (1908-82) was the grandson of Berthe Morisot and conservator of the Musée des Beaux-arts, Nancy.
Reviews: *Connaissance des arts* 543(Oct. 1997):12; P. Piguet, *L'Oeil* 489(Oct. 1997):18.

Marie Bracquemond

Biography

Unlike the other three women Impressionists featured in this sourcebook, Marie Quivoron-Pasquiou Bracquemond did not enjoy the advantages of a privileged, cultured, and supportive background. She was born at Argenton near Quimper in Brittany. Her father, a sea captain, died soon after her birth and her mother remarried. Her youth was spent in the Jura region of Switzerland and in Auvergne in the Massif Central, eventually settling in Estampes, south of Paris, where she began to study drawing. Largely self-taught, Bracquemond received advice and criticism initially from Ingres and later from Gauguin and Sisley. She most admired Monet and Renoir among the major Impressionists.

Bracquemond was admitted to the Salon in 1857 (where she showed sporadically into the mid-1870s) and was commissioned to copy pictures in the Louvre. There she met the successful printmaker Félix Bracquemond (1833-1914), whom she married in 1869. Although Félix had contacts among contemporary artists and critics, including the Impressionists, he opposed their aesthetics and discouraged his wife's career. The couple's son Pierre was born in 1870. In 1871, they moved to Sèvres, where Félix was appointed artistic director and later head of the Auteuil studio of the Haviland Limoges factory. In addition to porcelain production, Félix designed furniture, jewelry, tapestries, and other decorative arts. Collaborators included Rodin and Jules Chéret, the father of lithography. Félix also created designs for his close friend and admirer, the influential critic Gustave Geffroy, who directed the Gobelins Tapestry works. In 1862, he founded La Société des Aquafortistes and in 1890 he founded La Société des Peintres-graveurs français. He was also a founding member of La Société des Artistes français and belonged to La Société Nationale des beaux-arts. Staunchly conservative and opinionated, he published theoretical treatises on the role of color in design and on aesthetics, most notable in his book *Du dessin et de la couleur* (Paris: G. Charpentier, 1885).

Marie collaborated on projects with her husband at Haviland and produced her own ceramics, including an acclaimed title series entitled *Muses*, which was shown at l'Exposition Universelle, Paris in 1878. Her sketch for *Muses*, shown at the 1879 Impressionist exhibition, captured the attention of Degas. She also created drawings for the avant-garde magazine *La Vie moderne*. Over her husband's objections, Bracquemond embraced Impressionism around 1880 and participated in three of their famous group shows (1879, 1880, and 1886).

Marie Bracquemond's Impressionist period lasted until 1890 when, at her husband's insistence, she abandoned painting altogether, producing only a few watercolors and drawings until her death in 1916. Although she created only about 100 paintings in her

lifetime, including many small sketches, her mature Impressionist works emphasize the effects of natural light in quiet domestic settings. Bracquemond's family members and friends, especially her son and her sister, were her most common models. She sketched *en plein air* and prepared her canvases in traditional ways, beginning with numerous drawings and sketches. *The Lady in White* (1880), *On the Terrace at Sèvres with Fantin-Latour* (1880), *Afternoon Tea* (1880), and *Under the Lamp* (1887) are often hailed as masterpieces.

Bracquemond spent her last year quietly as a homemaker in Sèvres. According to her son, she was acutely aware of the sacrifice of her artistic talent for domestic harmony. Félix died in 1914. Their son Pierre followed a similar career in the decorative arts and became a noted encaustic painter. In 1919, he organized a major retrospective of his mother's œuvre held at the Galerie Bernheim-Jeune, Paris, which included 90 paintings, 34 watercolors, and 9 engravings. At his death in 1926, Pierre left important yet unpublished critical articles and manuscripts regarding his parents.

Marie Bracquemond

Chronology, 1840–1916

Information for this chronology was gathered from Jean-Paul Bouillon, "Marie Bracquemond" in *The Dictionary of Art* (NY: Grove, 1996)4:626-7; Jean-Paul Bouillon and Elizabeth Kane, "Marie Bracquemond," *Woman's Art Journal* 5:2(Fall 1984-Winter 1985):21-7; Tamar Garb, "Marie Bracquemond" in *Dictionary of Women Artists*, ed. by Delia Gaze (London: Fitzroy Dearborn, 1997)1:308-10; and Elizabeth Kane, "Marie Bracquemond: The Artist Time Forgot," *Apollo* 117:252(Feb. 1983):118-21.

1840-56

1 December
Birth of Marie Quivoron-Pasquiou in Argenton near Quimper, Brittany. Her father, a sea captain, dies soon after her birth and her mother remarries. She spends her youth in the Jura region of Switzerland and in the Auvergne region of France before settling in Estampes, south of Paris, where she studies drawing with a local restorer named Wassor. Unlike the other three women Impressionists in this sourcebook, Bracquemond does not come from a prosperous, cultured, and supportive family.

1857-67

Shows for the first time at the Paris Salon and is commissioned by the State to copy pictures from the Louvre. She receives no formal art training, only occasional advice from various painters including Ingres and later Gauguin.

1867

Meets her future husband, Félix Bracquemond (1833-1914), a leading engraver, printmaker, and ceramicist.

1869

5 August
Marries Félix Bracquemond and associates with his circle of major artists and critics.

1870

26 June
Birth of her son Pierre, an artist and interior decorator involved with the Gobelins Tapestry workshop. He later documents his parents' lives in an unpublished manuscript, "La Vie de Félix et Marie Bracquemond" (private collection, Paris). Pierre dies in 1926.

1871

Moves to Sèvres after Félix is appointed artistic director of the Haviland Limoges porcelain works in Auteuil.

1874-75

Shows again at the official Salon.

1875-86

Interest in Impressionism fueled by the influence of Monet, Renoir, and other Impressionists. Her shortlived Impressionist style begins in earnest around 1880. Félix increasingly disapproves of the new style, favoring more conservative approaches.

1878

Exhibits dishes and a panel of faience tiles entitled the *Muses* at l'Exposition Universelle, Paris.

1879

Shows her sketch of *Muses* at the Fourth Impressionist exhibition, which is admired by Degas. Produces drawings for the avant-garde magazine *La Vie moderne*.

1880

Exhibits again with the Impressionists and is encouraged by the critic Gustave Geffroy.

1880-90

Confined to Sèvres, her career languishes and she produces a limited number of works. Her son, sister, and close friends are her most common models.

1886

Exhibits at the Eighth and final Impressionist show.

1890

Hampered by her husband's disapproval and to preserve domestic harmony, Marie largely

abandons painting, producing only a few small canvasses until her death in 1916.

1914

Death of her husband Félix.

1916

17 January
Dies in Sèvres.

1919

Retrospective of 90 paintings (mostly small sketches), 34 watercolors, and 9 engravings held at Galerie Bernheim-Jeune, Paris. Exhibition organized by her son Pierre.

1926

Death of her son Pierre.

Marie Bracquemond

Bibliography

I. Articles

784. BOUILLON, JEAN-PAUL. "La Correspondance de Félix Bracquemond: une source inédite pour l'histoire de l'art français dans la seconde moitié du XIXe siècle." *Gazette des Beaux arts* ser. 6, 82(Dec. 1973):351-86.

785. BOUILLON, JEAN-PAUL. "Les Lettres de Manet à Bracquemond." *Gazette des Beaux-arts* ser. 6, 101(April 1983):145-58.

Concerns correspondence between Edouard Manet and Félix Bracquemond.

786. BOUILLON, JEAN-PAUL and ELIZABETH KANE. "Marie Bracquemond." *Woman's Art Journal* 5:2(Fall 1984-Winter 1985):21-7. 7 illus.

Examines Bracquemond's life and career, noting her experimentation with Impressionism and prejudices against her as a woman artist. Despite Ingres' refusal to train her properly and her husband Félix's lack of support and hostility towards Impressionism, Bracquemond produced exceptional works between 1870 and 1890, notable for capturing the effects of light and white in open air.

787. BOUILLON, JEAN-PAUL. "Degas, Bracquemond, Cassatt: actualité de l'Ingrisme autour de 1880." *Gazette des Beaux-arts* 3:6(Jan.-Feb. 1988):125-7. 2 illus.

Discusses the close relationship between Degas, Bracquemond, and Cassatt, three artists who actively participated in the Impressionist movement. Mentions that Degas' published correspondence includes 14 letters addressed to Bracquemond, verifying their friendship and appreciation for each other's work.

788. BROUDE, NORMA F. "Will the Real Impressionists Stand Up?" *ARTnews* 85(May

1986):84-9. col. illus.

Appreciation of works by Cassatt, Bracquemond, and other women Impressionists.

789. KANE, ELIZABETH. "Marie Bracquemond: The Artist Time Forgot." *Apollo* 117:252(Feb. 1983):118-21. 6 illus., 2 col.

Biographical overview of Bracquemond's life and career that notes her husband Félix's lack of support for her art and hostility towards Impressionist aesthetics. Notes that with only four exceptions, the 156 Marie Bracquemond works assembled by her artist son, Pierre Bracquemond, for the 1919 exhibition at Bernheim-Jeune, Paris, are in private collections. The four paintings on public view are *The Woman in White* (Municipal Musem, Cambrai); *The Three Graces* (Mayor's Office, Chemille); *Tea Time* (Petit Palais, Paris); and *On the Terrace* (Petit Palais, Geneva).

II. Reproductions of Paintings

790. *La Promenade en bateau: Sisley et sa femme* (1880). *Connaissance des arts* 217(March 1970):40.

791. *La Lettre (Madame Bénédict)* (1886). *Antiques* 100(Oct. 1971):517; 10(Jan. 1972):28.

792. *Sous la lampe–Alfred Sisley et sa femme, chez Bracquemond à Sèvres* (1887). *Antiques* 101(Jan. 1972):72.

793. *Portrait de Félix Bracquemond dans son atelier* (1886). *Gazette des Beaux-arts* ser. 6, 80(Sept. 1972):supp. 19.

794. *Portrait de Madame Théodore Haviland à l'époque d'Auteuil*. *L'Oeil* 223(Feb. 1974):47.

795. *Sur la terrasse, avec Monsieur Fantin-Latour, à Sèvres* (1880). *Apollo* new ser. 99(March 1974):126.

796. *On the Terrace at Sèvres* (1880). *Art Journal* 3(Spring 1980):205.

797. *Sur la terrasse à Sèvres* (1880). *Revue de l'art* 51(1981):80.

798. *La Terrasse de la Villa Branca* (etching, 1876). *Revue de l'art* 51(1981):81.

III. Individual Exhibition

1919 Paris, Bernheim-Jeune. *Catalogue des peintres, aquarelles, dessins et eaux-fortes de Marie Bracquemond*. Préface de Gustave Geffroy. 156 works shown.

Exhibition organized by her artist son, Pierre Bracquemond, of all extant work. In his preface Geffroy identifies Bracquemond as one of the three great women Impressionists, along with Morisot and Cassatt.

IV. Group Exhibitions

1972, May-September	Mortagne, Musée de Mortagne. *Félix Bracquemond, 1833-1914: gravures, dessins, céramiques. Marie Bracquemond, 1841-1916: tableaux.* Also shown Chartres. Exposition et catalogue par Jean-Paul Bouillon. 50 p., illus., 9 pl.
1979-80, 2 November-6 January	Ann Arbor, University of Michigan, Museum of Art. *The Crisis of Impressionism, 1878-1882.* Catalogue by Joel Isaacson, with the collaboration of Jean-Paul Bouillon, Dennis Costanzo, Phylis Floyd, Laurence Lyon, Matthew Rohn, Jacquelynn Baas Slee, and Inga Christine Swenson. 220 p., 78 illus., 6 col. 56 works shown.
	Included works by Marie and Félix Bracquemond, Cassatt, and Morisot, among many other Impressionist artists.

Eva Gonzalès

Biography

Eva Gonzalès was the product of a cultured and sophisticated upbringing among Paris' intellectual elite. Her father Emmanuel was a popular French novelist of Spanish origin who founded *La Revue de France* and was later appointed honorary president of La Société des Gens de Lettres. Her Belgian mother was an accomplished musician. The Gonzalès home was a meeting place for writers, critics, and artists. Through Philippe Jourde, publisher of *Le Siècle*, she met Charles Chaplin (1825-91), an academic society-painter who ran a women's program in his studio and who would later teach Mary Cassatt. Eva began formal compositions and landscapes, exhibiting a Manet-inspired realistic painting entitled *The Little Soldier* at the 1870 Salon as Chaplin's pupil.

Eva had met Edouard Manet a year earlier and, over her father's objection, became first his model and then his student. *Manet's Portrait of Eva Gonzalès* (1870) shows the young and fashionably attired artist seated before an easel creating a still-life with flowers. Under Manet's tutelage, Gonzalès further adopted a realist style characterized by the broad and broken painterly brushstrokes of the Impressionists. She shared the Impressionists' affection for contemporary settings and intimate scenes. Family members, especially her sister Jeanne, served as models.

Gonzalès was linked to Manet for the rest of her short life and was remembered for decades as his model more than as a professional artist in her own right. The 1874 Salon rejected her *A Loge at the Théâtre des Italiens*; when it was admitted in 1879, critics immediately seized upon comparisons to Manet. Realist critics such as Philippe Burty, Edmond Duranty, and Emile Zola defended her work. In 1879, Eva married the engraver Henri-Charles Guérard (1846-97), who, after Eva's death at age 34 following childbirth, married her sister and model Jeanne.

Gonzalès preferred the official Salons over the independent exhibitions organized by her Impressionist colleagues. Her work was exhibited at the office of *L'Art* in 1882, the same year that *The Milliner*, one of her most famous works, was shown at Le Cercle de la rue Volney. The following year she held an exhibition at Galerie Georges Petit, showing mature works that some critics thought echoed Degas. In May 1883, she died after giving birth to a son. A retrospective of 88 works (including 22 pastels) was held at the offices of *La Vie moderne* in early 1885. Few sold and most were later disposed of at an auction at Hôtel Drouot, Paris.

Eva Gonzalès

Chronology, 1849–1883

Information for this chronology was gathered from Marie-Caroline Sainsaulieu and Jacques De Mons, *Eva Gonzalès, 1849-1883: étude critique et catalogue raisonné* (Paris: La Bibliothèque des arts, 1991):11-20; Tamar Garb, "Eva Gonzalès," in *The Dictionary of Art* (NY: Grove, 1996)12:915; Mary Thompkins Lewis, "Eva Gonzalès" in *Dictionary of Women Artists*, ed. by Delia Gaze (London: Fitzroy Dearborn, 1997)1:596-9; Donna G. Bachmann and Sherry Piland, *Women Artists: An Historical, Contemporary and Feminist Bibliography* (Metuchen, NJ: Scarecrow, 1978):168-69; among other sources.

1849

19 April
Birth of Eva Carola Jeanne Emmanuela Antoinette Gonzalès in Paris, daughter of the novelist Emmanuel Gonzalès and Marie Céline Ragut.

1852

16 February
Birth of Eva's sister, Jeanne Constance Philippe Gonzalès.

1866

January
Philippe Jourde, director of the magazine *Le Siècle*, arranges for Eva to have art lessons with Charles Chaplin, who runs an art studio for women. Eva leaves the studio the next year.

1868

October
Eva travels to Dieppe. Chaplin continues to monitor his ex-student and convinces Eva's father to give her his studio.

1869

Eva paints *Thé* and meets Manet through the Belgian painter Alfred Stevens. She becomes Manet's model and his only formal pupil. In the Summer, Eva poses for two portraits for

Manet: *Portrait d'Eva Gonzalès* (1870) and *Eva Gonzalès peignant dans l'atelier de Manet* (1870). Later in the year she finishes her own *Etude corrigée par mon maître.*

1870

Eva's paintings *L'Enfant de troupe*, *La Passante,* and *Portrait de Mademoiselle J. G.* are accepted and exhibited at the Paris Salon, where she is listed as Chaplin's student. Manet exhibits his *Portrait of Eva Gonzalès.* In July, the State buys her *L'Enfant de troupe.* The Gonzalès family seeks refuge from the Franco-Prussian war in Dieppe, where they stay until the following year.

1872

Exhibits *L'Indolence* and *La Plante favorite* at the Salon, where she is still listed as Monsieur Chaplin's student.

1873

The Salon's jury does not accept her *Les Oséraies (ferme en Brie)* and she shows it at the Salon des Refusés. In the Salon des Refusés' catalogue she is described for the first time as Chaplin's and Manet's student.

1874

Eva and Léon Leenhoff pose together for Manet's *Dans la loge* at the studio at place Bréda. Eva paints her *Une Loge,* inspired by Manet's pastel, but replaces the characters for Jeanne Gonzalès, her sister, and Henri Guérard, Manet's friend and engraver. Guérard will become Eva's future husband. In May, the Salon's jury does not accept her painting *Une Loge* but accepts the pastel *La Nichée.* Eva exhibits *Une Loge* in her own studio at place Bréda. The work is associated with Manet's *Olympia* because of the portrayal of a bouquet of flowers on the bottom left-hand corner. The art historian Jules Clarétie communicates to Eva's father his feelings of injustice in the refusal of Eva's work by the Salon. Manet also compliments Eva on her success in her studio.

22 December
Marriage of Berthe Morisot and Eugène Manet. Eva exhibits *Thé* and *Prélude* in London.

1875

Receives an invitation from the International Commission, International Exhibitions to come to London to receive a medal.

1876

Exhibits *Le Petit lever* at the Salon.

1878

In May, exhibits two paintings: *Miss et Bébé* and *En Cachette* and two pastels: *Le Panier à ouvrage* and *Pommes d'api* at the Salon.

1879

15 February
Eva marries the painter and engraver Henri Guérard in Paris. Edouard Manet attends the civil ceremony. The religious ceremony takes place on February 17. In April Henri is drafted into the Army. Eva exhibits the previously refused *Une Loge aux Italiens* at the Salon, along with two pastels, *Portrait de Mlle S.* and *Tête d'enfant*. There is mixed criticism regarding *La Loge*, mainly for the fact that it had been shown too often.

1880

22 February
Death of Eva's mother.

May
Eva exhibits only one pastel, *La Demoiselle d'honneur,* well received by the press. She is still referred to as Chaplin's and Manet's student.

Summer
Eva and Henri vacation at Honfleur. During this time, Manet writes to them congratulating Eva on her artistic success.

1882

21 January
Eva exhibits *La Chronique des arts et de la curiosité* in Belgium.

In May, she exhibits *Au bord de la mer* (pastel) at the Salon. In August, Eva and Jeanne go to Dieppe, while Henri stays in Paris. Eva exhibits *La Toilette* and *La Modiste* at the Cercle Artistique et littéraire des œuvres. Her work is exhibited in the offices of the magazine *L'Art* in 1882. *The Milliner* is shown at the women's exhibition at the Cercle de la Rue Volney.

1883

19 April
Eva gives birth to Jean Raymond Guérard in Paris.

30 April
Edouard Manet dies.

May
Eva submits *La Modiste* to the Salon. She dies May 6, following complications from childbirth.

1885

16 January
Retrospective exhibition at the salons de *La Vie moderne* in Paris, organized by Henri Guérard, Emmanuel Gonzalès, and Léon Leenhoff. Catalogue preface by Philippe Burty, with 88 works (oils, pastels, and one drypoint) by Eva, a cameo by Théodore de Banville and an eau-forte by Henri Guérard representing Manet's portrait of Eva.

20 February
Sale of 80 of Eva's paintings, pastels, and watercolors at l'Hôtel Drouot, Paris. Sale catalogue preface by Edmond Bazire. Before the sale, the State purchases *Sur le seuil* and *La Nichée.*

1887

15 October
Death of Emmanuel Gonzalès, Eva's father.

1888

17 September
Marriage of Henri Guérard to Jeanne Gonzalès, Eva's sister.

1889

Eva's *Portrait de Mme G.G.* (Madame G.G. being her sister Jeanne Gonzalès) appears in l'Exposition Universelle's section of drawings and watercolors.

1897

24 March
Death of Henri Guérard.

1900

Eva's *Une loge au Théâtre des Italiens* and *L'Indolence* appear in l'Exposition Universelle, Paris.

1924

31 October
Death of Eva's sister Jeanne Guérard-Gonzalès.

Eva Gonzalès

Bibliography

I. Books

799. AUSTIN, LLOYD JAMES. "Mallarmé critique d'art" in *The Artist and the Writer in France: Essays in Honour of Jean Seznec.* ed. by Francis Haskell, Anthony Levi, and Robert Shackleton. pp. 153-162. Oxford: Clarendon Press, 1974. 8 illus.

Commentary on Mallarmé's article on the Impressionists and Edouard Manet, published in *Art Monthly Review,* 1876. Mentions Gonzalès among other artists.

800. COURTHION, PIERRE and PIERRE CAILLER. *Portrait of Manet by himself and his Contemporaries.* London: Cassell, 1960.

801. FINE, ELSA HONIG. *Women and Art: A History of Women Painters and Sculptors from the Renaissance to the 20th Century.* Montclair, NJ: Allanheld & Schram, 1978. 240 p., illus.

Contains information on Gonzalès on pp. 135-6.

802. GARB, TAMAR. *Sisters of the Brush: Women's Artistic Culture in Late Nineteenth-Century Paris.* New Haven, CT; London: Yale University Press, 1994. 215 p., 62 illus.

Discusses the Union of Women Painters and Sculptors, founded in Paris in 1881, which mentions Gonzalès among other women Impressionists.
Review: M. Lewis, *Art Journal* 53:3(Fall):90-2.

803. GARB, TAMAR. *Women Impressionists.* Oxford: Phaidon; NY: Rizzoli, 1986. 78 p., 40 illus., 32 col.

Surveys the lives, careers, and influence of the four major women impressionists: Berthe Morisot, Mary Cassatt, Eva Gonzalès, and Marie Bracquemond. Analyzes their individual responses to 19ᵗʰ century avant-garde French art. Reproduces, annotates, and provides full catalogue entries for 32 representative paintings. Includes seven color reproductions by Eva Gonzalès.
a. German ed.: *Frauen des Impressionismus: die Welt des farbigen Lichts*. Stuttgart; Zurich: Belser, 1987. 80 p., 40 illus., 32 col.
Reviews: C. Cruise, *Art Monthly* 103(Feb. 1987):27; B. Thomson, *Burlington Magazine* 129:1009(April 1987):254-5; N. Mathews, *Woman's Art Journal* 101:1(Spring-Summer 1989):46-9.

804. HARRIS, ANN SUTHERLAND and LINDA NOCHLIN. *Women Artists, 1550-1950*. Los Angeles: Los Angeles County Museum of Art; NY: Random House, 1976. 367 p., illus.

Specific information about Gonzalès on pages 246-8, 260, 352.

805. LUCIE-SMITH, EDWARD. *Impressionist Women*. London: Weidenfeld and Nicolson, 1989. 160 p., 128 illus., 79 col.

Discusses the role and representation of women in Impressionist art, including Gonzalès.

806. MATHEY, FRANÇOIS. *Six femmes peintres: Berthe Morisot, Eva Gonzalès, Séraphine Louis, Suzanne Valadon, Maria Blanchard, Marie Laurencin*. Paris: Les Editions du Chêne, 1951. 14 p. illus., 16 col. pl.

807. MOREAU-NÉLATON, ETIENNE. *Manet raconté par lui-même*. Paris: Laurens, 1926. 2 vols.

808. PETERSEN KAREN and J. J. WILSON. *Women Artists: Recognition and Reappraisal from the Early Middle Ages to the Twentieth Century*. NY: New York University Press, 1976. 212 p., illus.

Discusses Gonzalès on pp. 91-2, 97.

809. REWALD, JOHN. *The History of Impressionism*. New York: Museum of Modern Art, 1946. 474 p., illus.

a. Other eds.: 1955, 1961, 1973.
b. Chinese ed.: *Yin hsiang hua pai shih*. Pei-ching: Jen min mei shu chu pen she, 1983. 355 p., illus.
c. French eds.: *Histoire de l'impressionnisme*. Paris: Albin Michel, 1955, 1959, 1965, 1966, 1976.
d. German eds.: *Die Geschichte des Impressionismus*. Köln: M. Dumont Schauberg, 1965; 1979.
e. Italian ed.: *Storia dell'impressionismo*. Prefazione di Roberto Longhi, traduzione a cure di Antonio Boschetto. Firenze: Sansoni, 1949; Milano: A. Mondadori, 1976.
f. Polish ed.: *Historia impresjonizmu*. Przelozyla Justyna Guze Warszawa: Państwowy Instytut Wydawniczy, 1985. 554 p., illus.

g. Portuguese ed.: *História do impressionismo.* Tradução Jefferson Luís Camargo. São Paulo: Martins Fontes, 1991. 560 p., illus.

h. Romanian ed.: *Istoria impresionismului.* Traducere de Irina Maurodin. Bucuresti: Meridiane, 1974. 2 vol., illus.

i. Russian ed.: *Istóriia impressionízma.* P.V. Melkóvoi. Leningrad: Gos. izd-vo Iskússtuo, 1959. 453 p. illus., some col.

j. Spanish ed.: *Historia del impresionismo.* Barcelona: Seix Barral, 1972. 2 vol., illus.

810. ROBERTS, KEITH. *The Impressionists and Post-Impressionists.* London: Phaidon Press, 1975. 96 p. 105 color illus.

Surveys Impressionist and Post-Impressionist paintings through the major artists and respective individual styles. Contains reproductions of artists including Morisot, Cassatt, and Gonzalès.

811. ROGER-MARX, CLAUDE. *Eva Gonzalès.* Saint-Germain-en-Laye: Neuilly, 1950.

Lists Gonzalès' Salon presentations and includes several black-and-white reproductions.

812. SAINSAULIEU, MARIE CAROLINE and JACQUES DE MONS. *Eva Gonzalès, 1849-1883: étude critique et catalogue raisonné.* Paris: La Bibliothèque des Arts, 1991. 360 p. illus., 34 col.

Comprehensive monograph includes a biographical overview of Eva Gonzalès' life and career. Lists 124 works, facsimiles of letters, including one to Edouard Manet as well as a letter from Manet to Eva, dated 1880. Includes lists of exhibitions, provenance, and bibliography for each work.
Reviews: B. Thomson, *Burlington Magazine* 134:1074(Sept. 1992):604-5; *Gazette des beaux-arts* 118:1474(Nov. 1991):25; *L'Oeil* 425(1990):103.

813. SPARROW, WALTER SHAW. *Women Painters of the World: From the Time of Caterina Vigri, 1413-1463 to Rosa Bonheur and the Present Day.* London: Hodder & Stoughton, 1905. 332 p., illus.

Beautifully illustrated book, contains a collection of essays about the "genius" of women artists throughout history including Gonzalès.

814. YELDHAM, CHARLOTTE. *Women Artists in Nineteenth Century England and France.* NY: Garland, 1984. 2 vols., illus.

Contains general summary of Gonzalès' life and artistic career (see vol. 1, pp. 365-6).

II. Articles

815. ALLARD, ROGER. "D'Eva Gonzalès à Madame Agutte." *Paris-Jour (*April 1914).

816. BAYLE, PAUL. "Eva Gonzalès." *La Renaissance,* xv/6 (June 1932):110-5.

817. BIGOT, CHARLES. "L'Exposition de Madame Eva Gonzalès." *XIXe siècle* (24 Jan. 1885).

818. BOIME, ALBERT. "Maria Deraismes and Eva Gonzalès: A Feminist Critique of *Une Loge au Théâtre des Italiens.*" *Woman's Art Journal* 15:2(Fall 1994-Winter 1995):31-7. 4 illus.

Analyzes the evolution of feminism in late 19th century France with reference to Deraismes'art criticism. Compares Gonzalès painting *Une Loge au Théâtre des Italiens* (ca. 1874) with similar views of women at the theater, including Cassatt's 1882 *The Loge*.

819. BOURET, JEAN. "Eva Gonzalès, muse inspirée de Manet." *Les Arts* (3 March 1950).

820. BUMPUS, JUDITH. "What a Pity They Aren't Men." *Art & Artists* 201(June 1983):9-10. 2 illus.

Overview of women artists' contributions to Impressionism emphasizing Morisot's role and associations, including Cassatt, Gonzalès, and Suzanne Valadon.

821. BURTY, PHILIPPE. "Eva Gonzalès." *La République française* (8 Jan. 1885).

822. DERAISMES, MARIA. "Une exposition particulière de l'école réaliste." *L'Avenir des femmes (*5 July 1874).

823. DUNSTAN, BERNARD. "The City Art Gallery, Bristol." *Artist* (U.K.) 83:1(March 1972): 21-2, 30-1. 9 illus.

Describes artists represented in the Bristol City Art Gallery's collection, including Eva Gonzalès.

824. GAUCHET, L. "Madame Eva Gonzalès." *Courrier de l'art* (30 Jan. 1885).

825. JACQUES, EDMOND. "Beaux-Arts, l'œuvre d'Eva Gonzalès." *L'Intransigeant* (23 Jan. 1885).

826. MAUCLAIR, CAMILLE. "Courrier des arts, Eva Gonzalès." *Le Figaro* (28 June 1932)

827. MONOD, FRANÇOIS. "L'Impressionnisme féminin, deux élèves de Manet: Berthe Morisot, Eva Gonzalès." *Arts et décoration* (May 1914):supp.

828. NESTOR-SOMLYO, ERNEST. "Eva Gonzalès." *Die Kunst und das Schöne Heim* (July 1951).

829. NOCHLIN, LINDA. "Why Have There Been No Great Women Artists?" *ARTnews* 69(Jan. 1971):22-39, 67-71.

830. ROGER-MARX, CLAUDE. "Un peintre du bonheur: Eva Gonzalès." *Le Figaro littéraire* 204(18 March 1950).

831. ROGER-MARX, CLAUDE. "Eva Gonzalès." *Arts* (14 July 1950).

832. SWEET, FREDERICK A. "Eva Gonzalès." *Bulletin of the Art Institute of Chicago* 34:5 (Sept.-Oct. 1940):74-5.

III. Reproductions of Paintings

833. *Autoportrait. Connaissance des arts* 487(Sept. 1992):46.

834. *Dans le parc* (ca. 1878). *Art in America* 76(April 1988):34.

835. *L'Espagnole. Burlington Magazine* 130(March 1988):xv.

836. *La Femme sur la falaise. Apollo* 132(Dec. 1990):60.

837. *The Painter and His Model. Art and Auction* 20:9(May 1998):110.

838. *Le Petit lever* (1876). *Apollo* 121(June 1985):424; *Connaissance des arts* 400(June 1985):32.

839. *Portrait d'une femme en blanc* (1879). *L'Oeil* 347(June 1984):36.

840. *Self-portrait. Burlington Magazine* 126(June 1984):vii.

841. *Woman at the Window* (1879). *Apollo* 120(Sept. 1984):207.

IV. Individual Exhibitions

1885, January Paris, Salons de la *Vie moderne. Catalogue des peintres et pastels de Eva Gonzalès.* Préface de Philippe Burty, essay by Théodore de Banville. Reprinted in *Modern Art in Paris, 1855-1900* (New York: Garland, 1981), no. 40.

 Major retrospective organized by Henri Guérard, Emmanuel Gonzalès, and Léon Leenhoff. Included 88 works (oils, pastels, and one dry-point) by Eva, a cameo by Théodore de Banville, and an eau-forte by Henri Guérard representing Manet's portrait of Eva.
Reviews: T. Duret, *La Chronique des arts et de la curiosité* 4 (24 Jan. 1885); F. Javel, *L'Evénement* (23 Jan. 1885); P. de Katow, *Gil Blas* (17 Jan. 1885); C. Marx, *Le Journal des arts* (20 Jan. 1885); O. Mirbeau, *La France* (17 Jan. 1885); O. de Parisis, *L'Artiste* (Feb. 1885).

1914, March-April | Paris, Galerie Berhneim-Jeune. *Eva Gonzalès.*

Reviews: H. Genet, *République Française* (9 April 1914); L. Hautecœur, *La Chronique des arts et de la curiosité* 15(11 April 1914).; A. Alexandre, *Le Figaro (*6 April 1914).

1932, 20 June-9 July | Paris, Galerie Marcel Bernheim. *Eva Gonzalès, exposition rétrospective.* Catalogue by Paule Bayle.

1950, 10 March-1 April | Paris, Alfred Daber. *Eva Gonzalès.*

1952, 3-23 March | Principauté de Monaco, Sporting. *Eva Gonzalès.*

1959, 28 May-3 June | Paris, Galerie Daber. *Eva Gonzalès rétrospective.* Catalogue de Alfred Daber, introduction de Claude Roger-Marx.6 illus.

V. Selected Group Exhibitions

1870 | Paris, Palais des Champs-Elysées. *Salon.*

1872 | Paris, Palais des Champs-Elysées. *Salon.*

1872 | Lyon, *Exposition universelle et internationale.*

1873 | Paris, Champs-Elysées. *Exposition des œuvres refusées à l'exposition officielle de 1873.*

1874 | Paris, Palais des Champs-Elysées. *Salon.*

1874 | Ghent, *Exposition triennale de Gand.* Salon de 1874.

1874 | London, *Expositions internationales, France, Oeuvres d'Art et produits industriels.*

1875 | London. *Expositions internationales.*

1876 | Paris, Palais des Champs-Elysées. *Salon.*

1878 | Paris, Palais des Champs-Elysées. *Salon.*

1879 | Paris, Palais des Champs-Elysées. *Salon.*

1880 | Paris, Palais des Champs-Elysées. *Salon.*

1882 | Paris, Palais des Champs-Elysées. *Salon.*

1882 | Paris, Cercle artistique littéraire, *Exposition spéciale des œuvres des artistes femmes.*

1883 | Paris, Palais des Champs-Elysées. *Salon.*

1886-87, December-January	New York, American Art Galleries. *Collection Modern Paintings.*
1889	Paris, *Exposition universelle, Exposition centennale de l'art français.*
1900	Paris, *Exposition universelle, Exposition centennale de l'art français.*
1907, 1-22 October	Paris, Grand Palais des Champs-Elysées. *Salon d'Automne.*
1910	Vienna, *Die Kunst der Frau.*
1914, 15 May-30 June	Copenhagen, Statens Museum for Kunst. *Fransk Malerkunst Fradet 19nde Aarhundrede.*
1922, 28 February-18 March	Stockholm, Copenhagen, Oslo. *Manet.*
1923, 1 November-16 December	Paris, Grand Palais des Champs-Elysées. *Salon d'automne.*
1928, 1-30 June	Paris, A la Renaissance. *Portraits et figures de femmes, Ingres à Picasso.*
1942, 16 June-16 July	San Francisco, California Palace of the Legion of Honor. *Vanity Fair.*
1948-49	American Federation of Art. *Circuit.*
1949, May-June	Paris, Orangerie des Tuileries. *Pastels français.*
1949	Paris, Galerie Charpentier. *L'Enfance.*
1950	Paris, Galerie Charpentier. *Cent portraits de femmes du XVe siècle à nos jours.*
1951	Paris, Galerie Charpentier. *Plaisir de France.*
1954	Detroit, Detroit Institute of Arts. *The Two Sides of the Medal, French Painting from Gérôme to Gauguin.*
1955, August-September	Nice, Musée Masséna, *Chefs-d'œuvres du Musée du Louvre.*
1957	Copenhagen, Statens Museum for Kunst. *Fransk Kunst.*
1961, 16 May-31 July	Marseille, Musée Cantini. *Manet.*
1961	Brême, Kunsthalle. *Erwerbungen der Letzen Jahre.*
1964, 11-28 November	London, Arthur Tooth & Sons Ltd. *Recent Acquisitions XIX.*
1968, 9-31 May	Paris, Galerie Daber. *Petits chefs-d'œuvre imprévus.*

1969, 7 May-7 June Paris, Galerie Schmit. *Cent ans de peinture française.*

1969, 11 June-18 London, Wildenstein & Co. Ltd. *Pictures from Bristol.*
July

1971, 19 March-25 Coral Gables, FL, Lowe Art Museum. *French Impressionists*
April *Influence American Art.*

1971, 13 May-13 Minneapolis, The Minneapolis Institute of Arts. *Drawings from*
June *Minnesota Private Collections.*

1972, 27 February- Winston-Salem, NC, Salem Fine Arts Center.
19 March

1972, 25 March-20 Raleigh, North Carolina Museum of Art. *Women: A Historical*
April *Survey of Works by Women Artists.*

1972, 16 Paris, Théâtre de l'est parisien. *Au spectacle, de Daumier à*
September-1 *Picasso.*
October

1973-74, 8 New York, Hirschl & Adler Galleries. *Retrospective of a Gallery*
November-1 *Twenty Years.*
December

1973-74, 17 Pittsburgh, Museum of Art, Carnegie Institute. *Art in Residence.*
October-6 January

1974, 18 April-10 Paris, Grand Palais. *Paris d'hier et d'aujourd'hui.*
May

1974, June-July Paris, Galerie Daber. *La Joie de peindre.*

1974 London, The Diploma Galleries, The Royal Academy of Arts.
 Impressionism, its Masters, its Precursors, and its Influence in
 Britain.

1975, 2 May-6 June Amsterdam, E. J. van Wisselingh & Co. *Maîtres français des*
 XIXe et XXe siècles.

1976-77, 20 Los Angeles, Los Angeles County Museum of Art. *Women*
December-16 *Artists, 1550-1950.* Also shown Austin, The University of Texas
March (12 April-12 June 1977), Pittsburgh, Museum of Art, Carnegie
 Institute (14 July-4 Sept. 1977); Brooklyn, Brooklyn Museum (8
 Oct.-27 Nov. 1977)

 Review: J. Butterfield, *ARTnews* 76:3(March 1977):40-4.

1977 London, National Gallery. *A Month in London.*

1978, 1 October-26 Philadelphia, Philadelphia Museum of Art.
November

1979, 18 January-18 March	Detroit, Detroit Museum of Arts.
1979, 11 May-13 August	Paris, Grand Palais. *L'Art en France sous le Second Empire.*
1979, 9 May-10 July	Paris, Galerie Schmit. *Maîtres français, XIXe-XXe siècles.*
1979, 13 May-24 June	Southampton, NY, Parish Art Museum. *William Merritt Chase in the Company of Friends.*
1979, 1 June-15 July	Minneapolis, The Minneapolis Institute of Arts. *Great Expectations.*
1979, 16 June-30 October	Dieppe, Château-Musée. Collections de Marine du musée, quinze ans d'acquisitions.
1979	London, National Gallery. *A Month in London.*
1979-80, 15 December-15 January	Tokyo, Sunshine Museum. Also shown Osaka, Osaka Municipal Museum of Fine Arts (22 Jan.-10 Feb. 1980); Fukuoka, Fukuoka Art Museum (15-28 Feb. 1980).
1980, 8 March-10 April	Tokyo, Sunshine Museum. *Ukiyo-E Prints and the Impressionist Painters, Meeting of the East and the West.*
1980, 14 March-26 April	Paris, Daniel Malingue, *Maîtres impressionnistes et modernes.*
1981-82, November-February	Mont-de-Marsan, Donjon Lacataye. *La Femme artiste d'Elisabeth Vigée-Lebrun à Rosa Bonheur.*
1982, 26 June-27 September	Saint-Tropez, Musée de l'Annonciade, *Fleurs de Fantin-Latour à Marquet, France 1865-1925.*
1982-83, 10 December-20 February	Berlin, Staätliche Museen. *Von Courbet bis Cézanne, Französische Malerei 1848-1886.*
1983, 29 March-14 April	Nagoya, Prefectural Museum of Aichi. Also shown Tokyo, Takashimaya Art Gallery (21 April-16 May); Osaka, Takashimaya Art Gallery (19-31 May); Utsunomiya, Fine Arts Museum of Tochigi (5 June-3 July).
1983, 14 July-14 August	Kumamoto, Japan, Prefectoral Museum of Fine Arts. *Six femmes-peintres.* Catalogue prefaced by Jacques de Mons. 190 p., chiefly illus. In French and Japanese.
	123 works shown from women artists including Morisot, Cassatt, Gonzalès, Valadon, and others.

1983, 23 April-28 May	Maastricht, Noortman & Brod
1983, 14 June-29 July	London, Noortman & Brod. *Impressionists, an Exhibition of French Impressionist Painting.*
1984, 17 June-21 October	Lausanne, Fondation de l'Hermitage. *L'Impressionnisme dans les collections romandes.*
1984, 18 September-20 October	Maastricht, Noortman & Brod. *La Peinture française au XIXe siècle.*
1985, 10 May-20 July	Paris, Galerie Schmit. *De Corot à Picasso.*
1985, 18 June- 30 July	London, Connaught Brown. *Aspects of Post Impressionism.* 36 p., 23 illus., 4 col.

Exhibition of works by Post-Impressionists including Eva Gonzalès, Manet, Degas, Vuillard, and Matisse among others.

1985-86, 18 October-17 December	Tokyo, The Seibu Art Museum. Also shown Fukuoka, Fukuoka Art Museum (5 Jan.-2 Feb. 1986); Kyoto, Kyoto Municipal Museum of Art. The Impressionist Tradition: Masterpieces from the Art Institute of Chicago (4 March-13 April 1986).
1986, 25 June-30 August	Lausanne, Galerie Paul Vallotton. *Maîtres suisses et français des XIXe et XXe siècles.*
1986, 7 November-22 December	Paris, Daniel Malingue. *Maîtres impressionnistes et modernes.*
1987, 6 May-18 July	Paris, Galerie Schmit. *25e exposition, Maîtres français du XIXe siècle.*
1989, 10 November-23 December	Paris, Daniel Malingue. *Maîtres impressionnistes et modernes.*
1993-94, 13 October-15 January	Paris, Musée Marmottan. *Les Femmes impressionistes: Mary Cassatt, Eva Gonzalès, Berthe Morisot.* Also shown Tokyo, Japan: Isetan Bijutsukan (2 March-11 April 1995); Hiroshima, Japan: Hiroshima Bijutsukan (16 April-21 May 1995); Osaka, Japan: Takashimaya 7-kai Gurando Horu (31 May-13 June 1995); Hakodate, Japan: Hokkaidoritsu Hakodate Bijutsukan (1 July-20 Aug. 1995). Catalogue preface by Arnaud d'Hauterives. Paris: Bibliothèque des Arts, 1993. 174 p., illus. 90 works exhibited.

a. Another ed.: Japan: Art Life, 1995. 157 p., col. illus.
Reviews: M. T. Lewisry, *Art Journal* 53:3(Fall 1994):90-2; A.
Riding, *New York Times* (28 Oct. 1993):C15+; P. Piguet, *L'Oeil*
457(Dec. 1993):91.

Art Works Index

Includes the titles of art works in all media, as referred to in the entries and annotations. By entry number.

Personal Names Index

Names of the women Impressionists in this sourcebook appear in bold type. By entry number.

About the Authors

RUSSELL T. CLEMENT is Humanities Coordinator, John C. Hodges Library, The University of Tennessee, Knoxville. His recent publications include *Neo-Impressionist Painters*, co-authored with Annick Houzé (Greenwood, 1999), *Four French Symbolists* (Greenwood, 1996), and *Les Fauves* (Greenwood, 1994).

ANNICK HOUZÉ is the French Cataloger at the Harold B. Lee Library, Brigham Young University, Provo, Utah. She co-authored along with Russell T. Clement *Neo-Impressionist Painters* (Greenwood, 1999).

CHRISTIANE ERBOLATO-RAMSEY is Fine Arts Librarian, Lee Library, Brigham Young University.